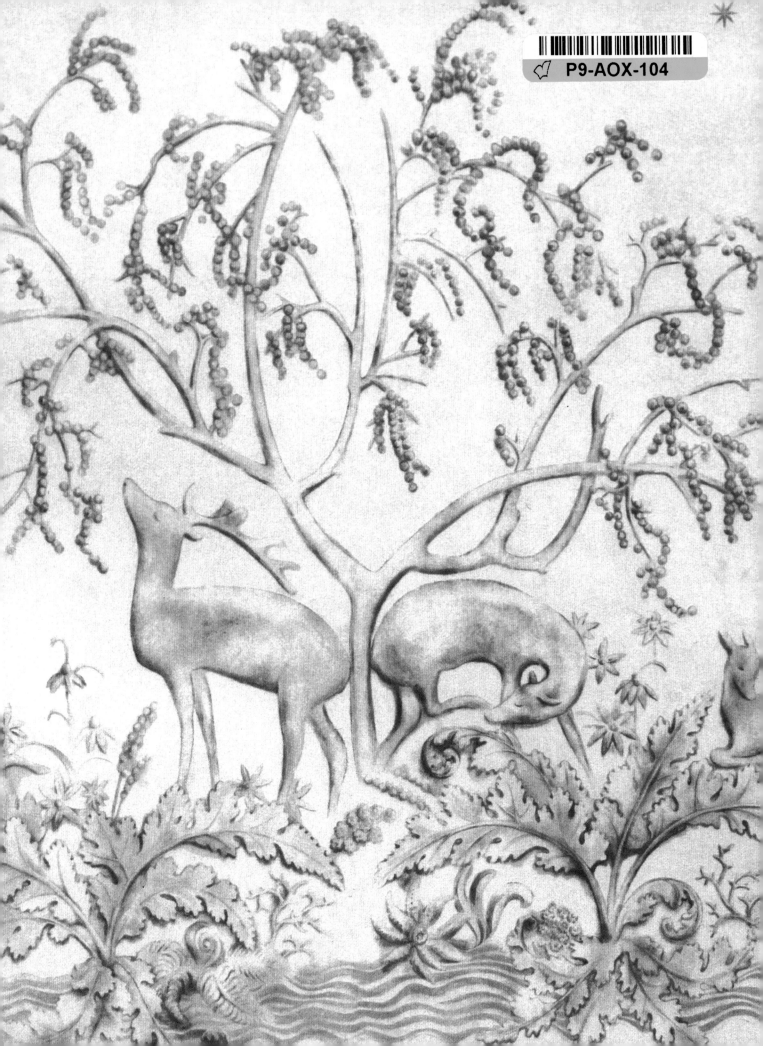

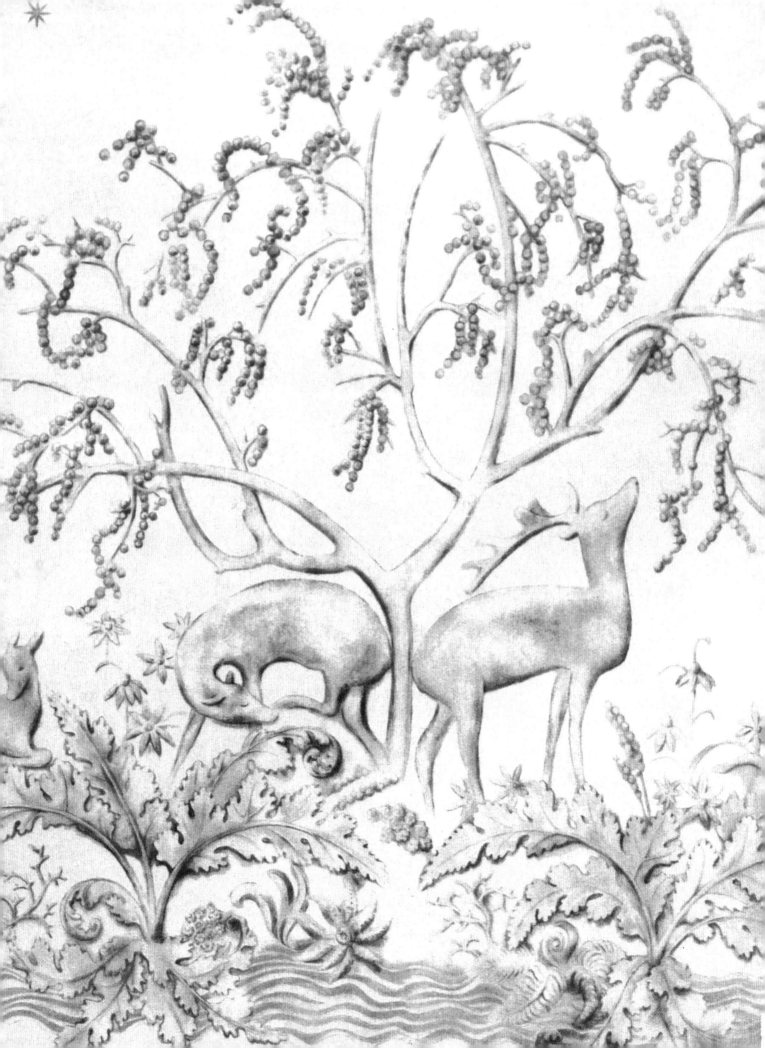

A PLACE TO CALL
HOME

A PLACE TO CALL
HOME
Timeless Southern Charm

JAMES T. FARMER III

Photographs by
EMILY J. FOLLOWILL

GIBBS SMITH
TO ENRICH AND INSPIRE HUMANKIND

Gladys —

Welcome Home y'all!

James

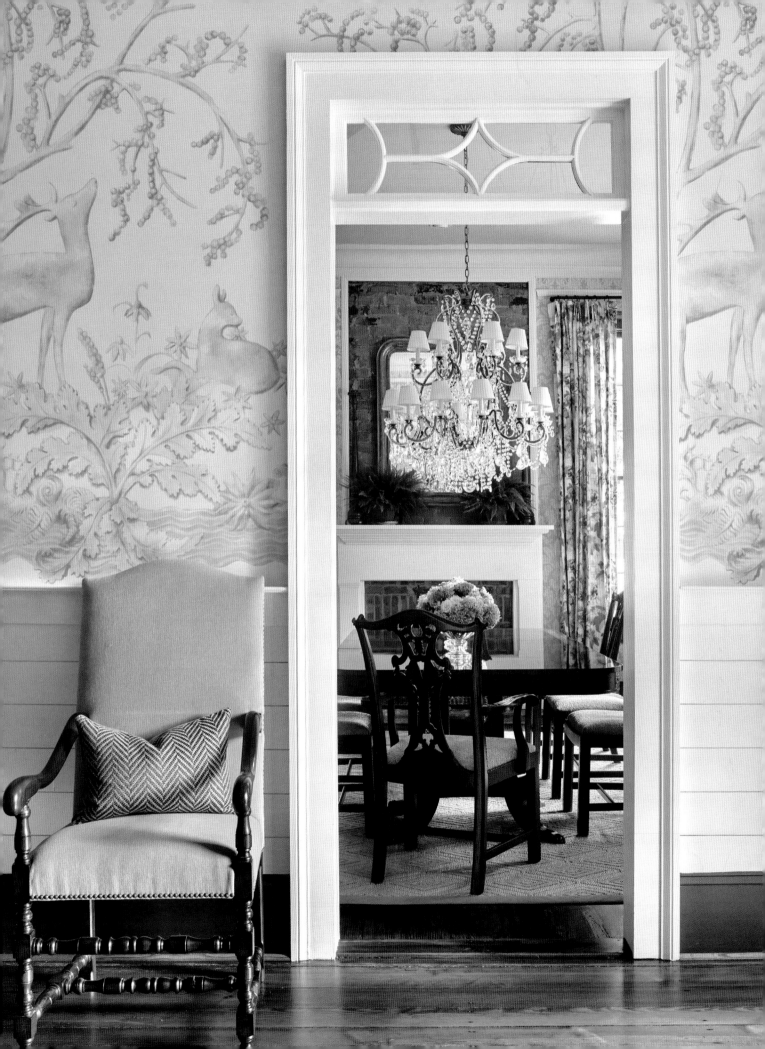

For me, to make my house a place to call home could not be achieved without a design crew, staff and support team that I have the privilege of working with every day. This group of ladies literally keeps me and my business going—and they are the reason why our clients trust us with their homes, the reason I can dream beyond my wildest expectations and the reason a book like this is possible. This book is dedicated to them.

Jesse Noble, my lead designer and the unshakable foundation of my design firm, makes each day and every project a true joy. Jesse epitomizes the paradox of creativity and logic abiding together. She serves as my shrink more often than she'd like, but she keeps me sane! Thank you for all you do for me and my business, Jesse! Your talent and skill are beyond measure.

Sarah Grace Harris, my personal assistant, is my right hand and gatekeeper. She makes the world of James Farmer Inc. come alive with her enthusiasm and spirit. She never ceases to support me and challenge me to dream bigger! "Sace," thank you for your infallible trust and faith in the dream! I can dream as big as I want with your support!

Nancy Cotton, my business manager, provides the stability and financial guidance I need to turn dreams into reality. Nancy, your belief in me and my business means more than you'll ever know. It gives me the drive to prove successful in all our endeavors. Having that support gives me roots *and* wings! Thank you for all you do.

Robin Becker, my associate designer, thought up the title for this book. Robin personifies style and pizzazz as well as having a heart for family and becomes a best friend to everyone she meets. Having her for a friend is truly a blessing. Robin, your new role as full-time mama is going to be exciting; you have so much to give your boys. Thank you for sharing your talent and passion with me!

Madeline Pittinger is a dynamo and team player to the last day! Your season with JFI was a highlight to us all, a "good and perfect gift." I am honored you chose to spend so much time with us. You're a delight and inspiration to me, and I look forward to future endeavors.

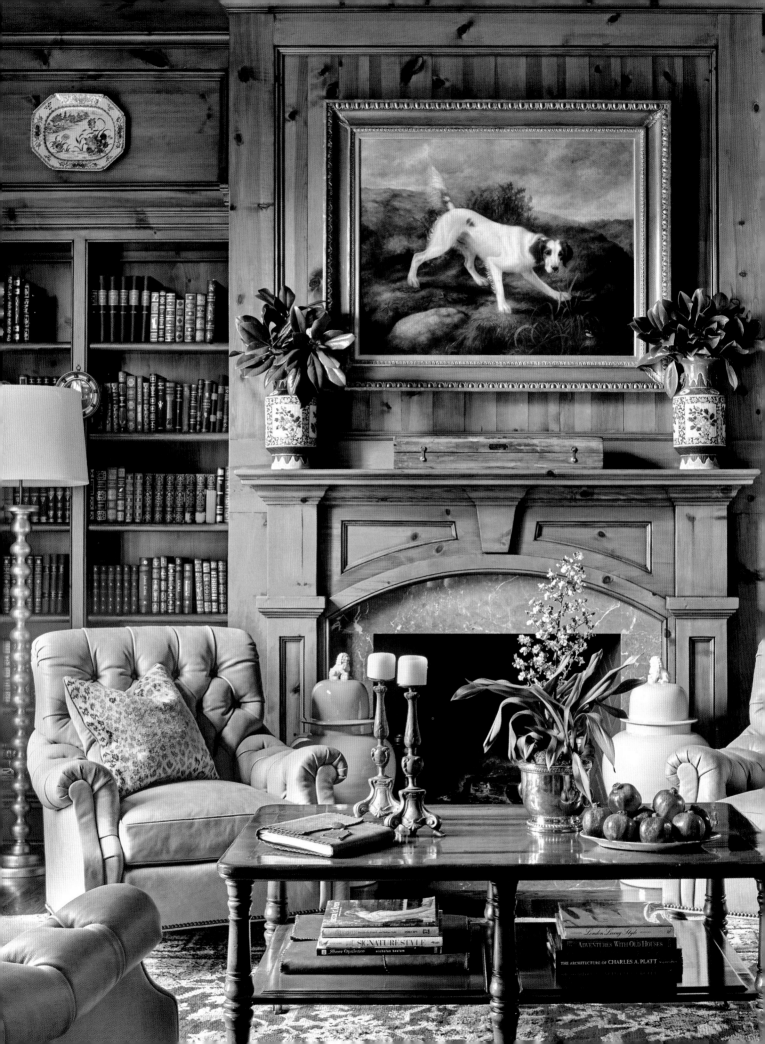

Contents

Introduction

It is where we long to be for respite and rejuvenation—home—and a place near and dear to our hearts. Home is the backdrop and stage for our families and friends to share our lives. There are the day-to-day chores that make it homey yet in turn duty filled: the armloads of grocery bags plopped on the counters, laborious hours spent planting and weeding, cooking and cleaning, decorating and sleeping—all for the sake of calling a place "home." Such acts of love and duty transform a place into more than just a house. It is an entity and being in and of itself and a significant part of our lives: IT IS A PLACE TO CALL HOME.

The term *house* denotes a structure, but the word *home* bestows an immediate feeling of warmth and tugs at our heartstrings; it evokes the scents of baked goods and fresh laundry, worn pine floors under bare feet, a comfy chair and a bed that hosts slumber better than any other. I have a particular fondness for houses and the process of their becoming homes. That, after all, is my job. While the particular title is interior designer, there is something more honorable and joyous about my job description when it involves the transformation of a house into a home.

My design firm is based in my hometown of Perry, Georgia, and I think that is one of the tricks of our trade. My design team and I believe that being grounded to one's locale and geography is a quick ticket to that metamorphosis of house to home. Our clients range in age, chapter of life, surroundings, wants and needs, desires, tastes and styles, but all want the same thing from their houses: welcoming comfort in an aesthetically pleasing environment. That feeling of being "at home" in their house is all-encompassing of the senses and makes the charge I have as their designer even more involved.

There is a distinct difference between when a client simply asks what color to paint their living room versus when they ask what color I feel would be right for their living room—not just an arbitrary color slapped onto sheetrock but an emotional response and inspiration—a backdrop for cocktails with friends, Christmas mornings, prom pictures posed in front of the mantel and quiet moments to simply be "at home" with oneself and one's family. That is the true meaning of a home—when by your own creation or with the assistance of a designer, you have a nest, a den, a burrow, a place to call your own and feel at ease, rooted and connected.

Growing up, I always knew I wanted to be a decorator. We had a couple of local, self-proclaimed ones, yet when I heard a "designer" from Atlanta (that's a big deal for country folks like us to have a city person instruct us on paint colors) tell my mother that she would be glad to "help" her "fluff" and "do" the house, I became enthralled with the idea of such a profession. I also came to know these words as "official" design terms. For me, that meant I would be able to "help" people "fluff" or "do" whatever needed my "help" "fluffing or doing." Flowers, pillows, paint or tearing down a wall and adding on a porch—it all culminates into "helping" nonetheless. That Atlanta designer went to college to be a designer—held a degree in design—thrusting her credentials above the others. That, along with natural-born taste, experience and a proper understanding of furniture form and function, made her word, and thus makes a good designer's word, infallible.

The lingo in the design field is hilarious to me. Granted, we have very technical terms for upholstery, period-correct wording for antiques, architectural styles and rug patterns, and we adhere to spreadsheets and detailed notes for finish schedules. Yet I especially love it when a client calls and asks for "help" with their house. Help? Honey, the "help" is all one-sided since I am paid to "do" what I love! I always knew that a decorator did a myriad of things from church Sunday school rooms, private homes, country clubs, flowers for weddings and even an office or bank or two. I had witnessed this at home growing up—watching a "decorator" pull together fabrics and furniture and create a space hopefully reflective of the individual residing there—all with my mother's natural good taste navigating the way. The words of *help, fluff* and *do* have become comical yet professional jargon too—especially in the Deep South. How I see it is this: if someone needs help or assistance picking out paints colors, arranging a living room or finding lamps for the dining room sideboard, then I am glad to oblige. My business is relationship building and rewarding therein. Helping someone forms a symbiotic relationship.

But for my design firm, we truly have the amazing opportunity to work further than just "fluffing." "Fluff" is what you do to get ready for a party. A "Major Fluff," as one client called it, is what you do to get ready for the holidays, a wedding or a fortieth wedding anniversary. "I can't help it, honey, we're just social." No need to explain to me—I was just glad for the business, creative outlet and invite to the parties! James Farmer Designs has the privilege of working with phenomenal clients across the Deep South and, in turn, some pretty incredible architects, craftsmen, trade suppliers, artists, antique dealers and builders. Our clients entrust my company with their *house* and expect their *home* in return. Sometimes this is a long process from the ground up or a remodel of an existing residence for a new baby, or an even bigger change such as acquiring a second home or moving to a new town.

Even as a child I had interest in homes—their stunning architecture and how the interiors were styled. I was given books on architect Frank McCall, out of Moultrie, Georgia—only an hour and change from my hometown. McCall was raised in Moultrie and lived and practiced there from the 1950s until his death in 1991. His books and understanding of the Southern vernacular have been the heaviest of influences on me as a designer. His approach was whole home—the way his clients would live there—and I try my best to emulate that. McCall's firm was carried on by Neil Turner, who had worked collaboratively with McCall and had the same understandings of Southern architecture as McCall did. My mama engaged Turner to help with the plans for remodeling our house on the farm where we lived in Perry. His work ranged all across Georgia and into the

surrounding states and communities like Sea Island and Cashiers.

Mr. McCall and his associates had mastered the ability to capture the vernacular of the Southern farmhouse with chic, classic proportions and with a perfect sense of scale and reverence for the setting. The experience of listening in when Mama and Mr. Turner discussed and executed the house allowed a young boy infatuated with Southern architecture, gardens, antiques and interiors to see McCall's and Turner's ideas come to life.

Moultrie is not unlike Perry, where I grew up and live now, and yet the McCall design team left a wake far beyond their county's lines. This firm, from their hometown perch, served clients from that area and into Atlanta, Highlands and Cashiers, Sea Island and jaunts, stretches and down roadways between them and beyond.

When I finished college at Auburn, I knew I wanted to model my design firm after Frank McCall's. The line from an old gospel hymn might as well be my company motto—"in the highways, in the hedges, we'll be working . . ." What I loved and was so influenced by with Frank McCall was that he was unapologetically Southern in his use of brick fired from Georgia red clay, heart pine for floors, cypress for ceilings and mantels, boxwoods girding Chippendale railings and crepe myrtles flanking porches like senti-nels guarding Buckingham Palace. There is an almost holy sanctity we Southerners possess for family heir-looms, and the McCall team instinctively infused that into their projects. Mr. McCall used his clients' fam-ily pieces—portraits and sideboards, china and art, heirlooms and treasured furniture—with respect and dignity. He also shopped the finest antique stores in Atlanta, New York and everywhere in between for the perfect marble mantelpiece, hunt board or chan-delier, and did not mind mixing it with an estate sale find or "side of the road" discovery. I think it is that

mix that creates harmony, rhythm and balance in a home. That perfect seasoning of a home comes from that cultivated mix of high and low pieces, storied and new, collected and found—all coming together in such a way that even a newer home can have a soulful presence and age.

The McCall style became synonymous with Southern elegance and the "at ease" feeling we portray in our homes while surrounded by our ancestors' things. Whether you had the finest home off West Paces or Sea Island Drive, or a cabin in Cashiers or on Lake Burton, or a farmhouse in Hawkinsville, Moultrie, Bainbridge or some hamlet in between, Mr. McCall and his team of architects, designers and landscapers instilled a sense of "place" in their projects, a feeling that the home belonged where it was and had been there forever. That became a true part of my moxie and design motto—the home must fit its family while representing the land and surroundings.

This notion of the unapologetic use of materials such as heart pine, pecky cypress and familial belongings has become a Southern hallmark—an extension of our English heritage as seen in the use of simple, native wide-planked oak floors in British homes such as Highclere Castle, Blenheim Palace and Goodwood House, layered with rugs and carpets and accented with generations of furniture. Frank McCall's books showcasing his homes and glimpses into his clients' lives mesmerized me. I spent countless hours poring over the pages and intensely studying the details of moldings, mantels, carpets, sideboards, mirrors and the way a room was arranged. Granted, the time and style were different from today, but classic scale, proportioned arrangements and great architecture are never dated. Seeing collaborations between the architect and his client come to life on the pages of a book astounded me.

So now I have the opportunity to share homes that I have had a hand in, where I've been able to bring together the elements and pieces collected and found by the family and by myself and my team and present them all as a thoughtfully exhibited array of taste, style, good architecture and interior comfort. As designers, we have the responsibility to make our clients and their homes look good—much like a fashion stylist—but our fashions will be the stage for our clients' lives, not just an outfit of the day. I take that responsibility seriously but with jovial humor, too, as the business presents deadlines, headaches, discontinued fabrics, price increases and other challenges at every turn that can either drive you mad or force you to roll with them as to not be rolled over by them.

The television show *Designing Women* was avant-garde for its timing on social and political views, and also spot on as interpretation of my design firm. I am fortunate enough to have a team like Dixie Carter's character Julia Sugarbaker did, representing her name and business, and at some point of every day I feel like Julia Sugarbaker—proud to a fault of my Southern heritage and family, unapologetic about my sense of style and fiercely traditional but not too socially rigid. Sugarbaker's clients, like mine and Mr. McCall's too, were often social acquaintances and friends—perhaps friends of her mother or aunt or connected simply by growing up together in the same town. Dixie Carter famously retorted, "Not as long as the name 'Sugarbaker' rests on this project!" when faced with a difficult situation testing her determination. And I have often felt the same (and said the same, no doubt) when faced with challenging decisions. Not for any self-edification, but for the satisfaction of bringing together the hopes and wishes of a place to call *home* into a reality.

The reason is simply this: I want nothing more than the elated reaction a client has upon walking into their home and experiencing the transformation from house to home. I want my clients when they

hire my firm to expect our designs to be a reflection of their family's heritage but infused with taste and style perhaps not thought of on their own. I will be the first to tell you that I am a terrible math student. Geometry, yes, but calculus and anything of the sort are not my strong suits. Yet I can walk into a room and "eye" without a tape measure whether or not two sofas and chest will fit, and I can even calculate yardage for window treatments and wallpaper off the cuff and be spot on. That said, many folks simply cannot decorate their own homes—the thought of picking a paint color or a door knob or a pillow for their sofa—let alone the sofa itself—is enough to send them into despair.

That is the great trade-off in life. In my occupation's lingo, those who cannot "fluff" hire a decorator. I am pleased to share some homes I have had the pleasure of working in—homes across the South that beckon their residents to be enveloped in the nurturing presence that comfort and style melded with familial belongings and memories affords. My mother kept a beautiful home and my grandmother instilled in me the importance of the generations before us. My family always loved and supported my passion for beauty and design (and tolerated me when I rearranged my room or the den or living room on the regular), and that support led to my collegiate pursuits and career.

When I was in high school, I was chosen to read Antoine de Saint-Exupéry's *Le Petite Prince* for a literary competition. I can still remember a judge's comment that said "this boy is certainly from Perry NOT Paris!" due to my heavy Southern drawl. Yet some of the words from *Le Petite Prince* and other works from Saint-Exupéry have lodged into my mind and heart. "True happiness comes from the joy of deeds well done, the zest of creating things new." That was a happiness I was born with and carry with me still. I love the zest for creating things new—especially creating things new with old, antique, vintage and heirloom pieces! Saint-Exupéry also said in his work *Wind, Sand and Stars* that "the marvel of Home is not that it shelters and warms a man, nor that he owns its walls. It comes from those layers of sweetness which it gradually stores up in us." Layers of sweetness! Ah, what a worthy goal.

Join me on a journey to places my friends and family call home—a journey through town and country, field and forest, seaside and mountaintop, antebellum and new—places filled with warmth and memories and seasoned with love. May we all find places to call home, feather these nests with our favorite treasures, and simply be ourselves in these homes. I harbor the strongest urge and need to "nest" and create home wherever I am. I hope that is accomplished in my designs as well, whether in my home or those of my clients. The door is open! Y'all come on in!

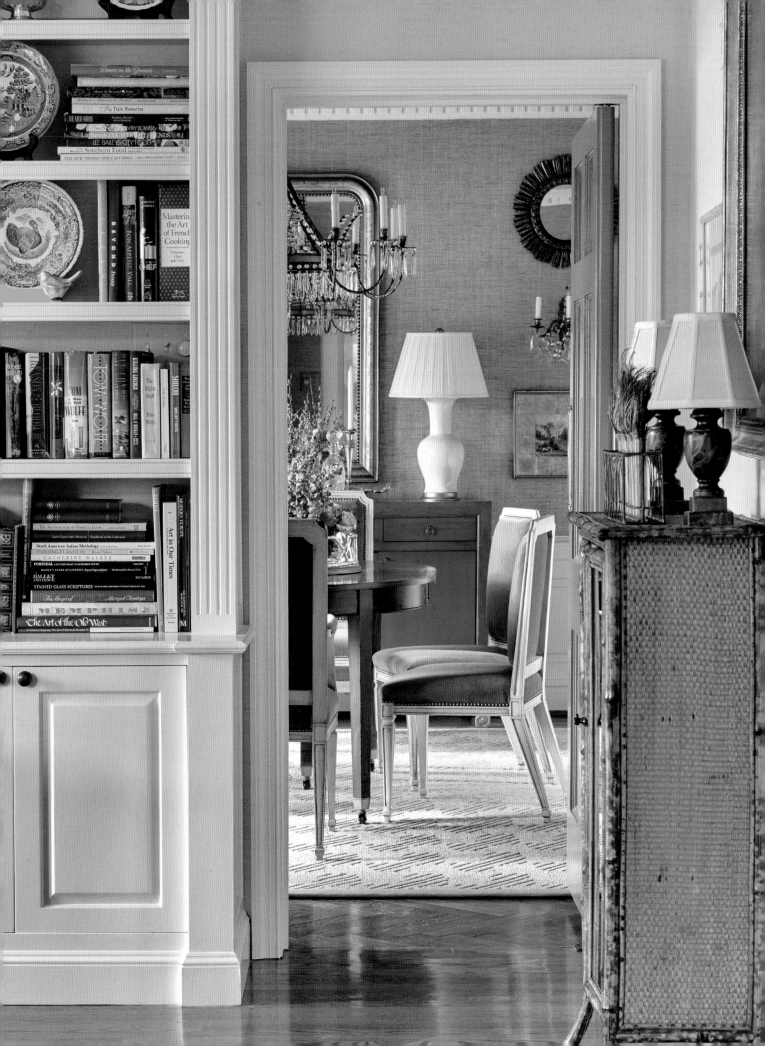

A Well-Seasoned Place

We all have those houses in our towns, neighborhoods, minds and memories that evoke the very essence of home. They simply have "something" that just seems right—that relates to our senses, like the perfect seasoning in a favorite dish. Flowers always seem to be in bloom; big trees provide the perfect dappled shade and sturdy limbs from which a swing lulls you to and fro; the scent of something baking is almost always palpable; and you know there's a porch and rocking chair waiting for you. All this and lovely aesthetics too make up such a home. For me, one of those homes is in my home county, I have cherished it and its family my entire life. And once, it was almost mine. This is the story:

My client, who is also a dear friend, told me that "if you had given me a dollar yesterday, I would have sold you this house." I politely and gleefully replied, "I'll give you two bucks today!"

It was a moment homeowners have with their homes when the structure is burdensome from maintenance or repair or the air-conditioning "going out" in mid-August. My client, whose home I have loved for years, sadly did not accept my double-the-money offer, but she allowed me to help her reinvigorate her home and be a part of the house's story. What an honor!

Georgian style brick, creamy white clapboard siding, and dark black/green shutters and doors give this home classic curb appeal. Cast iron urns, a heavy brass door knocker and a leaded glass fan light add architectural interest. The contrasting trim is a buff white that makes the creaminess a bit crisper in this leafy setting.

Within the walls of this classic Georgia red clay brick home with clapboard siding and leaded glass transoms, three children were raised—along with half of the neighborhood. This house was "home" to more than the family that abided within its walls, for friends and family always found a place at the table, a bed for a sleepover and a backyard for football games. As families grow and time changes with the ever-moving current of life, a house must be flexible with the flow and not become rigid and unchanging. Children will leave the nest but bring grandchildren in return. A family of five becomes a family of fifteen in what seems a matter of moments, and a house must absorb the ebb and flow of familial growth. It is with this in mind that many clients choose to feather the nest where they've raised their broods in preparation for the next chapter in their lives. Especially when the children and their children now live next door!

When classic scale and proportion are at hand, the job of a designer is pressed towards furnishing rather than fixing. This is the case with this home. Rooms are scaled for large dining tables and many chairs; ample built-ins are hidden for storage and open for display too; living spaces are wide and can host a crowd on Christmas morning or a dinner party overflow. Hallways serve not as wasted space but as vestibules to welcome guests and connectors to channel the family from room to room. I love a good hallway, and this house has them as windowed frontage for curb appeal and lined with cabinets, serving as the perfect butler's pantry. My task was to keep the house fresh and comfortable and expectant of the holidays, family dinners and many guests who will grace its doors.

In the living room, relaxed formality keeps the room elegant and inviting but not stuffy. Layering materials such as a seagrass rug topped with an antique Persian carpet, an old farm table-turned-coffee table and warm leather club chairs invoke one to linger longer with a book, an old friend or a cup of tea.

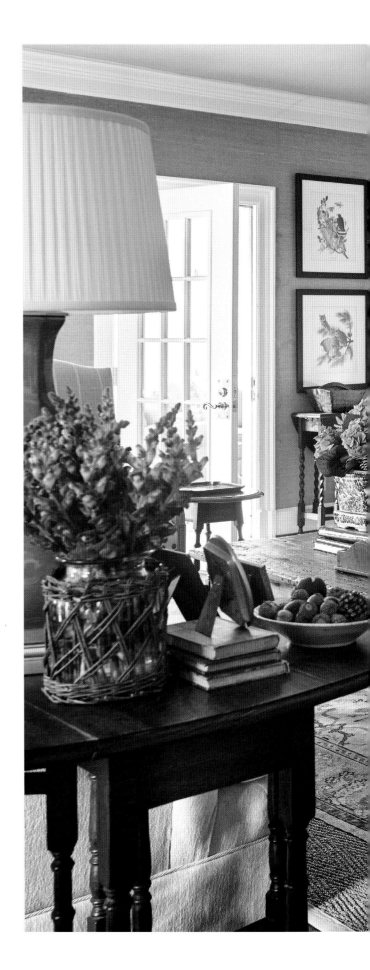

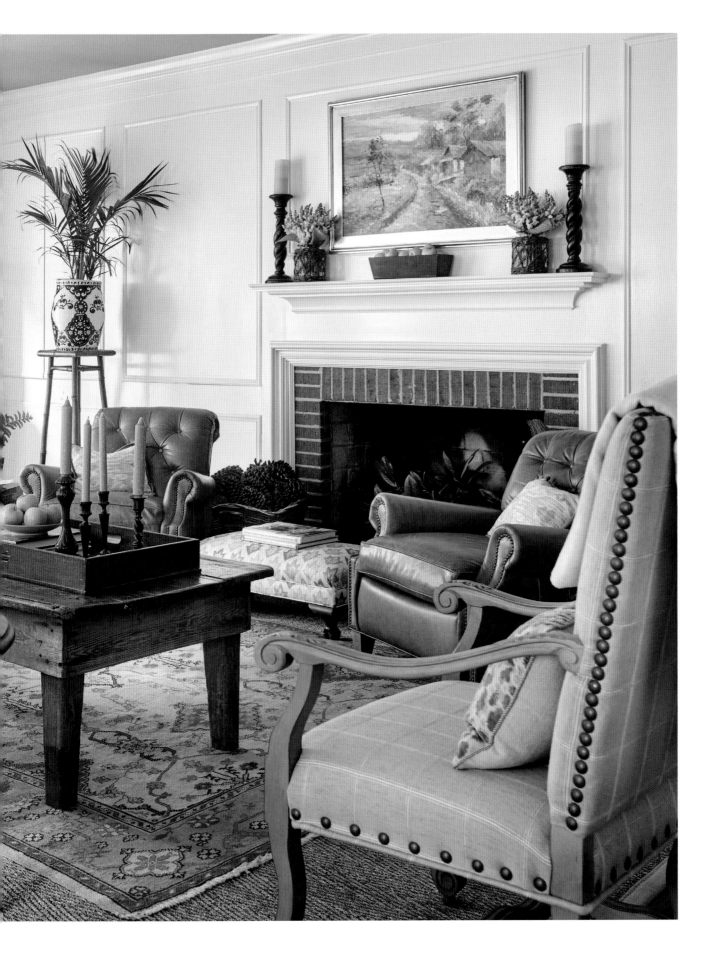

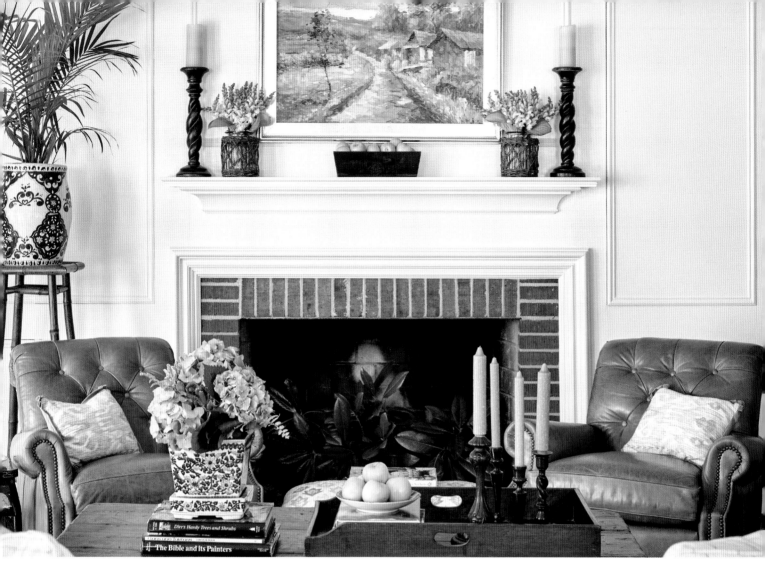

From the enclosure of a porch into a keeping room and thus the creation of a larger screened porch and open kitchen, to rearranging rooms and reupholstering furniture, to the updating of certain pieces for bright style and modern comfort, this project was a joy. As with many of my clients, the family in this home are my friends and I know how they live. They cherish heirlooms and find comfort in their display and use; they crave comfort and value the importance of aesthetics. Artwork of local prominence, family photos and fabric for wear and reflection of nature too culminate together with a mix of high and low textures and finishes to create warmth and jovial scenes in this house. Formal spaces are kept more relaxed than polished with warm wood surfaces, seagrass rugs layered with antique carpets and rattan furniture amidst antiques, for an unexpected sing-song creating casual elegance. These are my favorite ingredients in a home's interior scheme—a mix of styles, periods, textures and ages in harmonious and pleasing juxtaposition.

This house exudes generational style, invites anyone to sit and enjoy their time here and beckon the family home for generations to come.

One time I asked the client of her home, "What is it that makes this place so special?" She replied, "This house is well seasoned." As a cook and lover of food, her reply struck a chord with me. The best dishes are well seasoned—not masking the authenticity and natural flavor of the food but bringing out the best the dish has to offer—the way a touch of salt on a cookie makes the sweetness sing or a pat of butter makes a biscuit heavenly or a tad bit of vanilla or coffee enhances the flavor of chocolate. Well seasoned—this house certainly is, and I look forward to every visit.

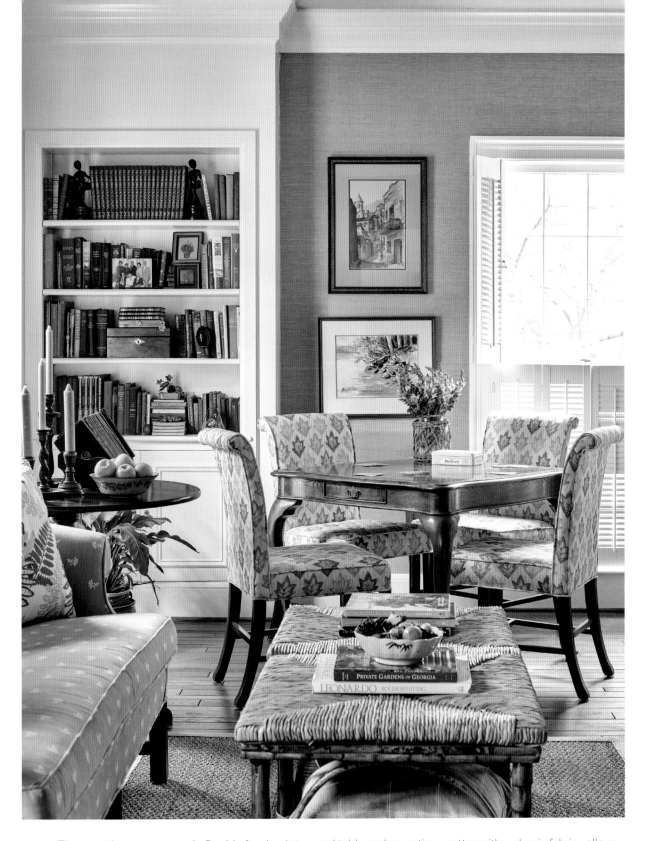

FACING: Three seating areas—a main fireside focal point, a card table and an antique settee with a classic fabric—allow this room to host a crowd and entertain a group without a television as the focal point. Fabrics include hand-dyed leather on club chairs, Peter Fasano printed linen on side chairs, a Colefax and Fowler windowpane on armchairs, Brunschwig and Fils strié on the settee and animal print on throw pillows.

ABOVE: A nearly pumpkin-hued grasscloth anchors three of the walls, while the paneling, trim and shutters are a crisp white for contrast and freshness. Pops of blue and white, fresh flowers and antiques reflect the well-seasoned approach to the home's décor.

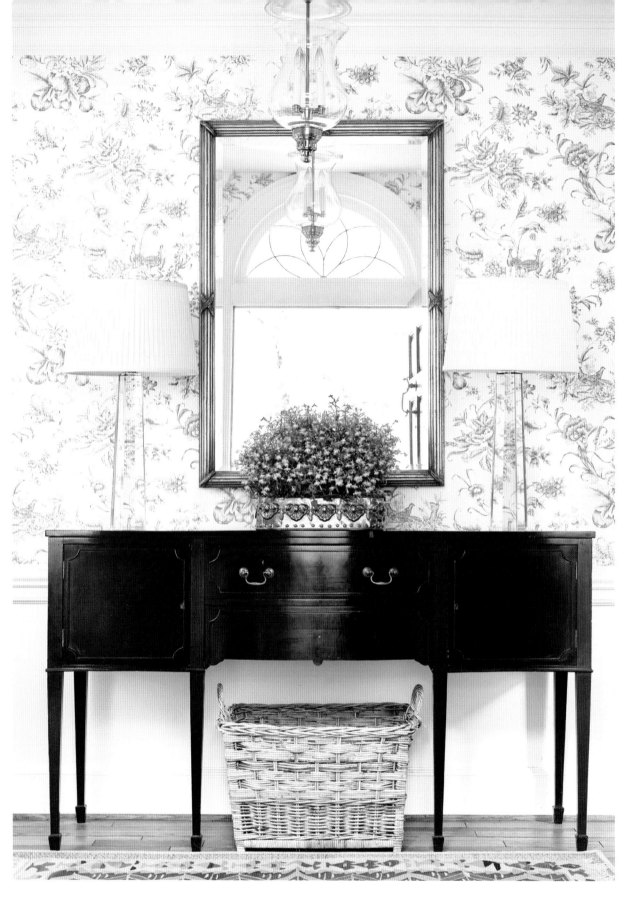

In the foyer, an antique English sideboard is topped with flanking crystal lamps that create a snappy, contemporary vibe amidst the vintage mirror reflecting the leaded glass transom. The Schumacher wallpaper extends from the foyer proper down the main front hall for continuity and rhythm. A tribal rug atop a custom-cut sisal grounds the floor with layers and depth of color.

DESIGNER'S JOURNAL— PURGING

The matriarch of this family and I are kindred spirits. We have a story and a memory for every piece and item in our homes—yet we must purge the things in our lives that do not bring the greatest joy and enliven our nests with a contemporary approach while rooted in the past. This task is often my greatest challenge within a home, but it can be the most rewarding. My goal is to make Grandmother's lamps shine, Grandfather's woodwork prominent, an aunt's painting, china or silver gleam amidst a setting that is gracious to those generations yet neutral enough for the next generation to leave their impression. No one loves "stuff" as much as I do, but it has to be great stuff! "Great" doesn't mean fine or expensive, but pleasing to the senses, mind, body and soul and reverently used, placed and respected.

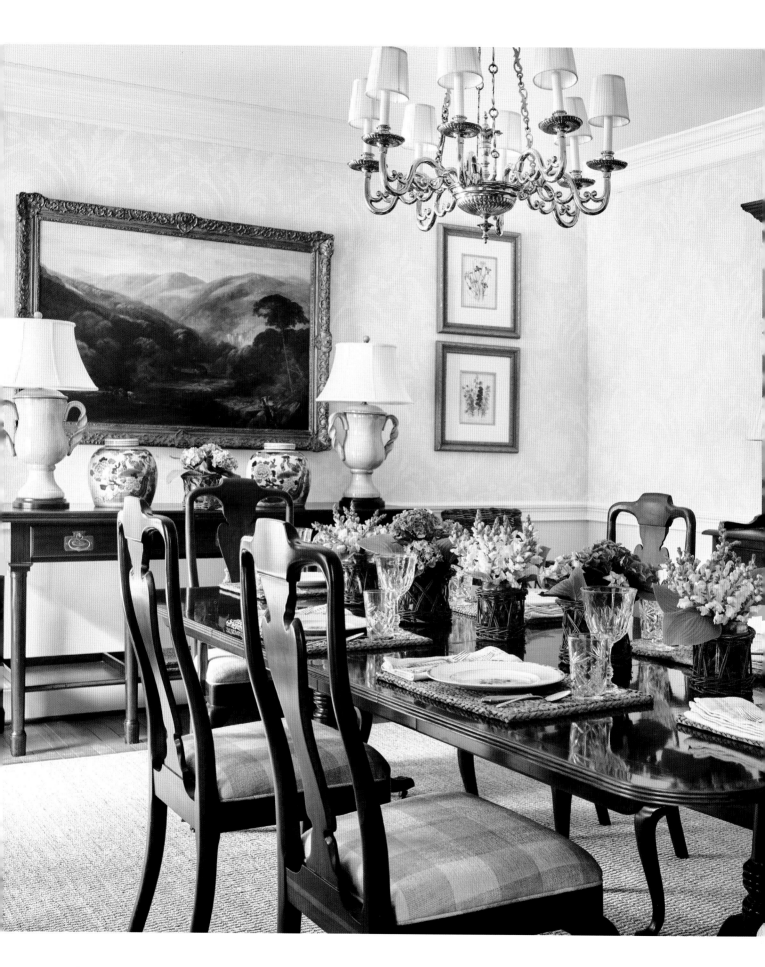

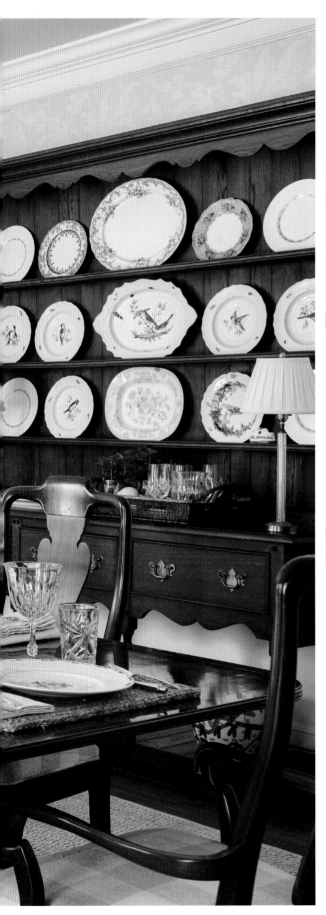

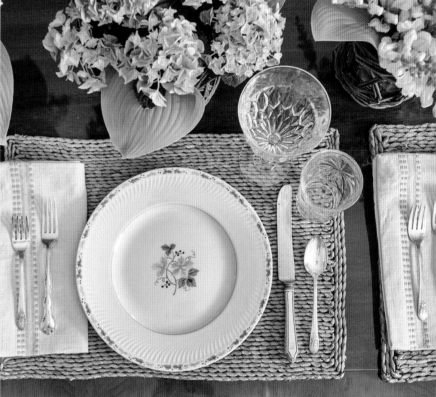

In the dining room, a classic tone-on-tone damask wallpaper, an antique brass chandelier, a Welsh dresser and an heirloom oil painting set the tone for formality but then relax with pairings of a sisal rug, rattan chairs (not seen) and placemats, blue and white china and a faint gray-blue ceiling.

Cowtan and Tout plaid on chair seats, family dinnerware, stemware and wedding silver set on woven mats, flowers from the garden and fresh linens make for a delightful place setting.

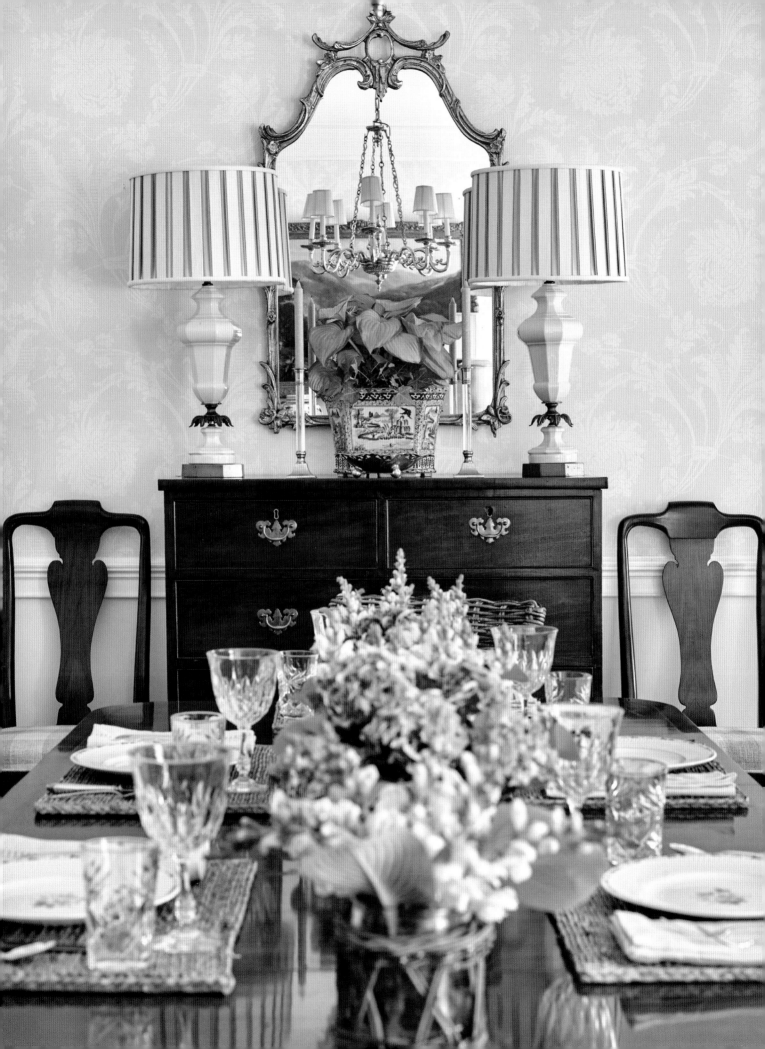

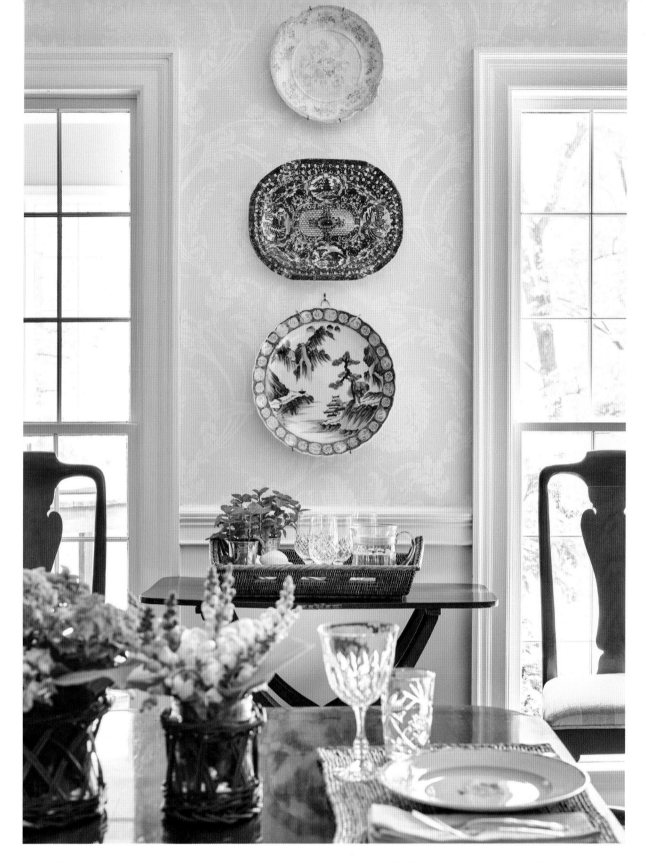

FACING: The homeowner's mother's lamps are repurposed on an antique English block chest, while a gilded mirror reflects the English brass chandelier.

ABOVE: Thick, clean-line moldings shape up windows and frame a "snowman" of antique blue-and-white platters. Garden mint, heirloom crystal and a wicker serving tray on an antique butler's tray further the vignette.

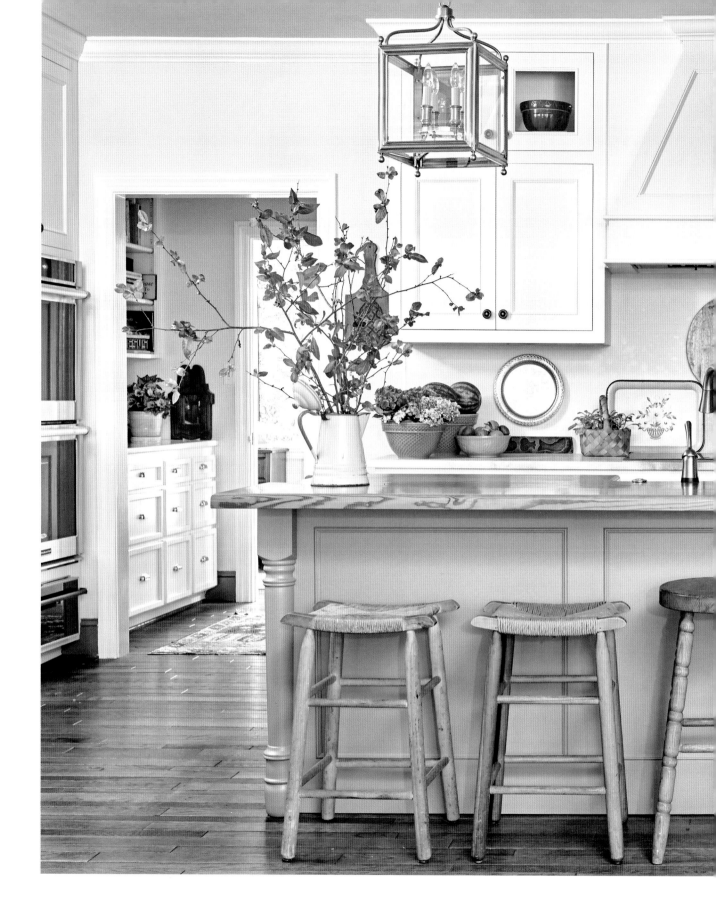

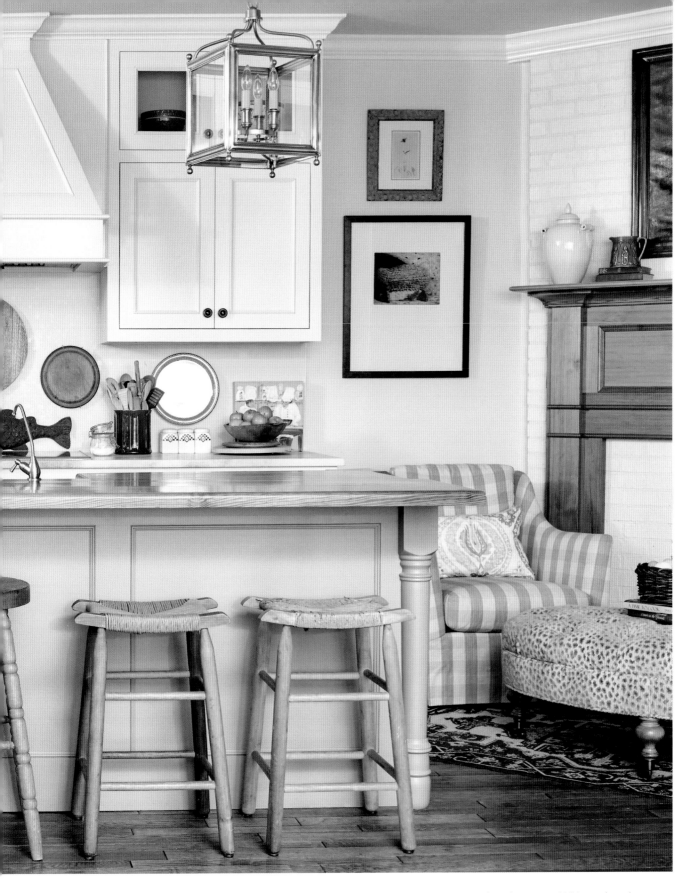

In the kitchen, the duck-egg blue island with its antique heart pine countertop anchor the space. White painted horizontal paneling serves as the wall treatment and backsplash. A mix of bar stools awaits grandchildren here in Grandmama's kitchen. Clean white walls allow for a tinted ceiling, fun island color and artwork to "pop" and work in harmony.

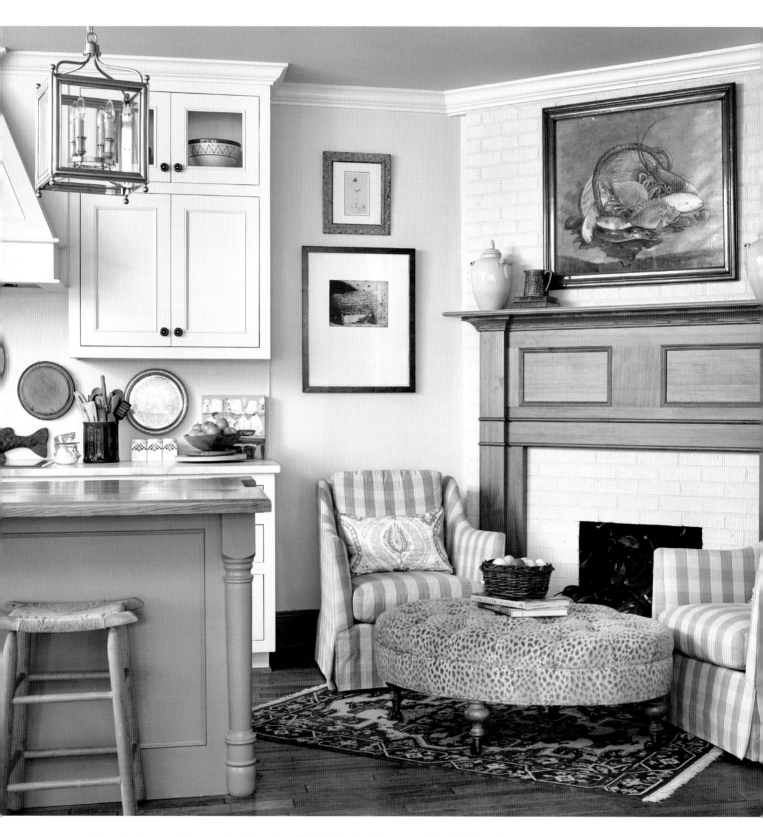

A heart pine mantel re-created in a simplified Federal style on a painted brick wall serves as the backdrop for a sitting area in the heart of the home. The antique French oil painting depicts a *plateau de fruit de mer*. A cheery Stroheim plaid on the swivel chairs and an ottoman in Cowtan and Tout "Ocelot" set the tone for warmth and comfort in this space.

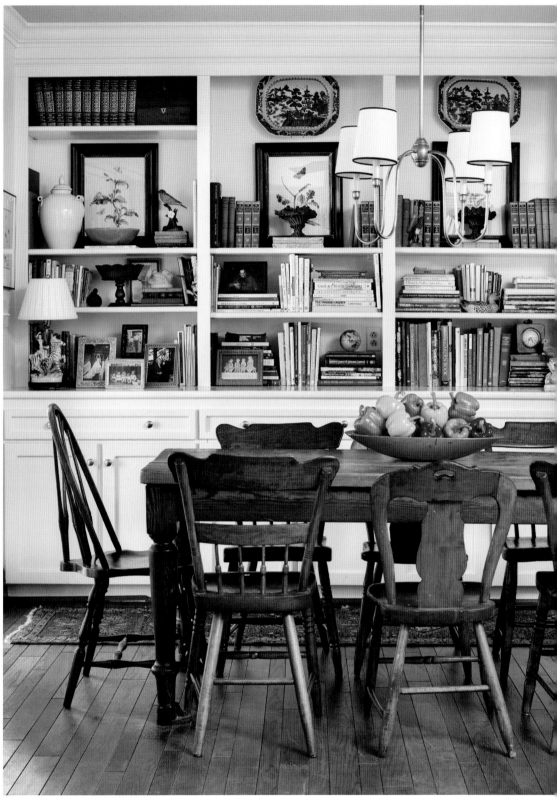

In the family dining room, antique and heirloom mismatched chairs gather around a storied table that has hosted generations of meals. A more contemporary light fixture freshens the space, while familial photos, prints, books and other treasures serve as a backdrop on the shelves. An antique runner with vegetable dyed colors leads through the space, connecting the kitchen to the back porch.

This home sits on a nice piece of property in an established neighborhood yet has the feel of a farmette with its mature trees, lush gardens and red barn complete with chickens, potting shed and vegetable beds.

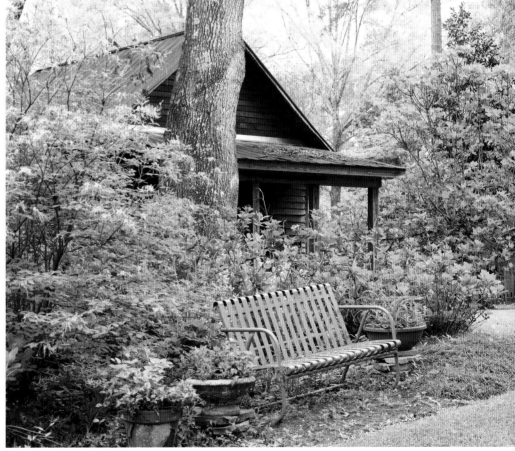

A Place that I Call Home

There is a painting of the Leroy, Alabama, Post Office that has hung in my grandfather's office since before I was born. That's where he and his siblings and generations of Granades have lived since the early 1800s. The piece was painted by my grandfather's niece, my cousin Julia Harwell Segar, and depicts the pine-and-cedar-clad building with a metal roof in all its grandeur—"grandeur" being a somewhat exaggerated word for such a humble, simple structure, mind you. But in true Southern fashion, I have admired and held an affinity for an antebellum building and grown a fondness for it in my heart. For years, I admired the Leroy Post Office. Although this building is not grand, white-columned, lined with live oaks or historical in any sort of fashion, members of my family and I held it in high regard nonetheless. Not that storing an affinity for a building is unique to Southerners, but we simply have made it a part of our well-known hospitality, culture and societal fabric.

My grandfather, Big Napp, always told me that I reminded him of his mother. I never had the plea-sure of knowing that great-grandmother, Mrs. Eugenia Tate Granade, but I did know that my mama, Jeanie Granade Farmer, was named for her, and I knew that she loved to cook and garden and arrange flowers and had an affinity for blue and white: blue being her particular favorite. Big Napp said I was

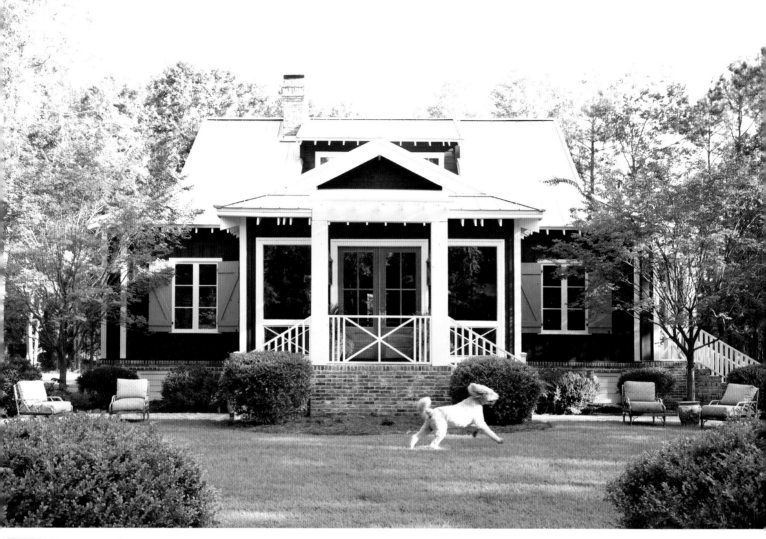

her "seed corn," meaning I was an exact kernel from the cob that was his mother. (We Southerners use farm and garden metaphors for emphasis.) Big Napp has told me stories of how his mother would walk from their farmhouse to the post office—a distance of a country mile or so—and go gather the mail, pick up a dry good or two or maybe a Coke and peanuts, and then walk back to their home place. Their rural farm community's news and mail could all be gathered at that post office.

When it came time for me to build my house on my family's land where I'd grown up in Perry, the thought of starting from scratch on a new home on old land was hardly daunting at all, for instinctively, the image of the Leroy Post Office came to mind. I showed my architect, Robert Norris, and he pointed out the solid cedar beams, pine boards, clipped hip roof and side entry brick stairs—the same architectural points I had

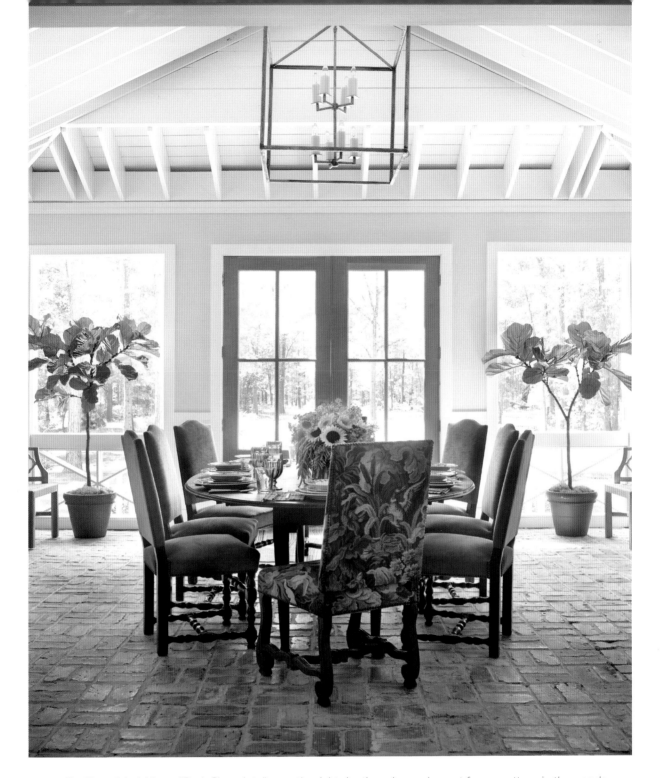

FACING: For Farmdale, Valspar "Dark Chocolate" gave the right depth and complement for my cottage in the woods. Natural stained wooden doors contrast with the dark board and batten, while Benjamin Moore "Linen White" makes the trim crisp but not too stark. A mix of brick from Cherokee Brick and antique bricks too grounds the foundation and connects to the land and native soils.

ABOVE: My dining room doubles as the entry hall. Antique brick floors from a church in Macon ground the space in peachy, terra-cotta notes. Shiplap paneling runs to the chair rail and a woven sisal grasscloth further treats the walls. Exposed rafters, simple moldings, and wide windows enlighten the space and allow the scenery and furnishings to truly shine. A hand-forged, open-sided lantern adds a contemporary note. Teak Italian Chippendale-style chairs can be pulled into the adjacent living room, to the dining table or outside for extra seating. Being teak, they're weather proof and thus serve a further multipurpose function.

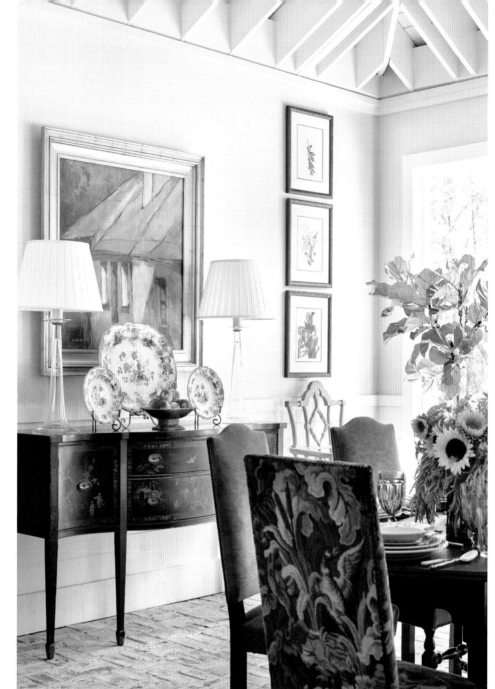

TOP AND RIGHT: A knife and palette painting adds a dose of the contemporary, while antiques such as an Irish drop leaf table and French chairs with their original velvet and tapestry add provenance to the dining room. Mixing old and new, fragile and sturdy, light and dark all come to fruition with this vignette. English green and white ironstone plates, a black chinoiserie sideboard and a contemporary painting are all lit by blown-glass lamps with classic pleated shades. Audubon prints are hung in stacks of three around the room, providing visual and vertical interest.

BOTTOM: Transferware china depicting hunting dogs and field birds are set with Provvista dinnerware, plaid linens and mixed flatware. I love to reinforce what Mimi taught me: "We eat with our eyes first." These create a visual feast before the first bite!

FACING: I am a collector of blue and white porcelain and pottery and use pieces throughout my home. A set of Limoges fish plates, Provvista dinnerware, an old French painting that Aunt Kathy brought me from her travels, and some family silver pieces fill out the English pine Welsh dresser along with antique books, Mimi's gold peacocks and a pair of barley twist lamps.

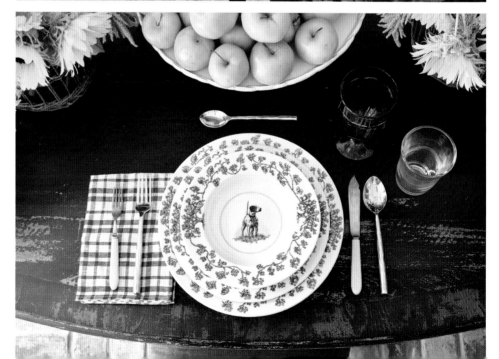

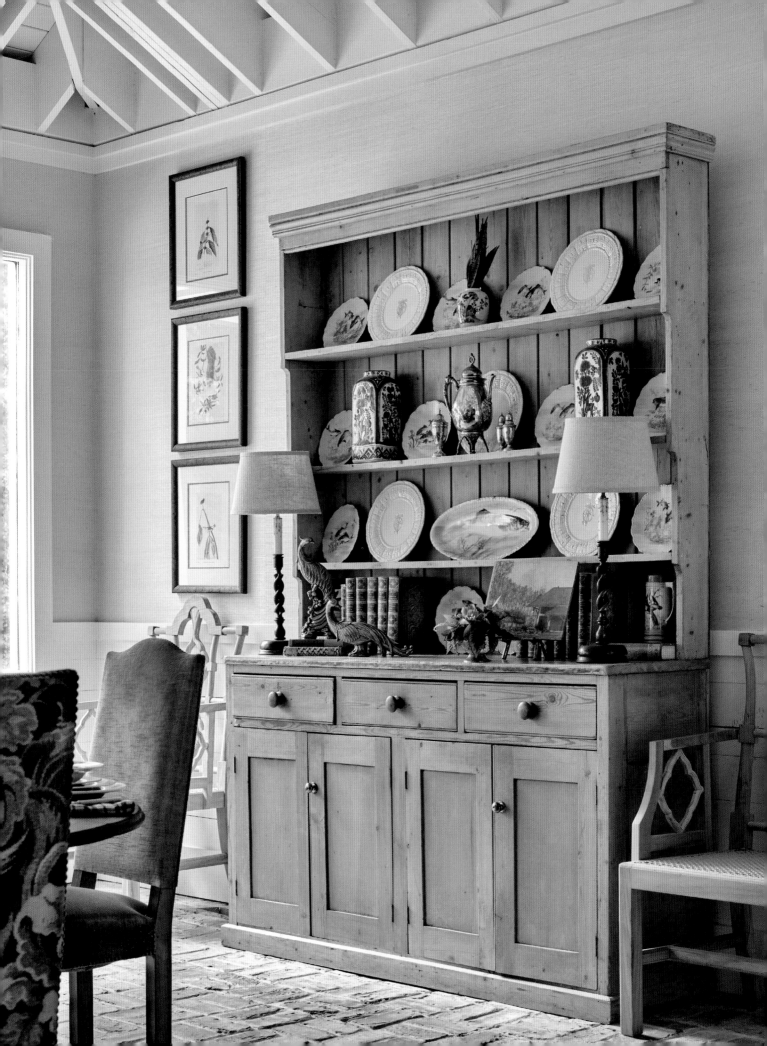

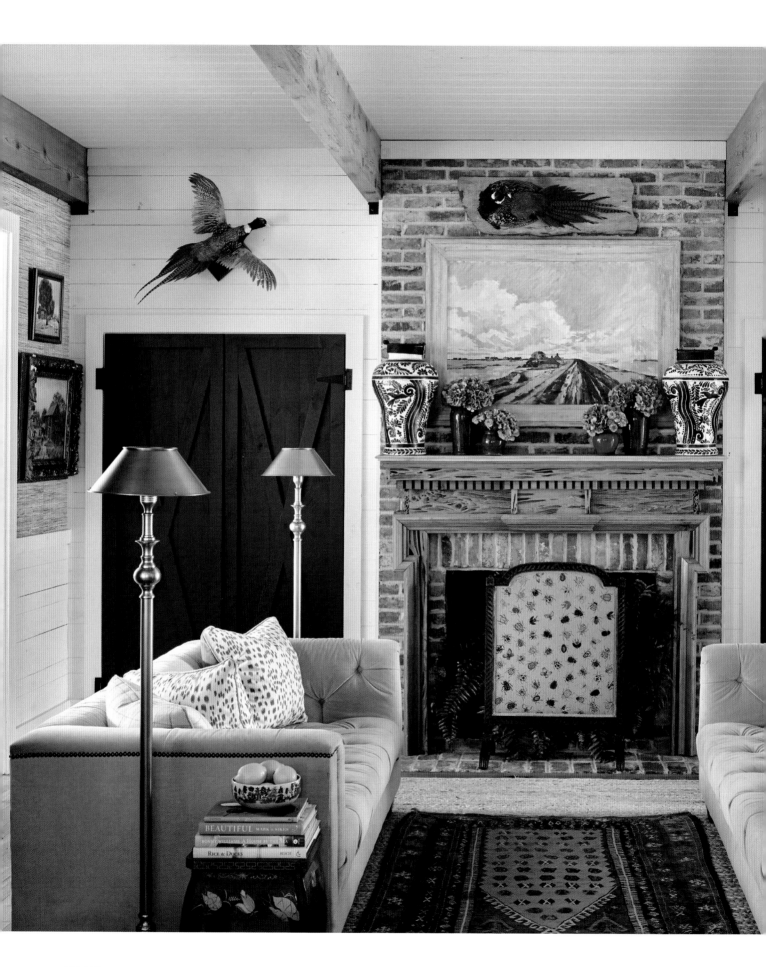

admired—and, thus, Farmdale Cottage started to take shape. The front facade of Farmdale is based on the Leroy Post Office, and Big Napp gave me the painting as my housewarming present. What a treasure!

Having had my hand in helping numerous clients with their homes, I knew a few things I wanted for Farmdale, and the setting dictated several decisions immediately. Place and setting are of the utmost importance for a house and a major navigational beacon towards making the house a home. I strive for my design projects to reflect their setting and place and family, and I had to practice what I preach.

Though I go weak in the knees for a multi-columned white house with dark green shutters, that style would not be appropriate in a dale set amidst thick stands of pine and oak trees. I wanted my house to blend with its surroundings, not fight them. The color of pine bark spoke to me as perfect color for the body of the house—blending with other barks and foliage for the shutters and accents. My bricks reflect our geography too, with many of them being reclaimed antiques that were molded from the same sand and clay that surrounds my county. Thick cedar posts serve as my columns, as they did for the Leroy Post Office. A coupling of stairs flank the front porch, and a herringbone brick walkabout trims the front lawn.

I knew I wanted simplicity for my grounds and gardens and have stuck with large boxwoods and crape myrtles that I brought from an old farm south of town. Their size and maturity were just what Farmdale needed, since there are large trees surrounding the property.

Inside, I wanted to evoke the classic combinations of heart pine, beams, and antique brick floors, taking

In my living room, a custom pair of Taylor Burke Home sofas in a sandy strié velvet flank the fireplace and create a cozy seating area to gather before or after dinner. Vintage Asian garden stools and an antique tribal rug atop a soft jute rug invite visitors to slip off their shoes and relax. Brass English study lamps illuminate the space, which makes for a cozy reading nook too.

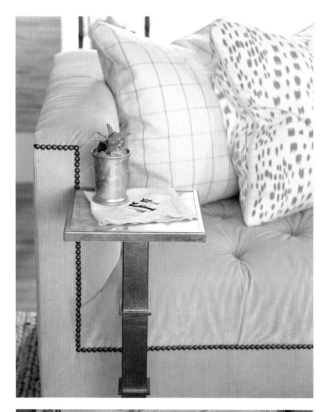

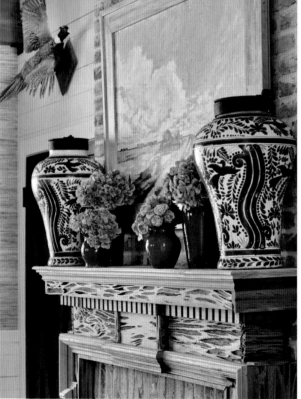

inspiration from my architect idols Frank McCall and A. Hays Town. Georgia marble quarried from ancient veins in northern Georgia has been used for centuries in the South for courthouse steps, bank floors, countertops, and façades. I wanted that muddy-veined marble in my kitchen and bathrooms (and I often use it on design projects too).

White painted pine shiplap walls in random widths runs throughout the home, while grasscloth treats the walls for further texture, warmth, and contrast. Much like many of my clients, I relied heavily on family pieces, found objects and storied furniture to "season" my home and give some credentials to a new house. From beams and bricks that once belonged in cotton barns and churches, to family heirlooms, childhood belongings and sentimental artwork, my home became a homage to all the things I love.

At the onset of construction, life for my family changed forever. My mother passed away, and I knew that my house was not to be mine and mine alone; I had to expand on my mother's style and skill for creating a lovely home filled with the familiar and seasoned with perfect love for my sisters and our growing family. My aunt and uncle also live on the land, and their children—my sisters and I now also—would all return to these houses for holidays and events. I wanted our rooms to be warm and recognizable. I wanted my sisters to feel "at home" from the moment they entered, and I wanted to honor my mother and grandmother by creating a home like they did with theirs—a place for entertaining, for loving and cherishing, for feeding folks body and soul.

Allow me to share with y'all my home—inspired by my family's history and now the setting for generational gatherings to come.

ABOVE, BOTTOM: The pecky cypress mantel was planed from a "sinker" log outside of Thomasville, Georgia, and is fashioned in a mix of federal and Roman styles. A pair of blue-and-white jardinières from San Miguel, Mexico, and a collection of Vicki Miller pottery all anchor the mantel along with Mama's needlepoint fireplace screen. The painting above the mantel was a gift from one of Mama's best childhood friends as a housewarming gift. It reminds me of the cattle farm I grew up on in Hawkinsville.

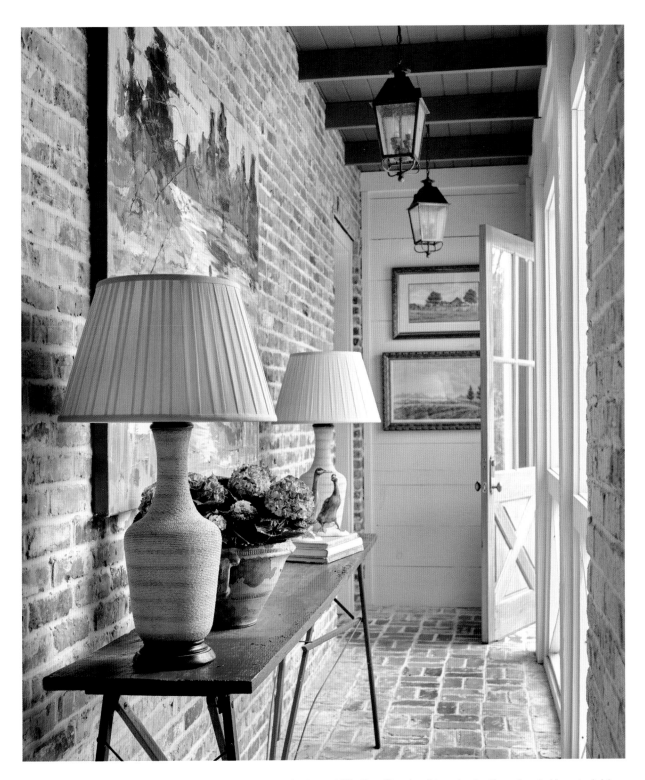

FACING TOP: Pillows pop against a neutral sofa. Brunschwig and Fils "Les Touches" is paired with a simple Kravet plaid, while a drink table adds a touch of pizzazz and picks up the antique brass nailhead detail of the sofa.

ABOVE: The back hallway at Farmdale is an homage to A. Hays Town's Louisiana vernacular architecture with the exposed rafters and antique bricks. The mallard green ceilings, which are dotted with four copper lanterns for an element of the outside notion, are a play on painted Southern porch ceilings. Plate glass windows between cedar posts give the feeling of an enclosed loggia or breezeway and fill the space with light. The large canvas painting from my dear Auburn friend EMYO—Emily York Ozier—depicts a duck hunting scene. More Butler Brown artwork is displayed on rough-cut white pine shiplap.

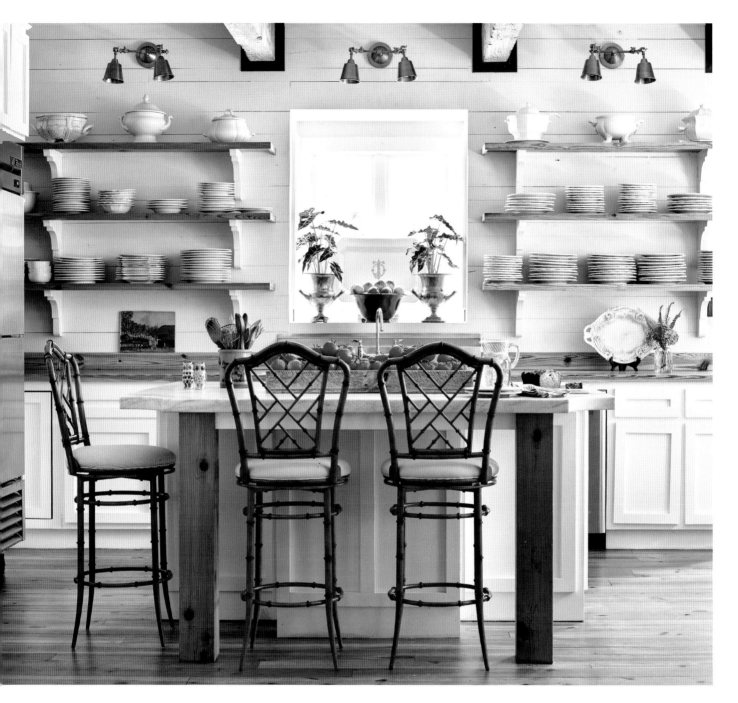

ABOVE: In my kitchen, open shelves dominate the main wall and allow me to serve supper to a crowd quickly. All the dishes stacked on the shelves are Provvista Designs—my Aunt Kathy's company. Shades of white, cream and flax majolica-style plates are used every day and for entertaining too. Heart pine shelves and countertops, like the floors throughout, were all planed from old beams once part of a cotton warehouse. White painted shiplap covers the walls and thus serves as a backsplash. My collection of white tureens finds their crowning placement atop the open shelves.

I believe in mixing metals and not necessarily keeping a set suite packaged together. Brass library sconces from Barbara Cosgrove, stainless appliances and sinks and faux bamboo metal barstools all meld together harmoniously.

FACING: An old farm table and a collection of platters anchors the eat-in part of the kitchen. Oil paintings depicting the farm where I grew up flank the large French-style casement window. A mix of chairs encircles the table. The iron chandelier is from my friend Becky Cumbie of Beckett Antiques in Montgomery, Alabama.

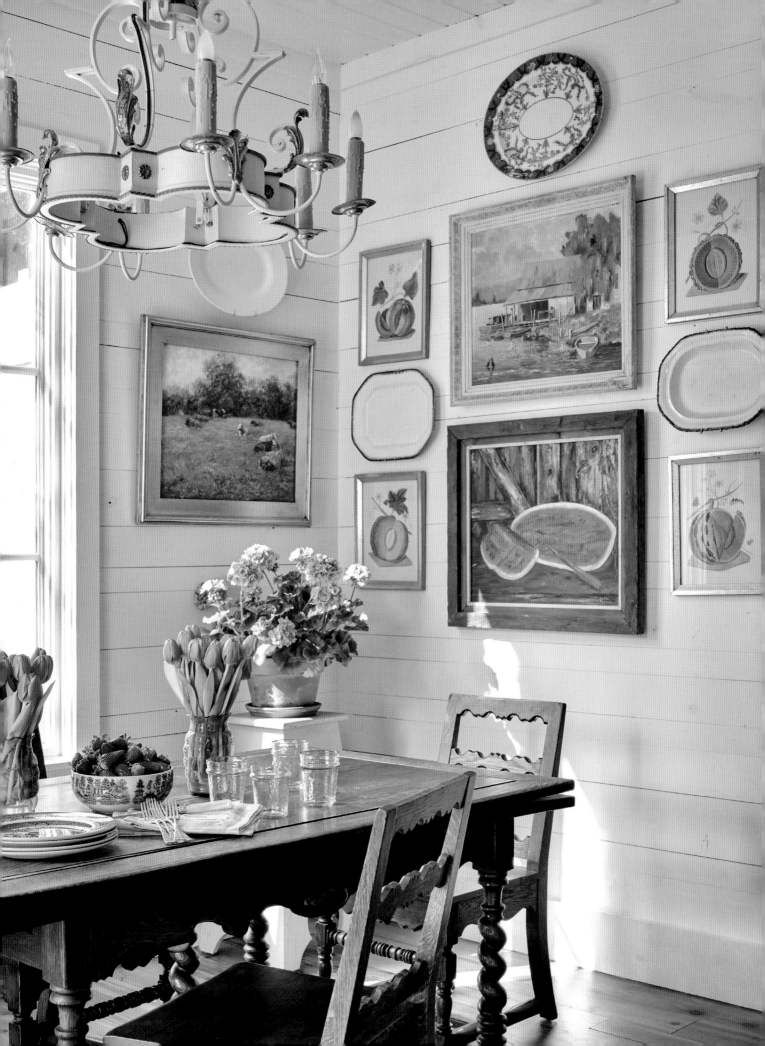

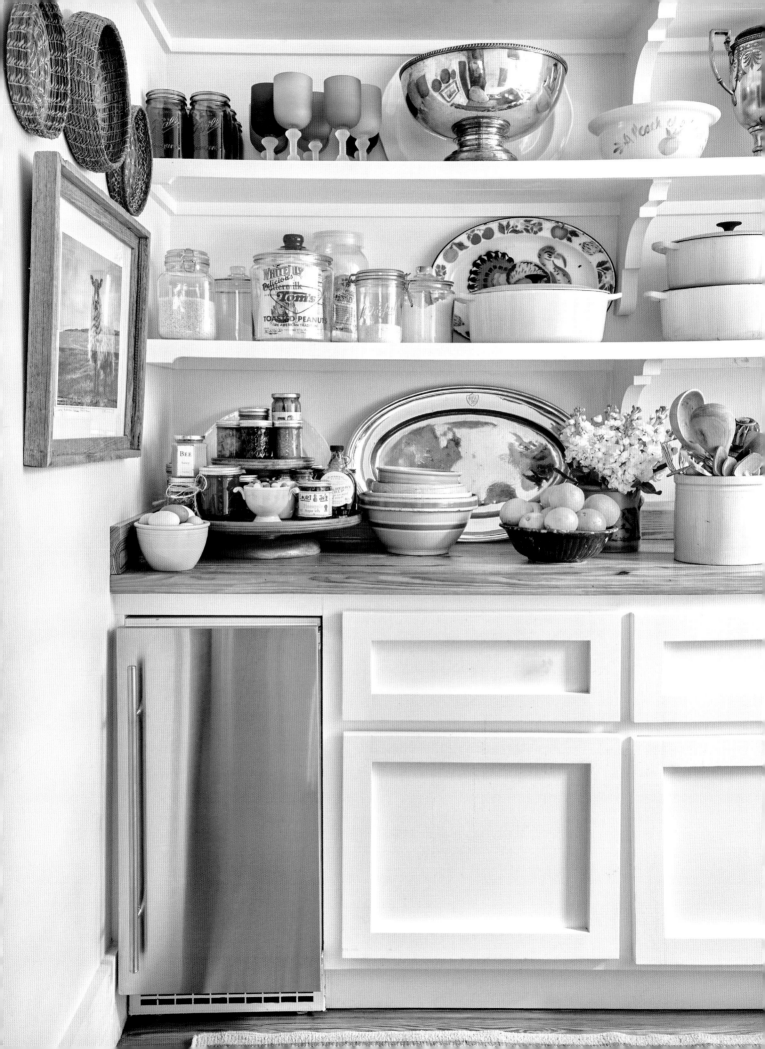

My walk-in butler's pantry hides more of my "stuff" and collection of collections. Serving pieces, another sink and the ice maker all find their home amidst simple white Shaker-style cabinets. I love having a door to simply close when it's a wreck! The painting over the pantry door is a still life of Vidalia onions from a local estate sale.

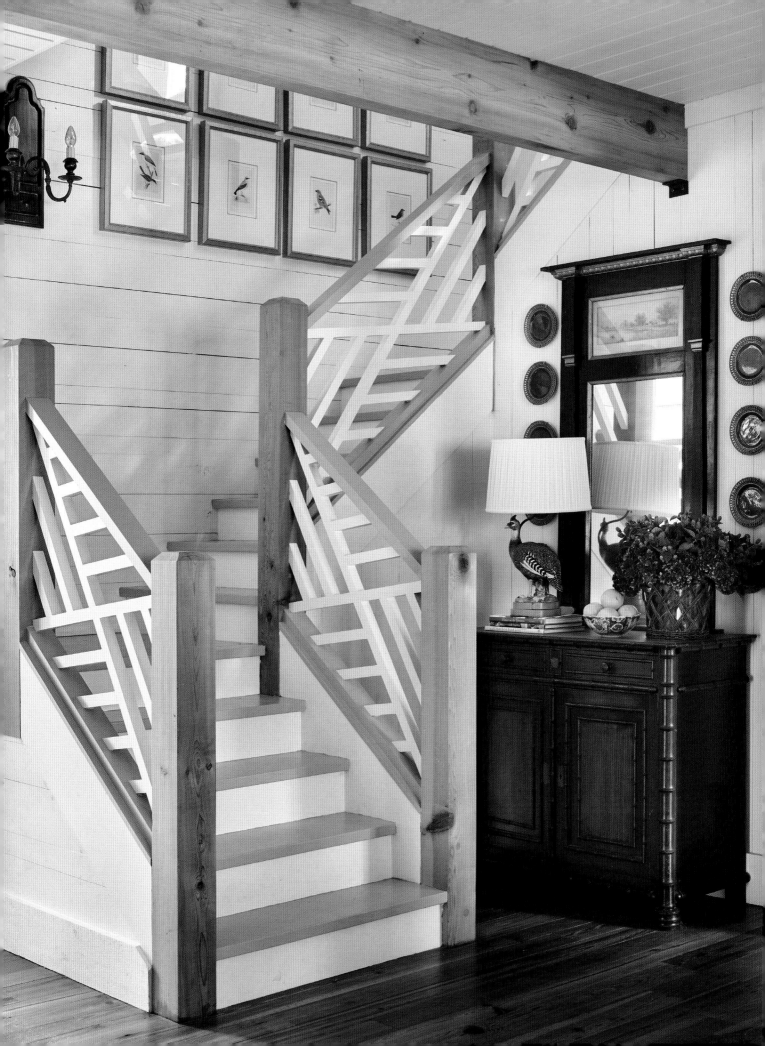

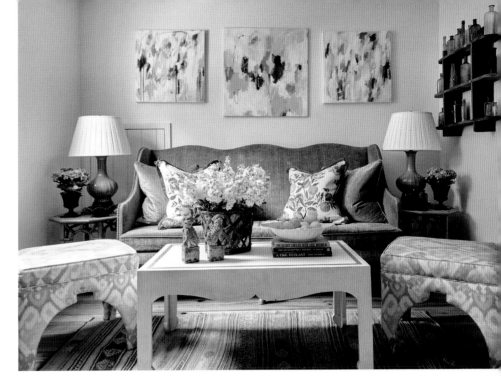

FACING: The stairwell with Chippendale railing is modeled on one at Frank McCall's home, "The Hedges" at Sea Island. A grid of antique bird prints in silver gilt frames brings the vertical interest into play, while antique Dutch sconces light the space. An antique French faux bamboo chest, vintage porcelain guinea turned lamp, an antique pier mirror and fresh flowers fill out the space.

ABOVE: In the upstairs loft, an antique French canapé boasts its original aqua-hued velvet. A couple of Schumacher's "Citrus Garden" made into pillows for me by my best friend Maggie Griffin were a housewarming gift. The triptych of abstract paintings by Renee Bouchon pick up the hues of my sister Meredith's antique amethyst glass collection. An antique tribal rug with its soft colors of plum, earthen tones and blues grounds the space.

RIGHT: An aqua-backed paper and woven grasscloth encapsulates the guest room in soothing tones. Pecky cypress framed bird prints, a heart pine sleigh bed and custom bunny lamps with painted shades create a fun aesthetic of young and old along with handsome and pretty. Sandy neutrals and soft blues are seen in the linens, pillows and Oushak rug. All my interior doors are painted a dark brownish green. Painted or stained interior doors is one of my signatures and a nod to Williamsburg and English interiors. The ceiling is a faint blue, reminiscent of Southern porch ceilings.

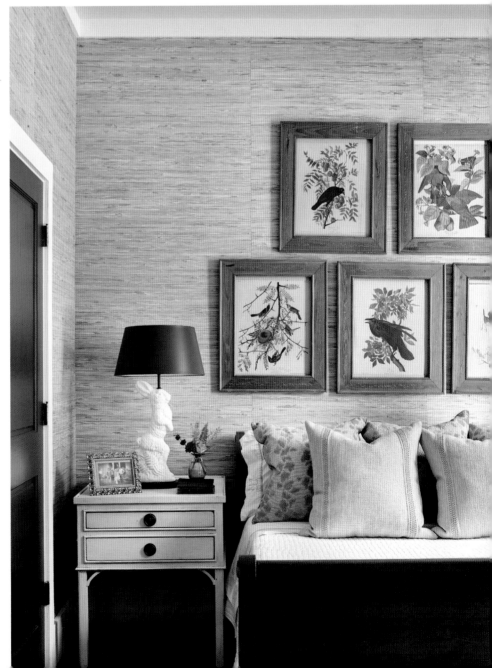

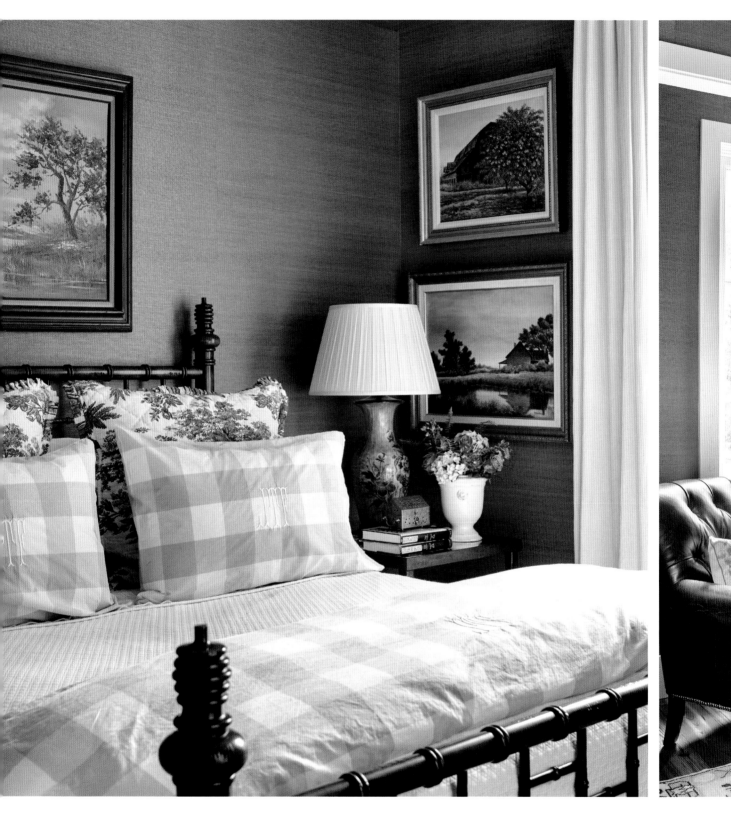

I gave in to luxury and commissioned a custom faux-bamboo bed. I have always found soft browns to be soothing, and they allow other colors to be warmer or more prominent. Artwork from Butler Brown depicting local farm scenes in my area seems to come to life against the pecan hued grasscloth. Mimi's papier mâché vases were turned into lamps and their colors are so striking with the browns and crèmes and whites of the bed linens and window treatments. I love fresh clippings from the yard by my bed as a seasonal nod and burst of color too.

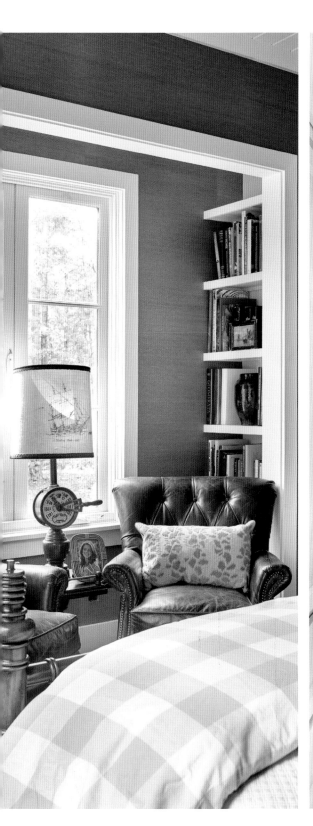

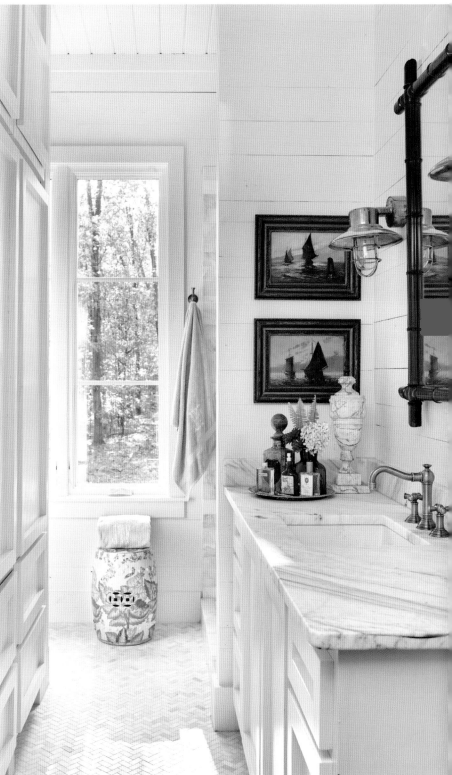

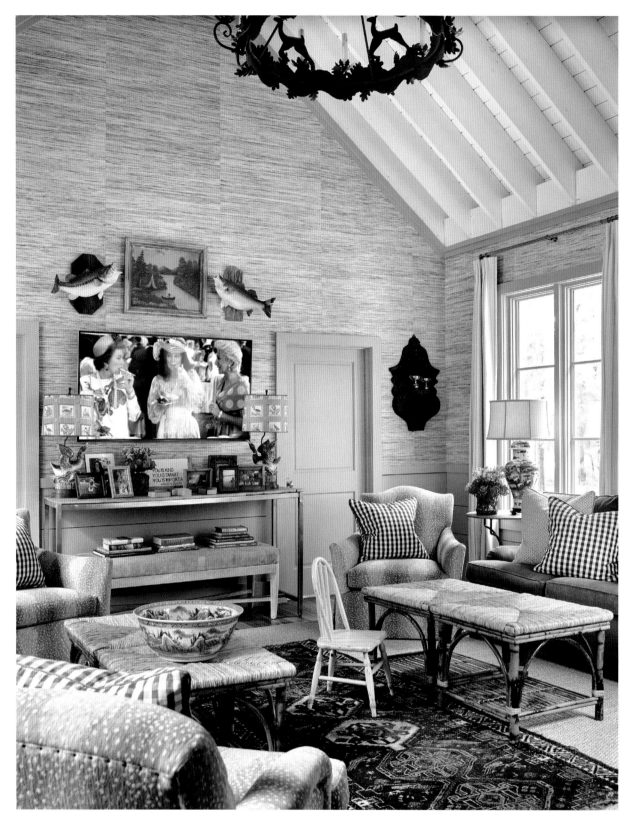

Built according to the scale of an old local chapel, the scale of the "waller" room is simple and comforting. Painted shiplap, trim and doors in a soothing, soft green are topped with a chunky grasscloth leading all the way to the creamy white ceiling. A custom iron chandelier depicts deer dancing through oak leaves—which could just as easily be seen outside the room's windows. Two velvet sofas and four deep-seated antelope pattern chairs ensure plenty of room for friends and family to snuggle and enjoy the movie, game or a good book.

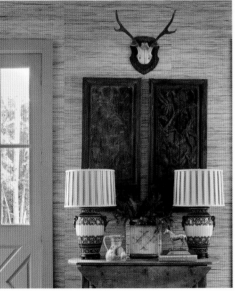

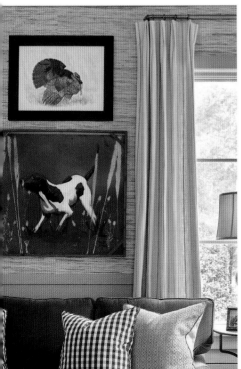

" W A L L E R "
R O O M S

"The foxes found rest, and the birds their nest. In the shade of the forest tree;": this line from an old hymn always made my sisters and me laugh in church. Our grandmother, Mimi, always told us that "foxes had dens and birds built nests—I see that my grandchildren have done the same as those animals in my living room!" Mimi also said that her children and grandchildren did not sit and watch TV, they "wallered," or lounged lazily. Thus, Farmdale had to have a "waller" room. Whether we're watching favorite old movies, binging on Netflix or rooting for Auburn football, the waller room is where we live and relax and replenish after a long day or on the weekends.

Rush-topped ottomans make for easy moving. They serve as footstools, TV trays or extra seating. I love having children's furniture in a room where generations will gather, and my nephew Napp has claimed the blue chair as his. Vintage porcelain mallard and hen lamps flank the TV which is anchored with a baker's dozen family photographs. Blue and white accents and lamps surround the room and create a perfect glow at night. Grounding along with the heart pine floors is a layered combo of sea grass and an antique Persian runner that is worn and dog friendly too, since my dog, Sampson, has claimed this room as his favorite spot.

Custom artwork from my Auburn buddy Andrew Lee depicts a tom turkey and hens in linseed-oiled pine frames. Derek Taylor's charcoal hunting dogs give some vibrancy to the tonal walls, while the Schumacher country plaid adds geometric rhythm and charm. I firmly believe every good Southern rooms reflects our English heritage with a dose of taxidermy, as seen with the mounted fish and various antlers. The hand-carved Japanese wood plaques depict pomegranate trees and dogwoods; pomegranates are on the Granade family crest, and Perry is the dogwood capital of Georgia.

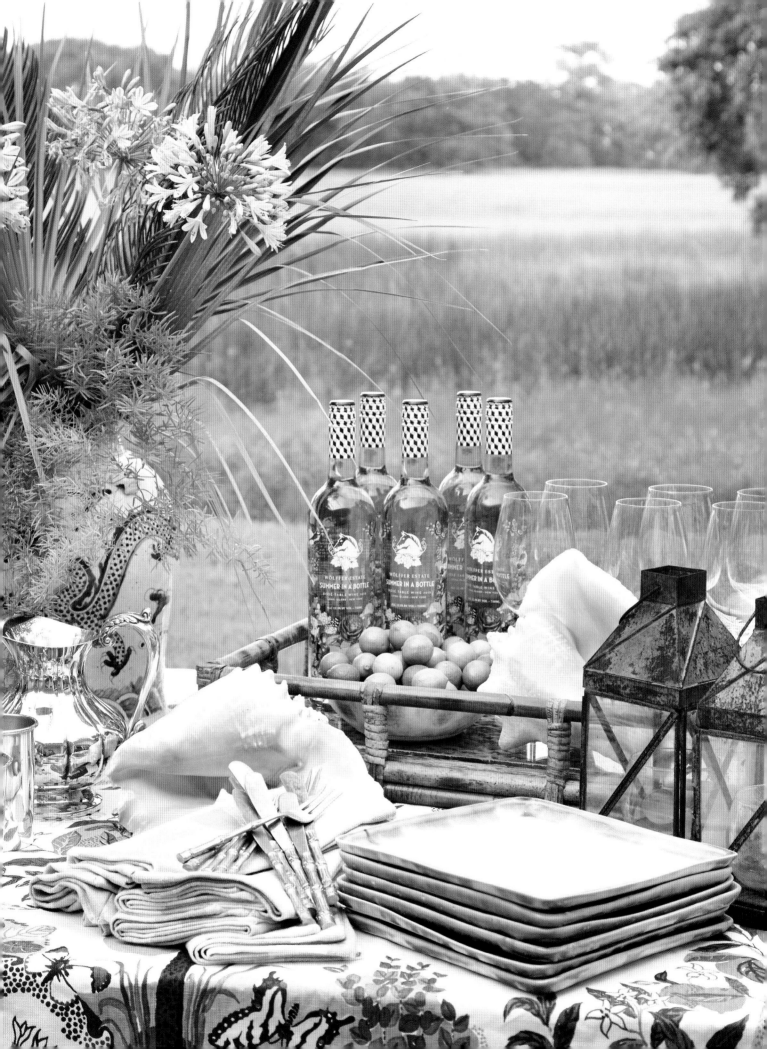

Beside the Marshes of Glynn

When dear friends approached my design firm about "helping" them with a second home, all it took was gentle persuading with these few words: "We've found a home, marsh side of the drive." That's all I needed to hear. The marshes of Georgia's coast and the Carolina Lowcountry are unique to our geography and are stunning as they change with the daily light, weather and seasons. Sidney Lanier poetically penned loving words about these marshes in his epic poem "The Marshes of Glynn," and I find the marshes enchanting, soothing and spectacularly brilliant at sunset. This home's story was one I could not wait to have a hand in!

First we did a "ranch dressing" of the home, renovating it to rearrange some of its rooms—enlarging some spaces to accommodate a growing family and enclosing a carport to create a couple of more suites and modernizing of bathrooms. We painted the brick and added working louvered shutters and an iconic terra-cotta roof added to turn a former hum-drum ranch-style home into a Sea Island classic.

Now it was time to furnish it—feather the nest. With its fresh new look and a stunning view across the marsh, we were able to bring this house to life through wall treatments, interior paint, furniture, antiques, art and lighting. Keeping with a fresh, lighter and brighter approach, the clean crispness of the white painted brick exterior was continued on the inside. Walls clad in wide

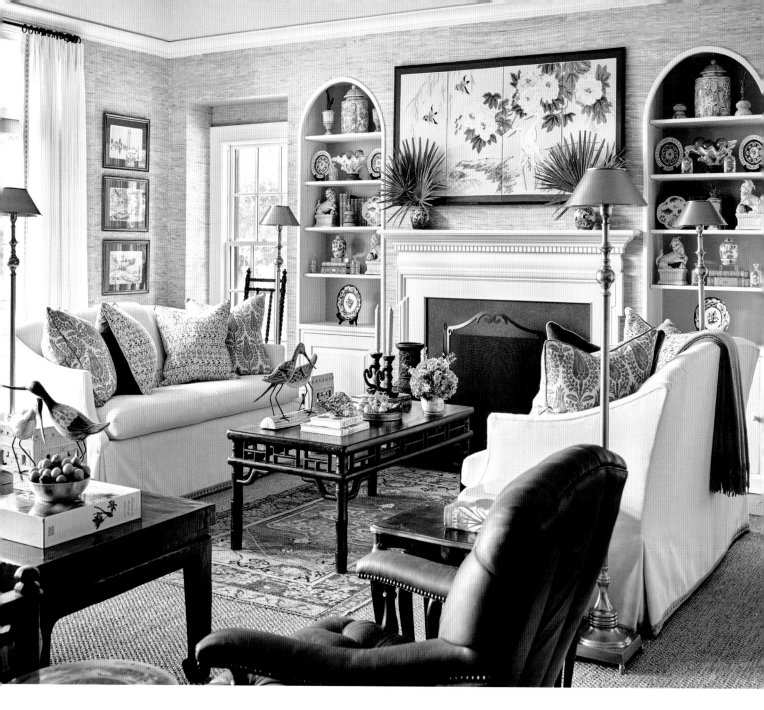

shiplap were painted in a glossy white and created structure and horizontal emphasis to reinforce the strong horizon and view. A West Indies vibe paired with a layered Southern style became our mantra, so we used grasscloth and wallpaper to accent in some major rooms and spaces.

Since our client wanted to move in "ready to party," we gathered our collection of found treasures, gifts from the sea and storied treasures to give the house personality and pizzazz. Family photos, trinkets and souvenirs from the owners' past travels, and

artwork they had collected over the years added the extra layer of "crunch," as we call it, to make a home that much cozier.

From the entrance hall's bust clad in shells by a local artist to tortoiseshell bamboo shelves, chinoiserie accents, English antiques and French chairs, the interior schematics proved true to a collected West Indies style, all with a nod to Southern tradition and modern comfort. Accents of coastal colors such as blue agapanthus, marsh grass green, seashell corals and pinks all found their way into the home through

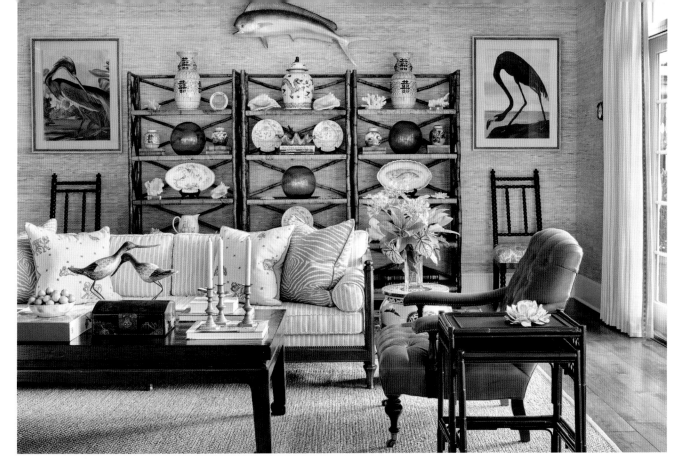

Layers upon layers created the "feel" for the living room, starting with the custom jute rug atop the wide-plank oak floors. Outdoor fabrics from Ralph Lauren Home and Schumacher allow the workhouse seating—the sofas—to be utilitarian as well as elegant. Leather "overseer" chairs in the Anglo-Indian style add a dose of handsomeness, while two coffee tables create solid surfaces for propping up feet and displaying treasures and flowers. Pops of blue and white bring the ceiling color into the room and complement the coral, Imari, Chinese porcelains and the gorgeous hand-painted screen scored at a local antiques shop. Touches of sepia brown in the nautical prints (which once hung in a seafood restaurant) pick up the cinnamon hue of the grasscloth. Accents of black in the nesting tables and bobbin-style side chairs are a nod to the West Indies style.

LEFT, CENTER: The Palladian-style shelves and mantel are original to the home. I love to treat the backs of shelves as an accent and backdrop for what will fill them. This particular color from Valspar is called "Afternoon Nap" and couldn't be more apropos in this setting. These shelves are chock-full of old leather-bound books, mounted coral specimens, pairs of foo dogs, antique porcelains and jars and "magic potion" bottles—all found and sourced from various antiques shops on the island and mainland and estate sales.

ABOVE: A wall of tortoiseshell bamboo shelves displays gifts from the sea, blue-and-white jars, heirloom plates and green glass buoys. A mounted mahi mahi in all his grandeur arches over the collection and picks up the colors in the Audubon-style prints.

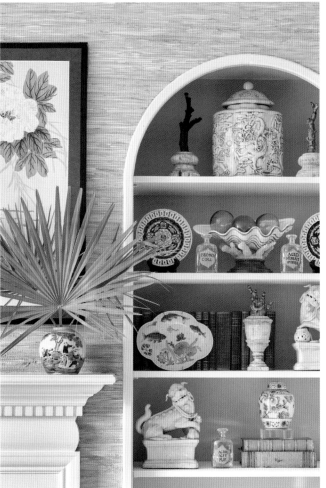

artwork, porcelains, shell collections and vegetable-dyed Turkish and Persian rugs. Gracious areas for seating and dining were created to absorb a crowd or feel intimate for a couple of folks. Using a mix of outdoor fabrics also ensured extra wear-and-tear resistance for some high-traffic areas and often-used pieces. Barstools, sofas and some reupholstered chairs all boast outdoor fabrics in case a post-"dip in the pool" sit occurs.

Barefoot at the beach is de rigueur and soft jute rugs and worn rugs encourage and embrace such a comfortable gesture. Nothing is too sacred or precious to not be enjoyed in this house, yet treasures abound from room to room. Taking the original footprint of the house and expanding and modernizing the common rooms allowed for the opportunity to create a large, eat-in kitchen filled with modern conveniences though tactfully hidden. Lighting, cabinet hardware and plumbing fixtures are the "jewelry" of a kitchen and bathroom, and simple mixes of antique brass, brushed nickel and stainless steel create a cadence and rhythm throughout. Further unity is achieved with the reclaimed sawn oak floors in a medium finish. This warm undercurrent is juxtaposed with cooler coastal tones in some of the rooms and a complementary tone-on-tone scheme in others.

In the dining room, a custom copper lantern with a full yoke and ladder rest creates an architectural and visual anchor in the space from which to build the room. An oval English drop-leaf table can easily squeeze in a few more, but the French chairs with their original blue velvet and Gothic nail heads serve as the main seating. A simple seagrass rug defines the dining area.

French brass candelabra and French majolica are set off by blue-and-white platters and bowls ranging in English and Chinese origin. Mounds of citrus and leafy caladiums fill the space, with reverence to the landscape and cash crops of the coast. Anglo-Indian-style mirrors face one another over Spanish-style bleached oak consoles, their warm, oiled teak finish juxtaposing the oak tables and their interlocking ellipses recall the cabinet design opposite them in the kitchen.

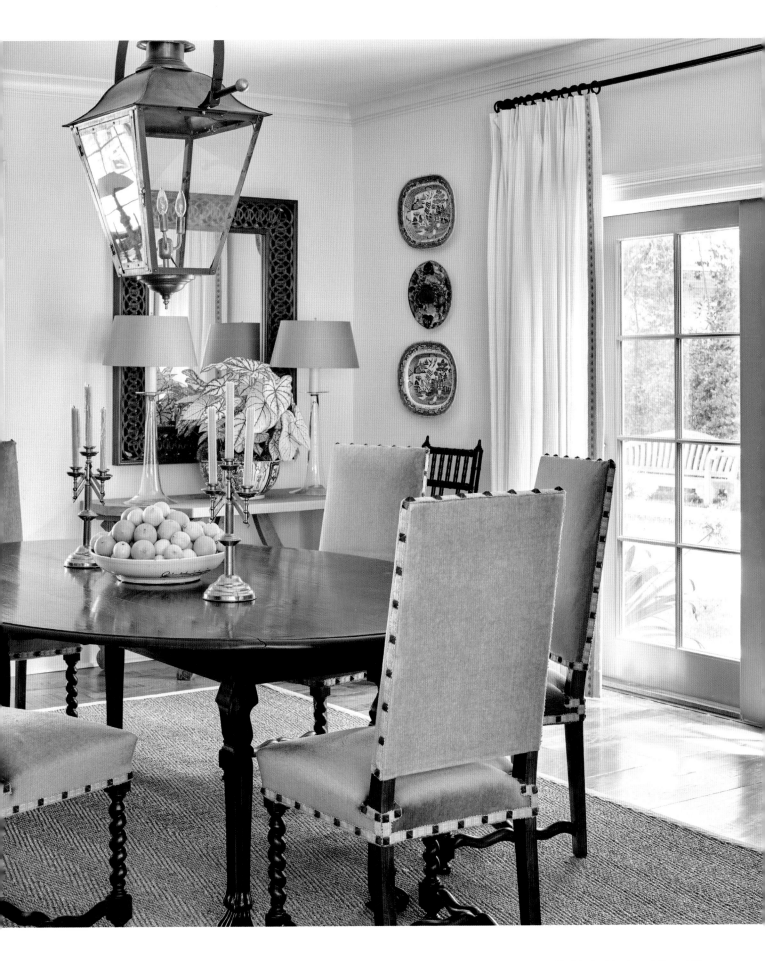

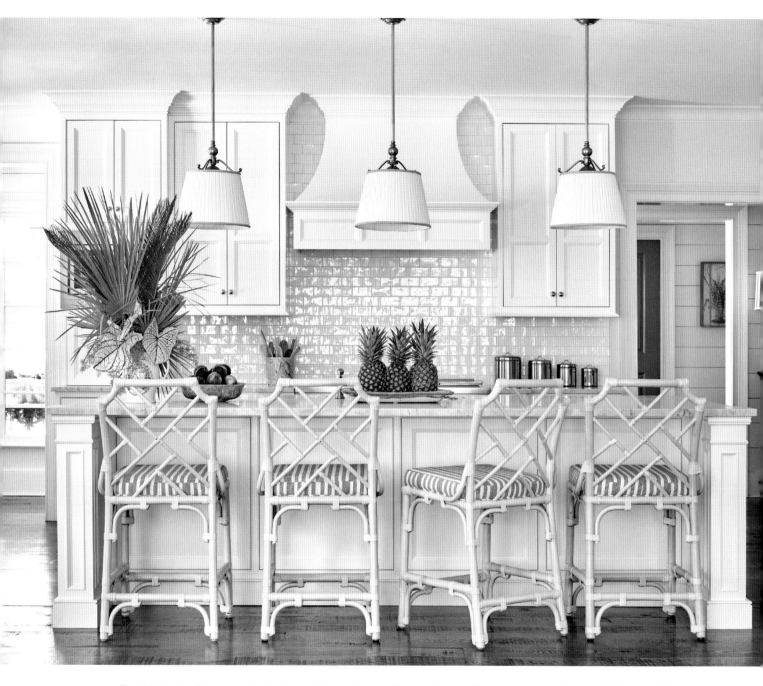

ABOVE: The kitchen in this home is a truly transformed space. The original a galley-style space with very little room for entertaining and gathering—let alone cooking—was reworked into a chic, classic space with a contemporary twist on tradition. Glossy white subway tiles running from counter to crown on the range wall add a touch of glam. The mix of metals—brass, stainless steel and brushed nickel—complements the glossy tile, while the crisp moldings, paneled cabinets and flared range hood create drama and add architectural detail. Muddy-veined Italian marble tops the counters. Bamboo barstools in a Chippendale fashion line the bar, and their scalloped corners mimic the flare of the hood. Repetition of elements like these creates cadence and rhythm and in turn a harmonious design scheme. A blue and white striped Ralph Lauren Home outdoor fabric allows the barstools to be even more utilitarian and yet elegant too.

FACING: A series of ellipses in the cabinet doors, much like a Southern plantation fan and sidelight, creates a geometric display case for silver, serving pieces and the homeowners' vast collection of McCarty pottery—a perfect homage to her Mississippi roots. A medallion-themed Oushak runner brings color and further geometric accents into the room.

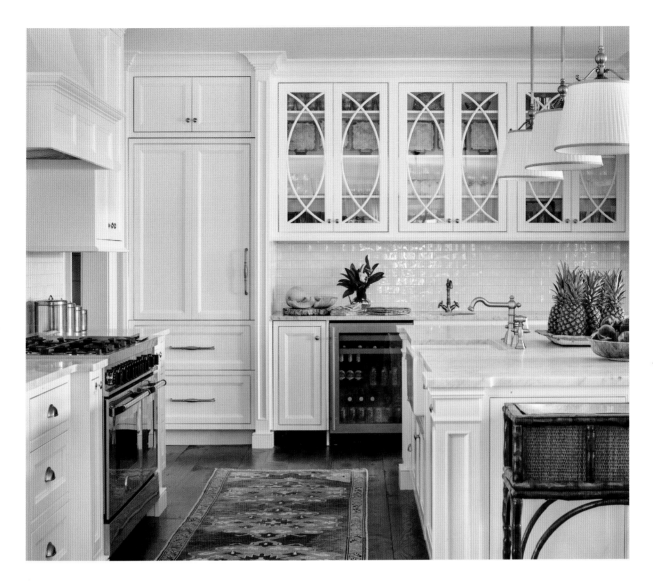

Ceilings received correlating treatment; thus some are painted a faint blue, like the marsh skyline at dawn, and some are banded in V-groove paneling for continuity with the shiplap. I am a huge proponent of what I call "un-colors" for ceilings, walls and doors—colors that are not definitely one hue or another but a fine balance of several. For the doors throughout this home, a green that can appear gray or even bluish at times was selected—mimicking how the marsh grass changes throughout the day or how the silvery sage underside of a palm frond is exposed and jostled in the breeze.

These clients are dear friends of mine, generationally from the grand dame matriarch to the children nearer my ages. I poured a great deal of heart and soul into this project and gleefully handed it over to the owners with contentment and joy, knowing that the folks who will live and love within these walls cherish and treasure the home and its contents as I do. This family has been coming to this particular resort for generations, and this pied-à-terre ensures future visits, no doubt.

As Sidney Lanier said, ". . . the slant yellow beam down the wood-aisle doth seem, Like a lane into heaven that leads from a dream . . ." in a line from "The Marshes of Glynn" is as much a lullaby as it is a religious soliloquy of "This Happy Isle" and seems to come to life here in this home. A place by the marsh to call home—a place for respite and retreat, celebration and solitude, family and friends alike. I am humbly grateful to have been a part of your history.

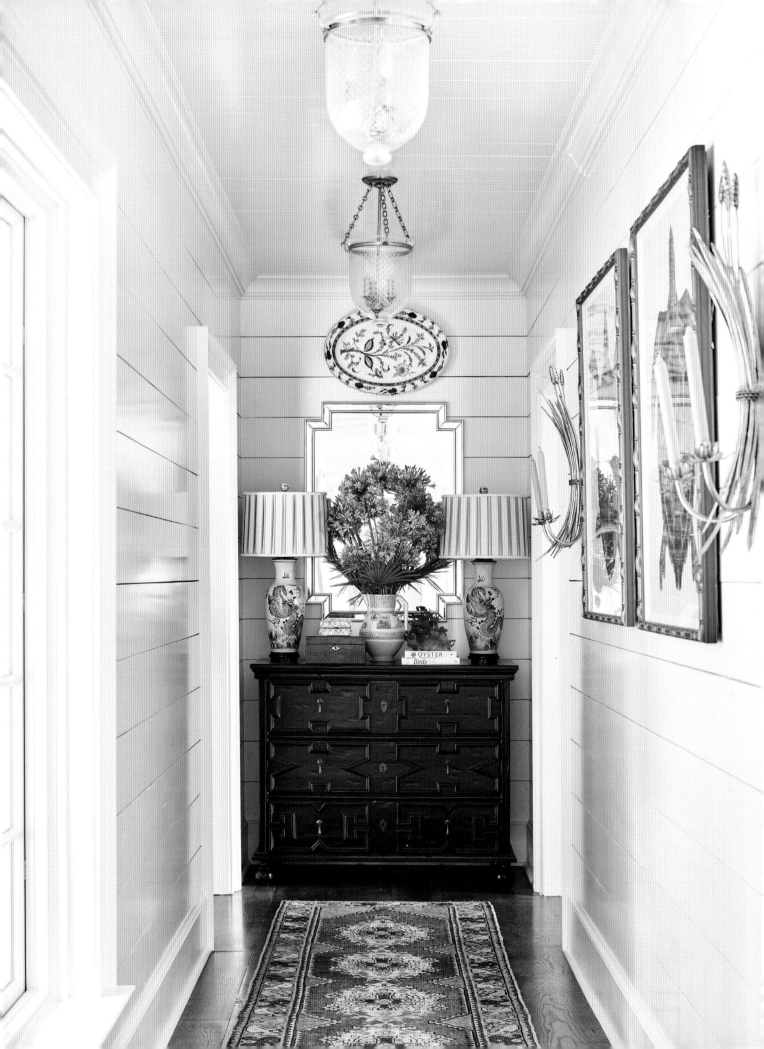

FACING: A shiplap-lined gallery connects the older and newer parts of the home, running parallel to the kitchen and dining room. Glossy white keeps the space fresh and allows for artwork and furnishings to take center stage. Florentine gold "wheat" sconces, bamboo-framed sea turtles, a contemporary line mirror and a Delft platter all adorn the walls while a series of hand-cut crystal "smoke and ball" lanterns lead the eye down the hall. Ming dragon vases converted into lamps flank the top of a black, Jacobean-style chest. Agapanthus from the garden and other coastal treasures form a welcoming vignette in this hallway. A thick, knotted Turkish runner grounds the space.

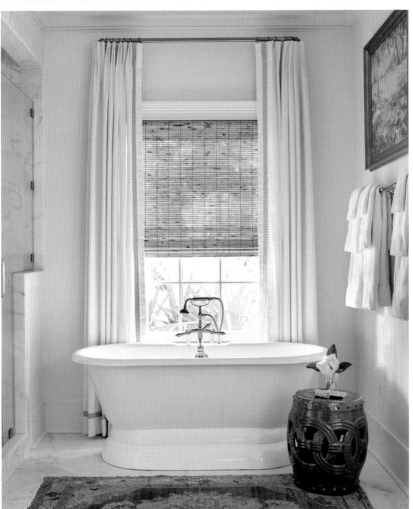

ABOVE: For the powder room, we selected a classic Brunschwig and Fils paper in a contemporary colorway. Brass lamps, a wide-framed tortoiseshell mirror and a trio of platters add character. The paint color of the distressed, louvered vanity is a colorful accent taken from a detail color in the wallpaper. I believe powder rooms should be "jewel boxes" filled with treasures, color and surprising design.

LEFT: In the master bath, Schumacher all-weather fabric panels make for easy wear on the window, while blonde tortoiseshell blinds, an antique Oushak rug, a deep turquoise garden stool and bright acrylic oil paintings add some color and texture to the predominantly white, tone-on-tone space.

For the master bedroom, we wanted to re-create the tones and shades seen in the marsh just outside the windows. A silvery grayish green sisal wall covering warms and swathes the rooms as marsh grass covers the landscape. Sepia browns of hand-blocked linen and tortoiseshell bamboo blinds further the palette. Pops of blue and turquoise—as the sky can appear above the marsh—are seen in the glazed lamps and artwork. Crisp white linens and a faux-bamboo poster bed complete the restful setting.

Two English chests—a block and a bow-front—serve as scaled side pieces for the bed. Bleached-oak armchairs reminiscent of driftwood in the marsh and on the beach are upholstered in a watery damask, while a pop of pattern is seen in the needlepoint animal-print pillow. A jute rug stretches across the room to ensure softness, and a tribal-patterned runner adds color.

A collection of family photos of generations on the island, gifts from the sea, heirloom porcelain and turquoise lamps are nested together on a glass-top desk. The leather-and-gold tooled box and pagoda votive holders add a touch of chinoiserie, while palm fronds bring the landscape indoors.

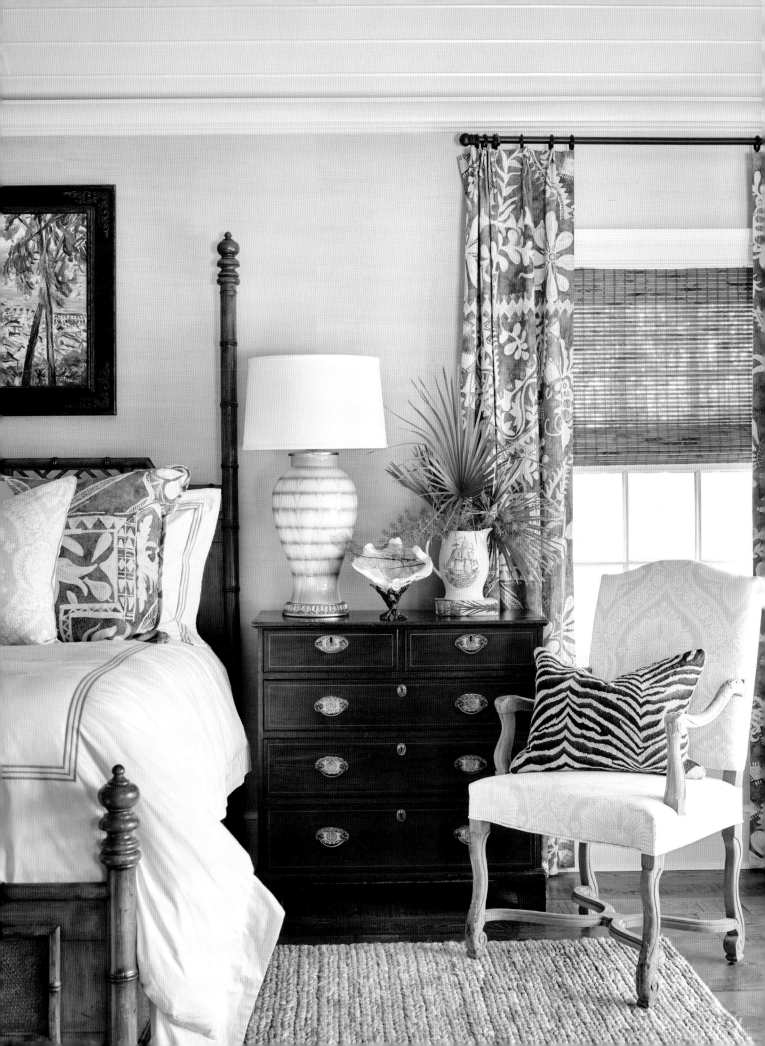

GUEST
SUITES

Each of the guest suites was treated in a particular theme or fashion, which made organizing the design more efficient but fun, too, for the homeowner: "Y'all will be in the Pirate Room" and so forth. Two suites created from a former carport (a new one was built) allowed additional room for a growing family and plenty of guest overflow too. We chose deep navy blues, British khaki and pops of white for the color scheme.

A Victorian mirror in polished mahogany reflects the room—it was found at a local antiques shop from a nearby estate. White bamboo chairs and bed linens keep the room crisp, while a bleached-pine bamboo dresser provides plenty of storage.

The "Alligator Suite" takes its name from a large Walter Anderson print in fantastic colors depicting flora and fauna easily seen in the marshes and lagoons of the Lowcountry. Tortoiseshell bamboo bedside chests and a side table between two rattan chairs keep the lightweight, casual coastal feel in check. The ebony-and-ivory barley twist four-poster bed blends the English Colonial styles, while a classic Brunschwig and Fils fabric on the French door frames the view towards the pool and marsh.

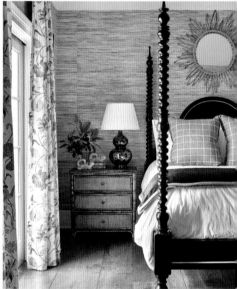

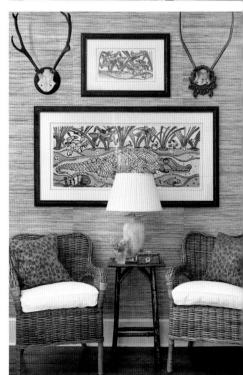

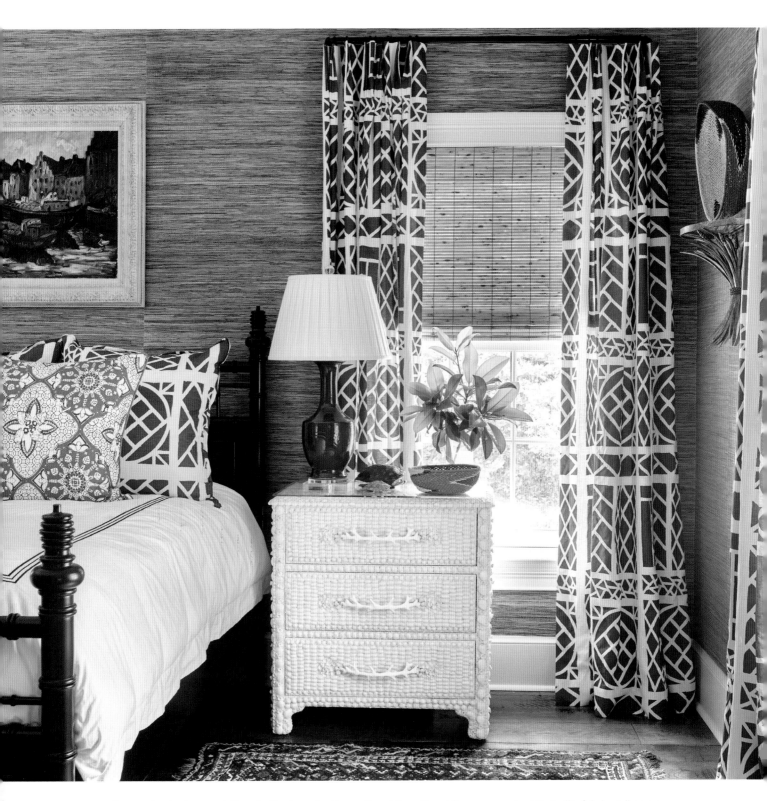

ABOVE: A navy-backed grasscloth sets the tone for the walls, while a Quadrille navy-and-white trellis fabric strikes an architectural accord created by the window treatment panels. A Dutch painting of a harbor scene hangs over the black lacquered faux bamboo bed.

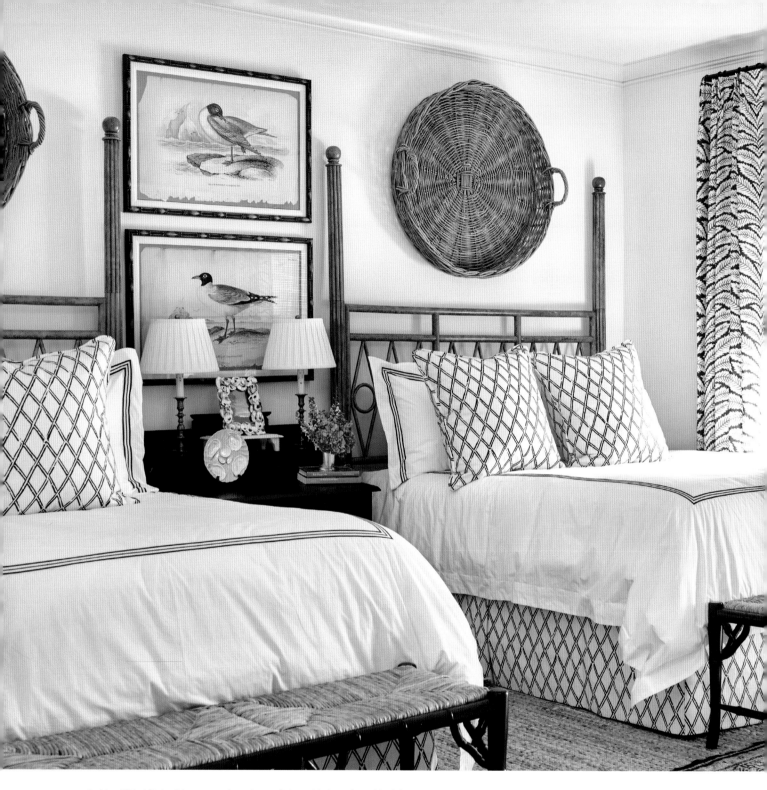

In the "Bird Suite," large-scale prints of shorebirds colored in blues, grays and whites set the tone. Two queen-size beds can host a crowd, and their blue-and-white linens and bedding is a classic choice for coastal locales. Wicker, rush and bamboo accents such as the benches, baskets, headboards and cane-topped garden stool create pattern and textural interest. The "dowry" runner is a Turkish antique, and its pink hues are repeated gently in the oyster plate, flowers and Sea Island sunset photo—all adding a feminine touch amidst handsome elements such as the Dutch brass candlesticks turned into lamp bases and the black chalk-paint finished desk.

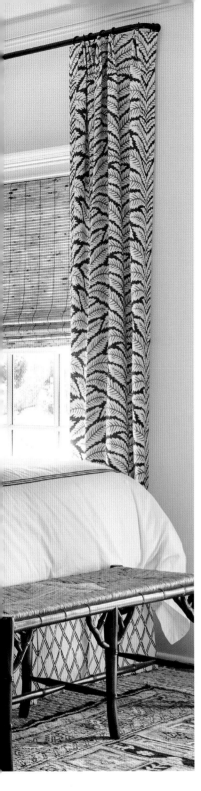

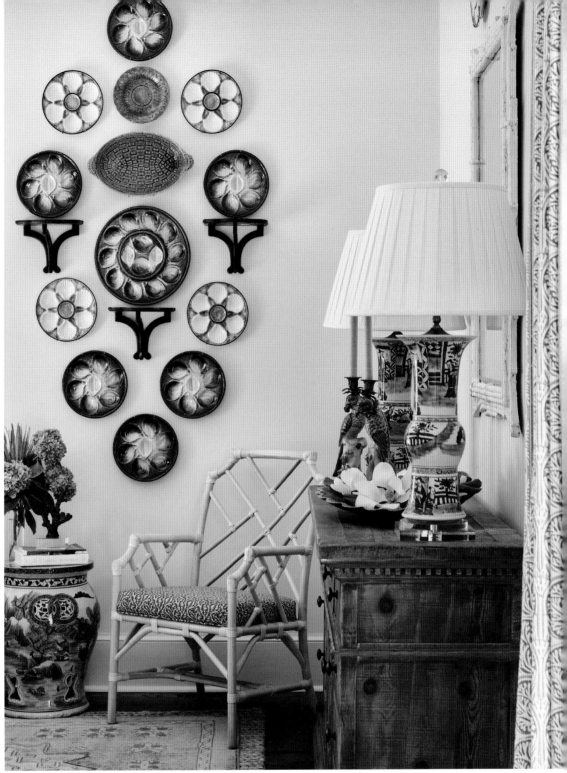

The "Oyster Suite" takes its name from the collection of majolica oyster plates grouped on a wall. Twin beds can host a couple of guests. Blonde bamboo chairs, oyster-shell and other sea shell-clad boxes, and blue and white vases turned into lamps create a soft lighting scheme and bring the nearby beach to mind. A knotty-pine dresser provides extra storage. Layers of soft jute atop the oak floors, further topped with a green Oushak rug create comfortable geometry underfoot.

Plates and platters alike form a lovely alternative to expected artwork. Brackets add depth and dimension. Oyster plates and their larger scaled platters became all the rage in the Victorian era and now are sought after as collector's items. The stunning glazing of majolica plates and their intricate "woven" look make each a work of art. Blues and greens meld together terrifically and create a soothing palette in this room.

En plein air entertaining is a must in this marsh-side home, and terraces filled with deep seating, dining tables, chairs and chaises stretch across the pool façade to capture the nearly 180-degree view of the marsh. Sliding French doors allow interior spaces to connect openly with outdoor spaces, creating a delightful balance and a more than hospitable setting. A pool perfectly poised for a leisurely dip simply caps the forever summertime feel that a coastal cottage can bestow.

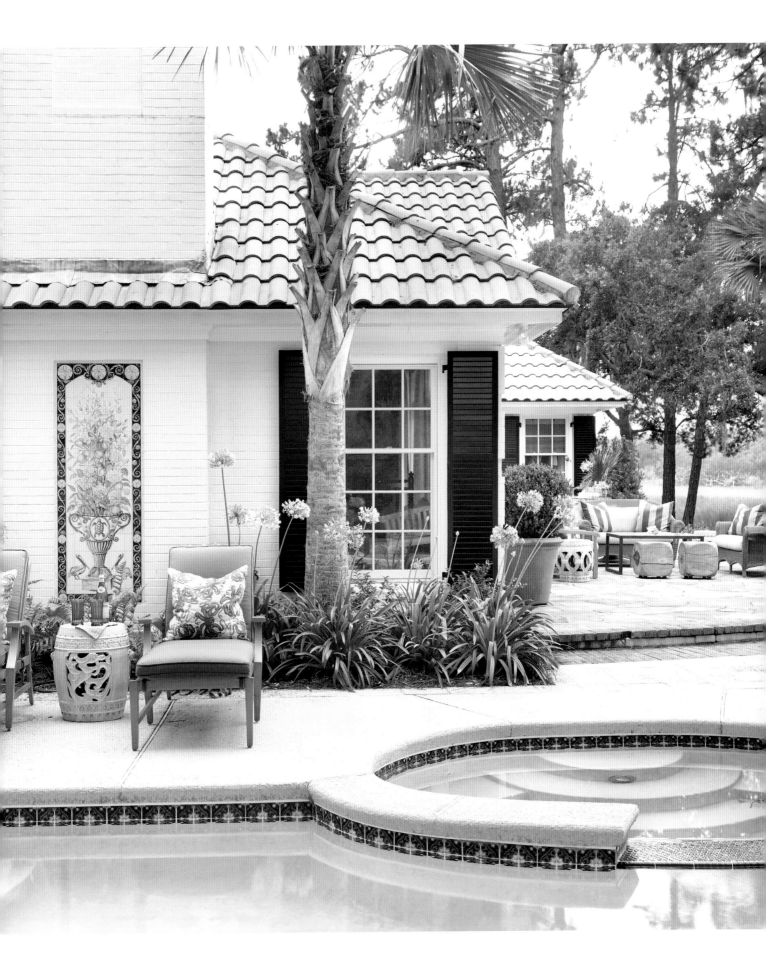

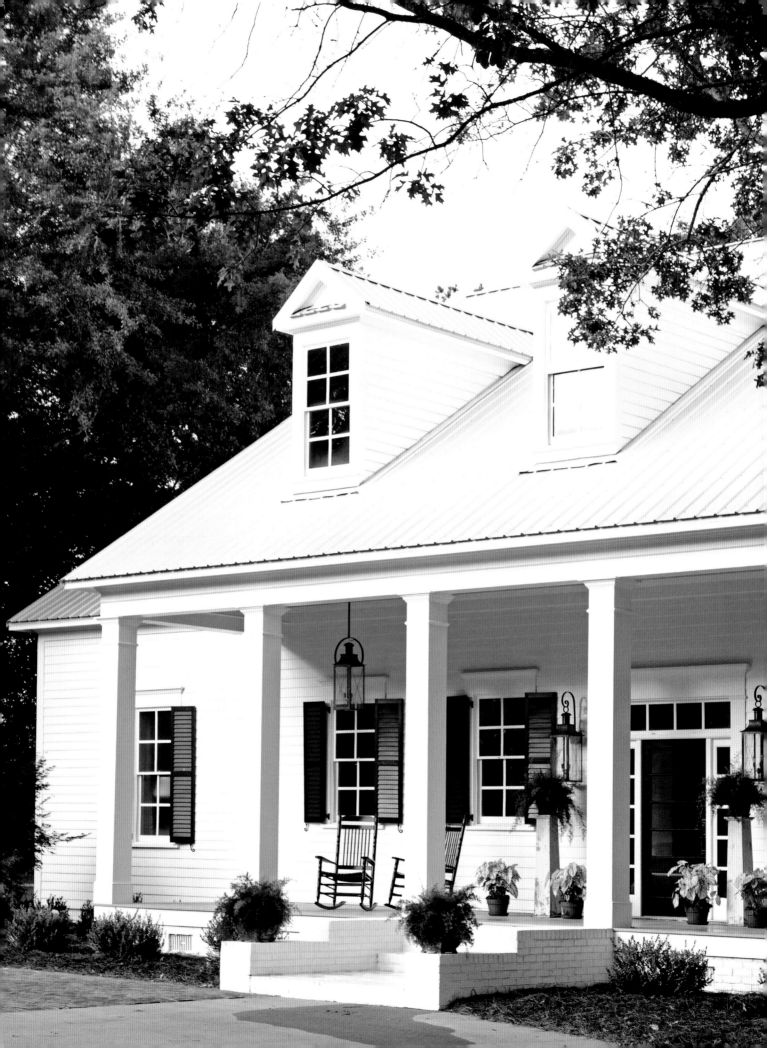

A Reflection of a Land so Dedicated

We have an area in our county's southerly locale known as Elko. Though not incorporated or a municipality proper, Elko does have a zip code and post office. For what the area lacks in municipal multitudes, Elko is geographically rich—a collision of soils, flora and fauna with wide breadths undisturbed from major development. The fall line—the geographical and topographical crest directing watersheds, creeks, streams and rivers to the Gulf or the Atlantic, respectively—runs through my part of Georgia. This demarcation has always fascinated me, since rivers running equidistant from my county's lines dump their cargo of silt, sand, clay and water into the Gulf and Atlantic.

Since childhood, I have been enthralled that I could throw a pinecone into the Flint River and it would end up in the Gulf of Mexico, while a pinecone thrown into the Ocmulgee would sail on down to the Atlantic. My county is the "crossroads of Georgia" and has been for generations.

For the exterior of the home, we chose a classic color pairing of white painted brick, clapboard siding and deep green-black shutters. Blue-gray floorboards and ceilings hearken to antebellum porches and their superstitious influences. Blue porch ceilings keep away "haints," or unwanted spirits.

Antique pieces of another home's porch columns boast billowing pots of asparagus ferns, while speckled white caladiums nod in the summertime breeze. Rocking chairs painted to match the shutters beckon "y'all sit a spell" and shade yourself from the Southern sun. A galvanized metal roof keeps the home in check with its agrarian roots while still being fresh and chic.

Native American trade routes connecting tribes from the lower, loamy flatlands of South Georgia to the iron-rich clay soils of the Piedmont are now major highways and interstates. Just about wherever you're travelling in Georgia, you'll come through Perry.

These geographical markings on my county lead to a topography in South Houston and Elko that is reminiscent of countryside found in Kentucky and Virginia. Bluffs overlooking rivers and streams and spring-fed ponds seem dramatically higher, as flat, fertile fields seem to collide underneath them. Hills abound in Elko while a few miles south and down to the Florida line, the terrain is flat as can be. The soil is sandier in Elko and the heavy red clay found a few miles north seems to give way to this loamy dirt, even though its empire reigns supreme from Perry to Atlanta. Deer, turkey, hog and bear are hunted here, while birds of prey and waterfowl find refuge. This collision of soil and abundant native fauna make Elko the gateway to South Georgia—a storied and historic land rich in hunting, agriculture and cultural heritage.

For friends from the northern part of Georgia, Elko proved to be the ideal location for a bucolic retreat. Spring-fed ponds, pecan orchards and grassy hilled countryside dotted with large live oaks and red and black jack oaks paint the perfect picture of a Southern farm. When the hustle and bustle of Atlanta and its urban sprawl becomes draining, a couple hours down I-75 brings this family to a home restored from a forgotten hunting lodge—now a home for soulful restoration, rest, hunting, fishing and a taste of farm life.

Working within the footprint of the original home, the homeowner and my design team rearranged the layout of the rooms, allowing for a more traditional, Southern-style farmhouse plan to come to life. The

For the outbuildings, we kept the same color scheme and roof material as the main house. I love how a crisp white barn glows in the morning light through the pines and field grasses.

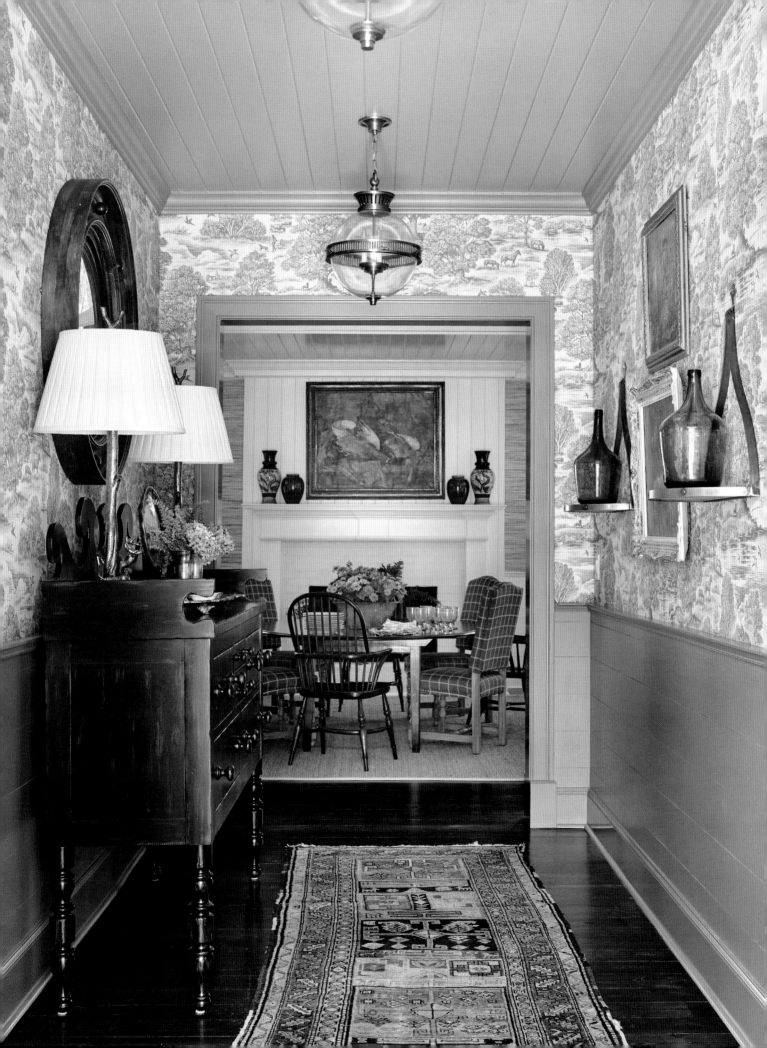

original kitchen, not much more than a galley, was gutted and enlarged to accommodate a family that loves to cook and congregate in the true heart of the home. Taking inspiration from antebellum plantation homes, I chose a custom-colored scenic paper with a fresh palette suitable for today—old-fashioned and contemporary melded together. Woodwork and beams, shiplap and grasscloth, open shelves and heart pine floors and countertops warm the home and create a nostalgic yet simple architectural shell, while gracious seating at tables and clustered arrangements of upholstery allow for relaxation and conversation.

Three *en suite* bedrooms in the main house accommodate the family, while two guest houses ensure room for a few more. Views framed by large oak trees—from these bedrooms across the farm pond and onto rolling hills—transform your sense of place from South Georgia to another bucolic land perhaps. But this land is the *entre* into South Georgia, where Middle Georgia's peach fields give way to fiefdoms of cotton, peanuts and pecans.

In her book *A Land so Dedicated: The History of Houston County, Georgia*, Bobbe Hickson Nelson chronicles our county's legacy and lineage and role in Georgia's history. Depicted on her cover, a watery scene of a pond and tree line brimming with longleaf pines could just about be any pond in the county. In a land that is home to a major Air Force base, a sleepy small town and a cast of characters dating back centuries, it is comforting to me that a tranquil pond surrounded by pines still depicts our homeland. This is what brought an Atlanta family here for their retreat—the proximity to their home in town and the lifestyle that a land not far from town affords. Those who call Houston County home are dedicated, and we welcome those who encourage that devotion and reverence to our land.

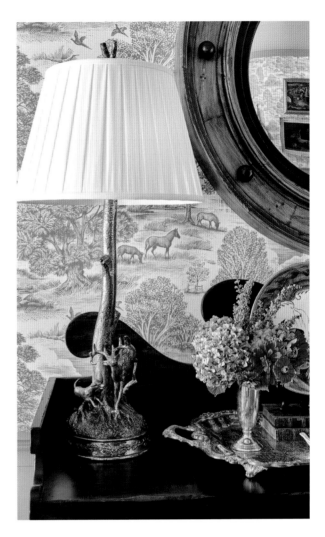

FACING: For the foyer, we rearranged some space to create an authentic layout of a Southern plantation home with a wide center hall and scenic wallpaper. Hand-colored in England, this paper depicts rural scenes of grazing horses, flying pheasants and large oak trees dotting the landscape—reminiscent of the scenery at this farm.

A reproduction huntboard anchors the foyer, with fitted brass lanterns illuminating it. Antique oil paintings, silver and porcelain add layers of collectiveness, while a custom bull's-eye mirror reflects the space. This nod to the Federal style is reminiscent of many antebellum-style homes.

ABOVE: Clippings from the land and garden always make the best bouquets. Silver trumpet vases and serving trays add a dose of old-world glamour and mimic the finish on the stag and hunting dog lamps.

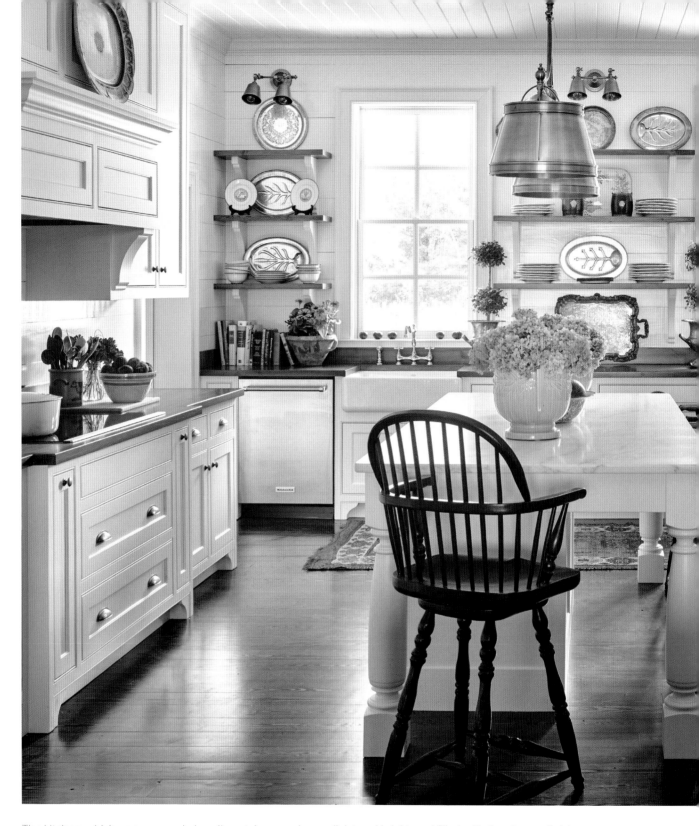

The kitchen, which was once a dark, galley-style room, is now light and bright and filled with farmhouse finishes and finds. White shiplap paneling, open shelves with heart pine tops and Windsor-style barstools create a warm collection for artwork, silver collections and dinnerware.

Wide heart pine floors unite the entire home, while antique Persian rugs add a layer of warmth and color atop the honey and coppery floors. Though thoroughly and modernly equipped, this kitchen is meant to feel old and welcoming—a collected study of yesterday's treasures, family recipes and modern tastes.

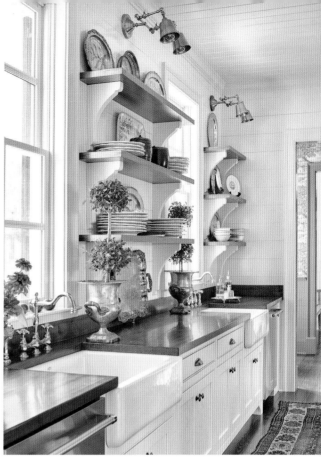

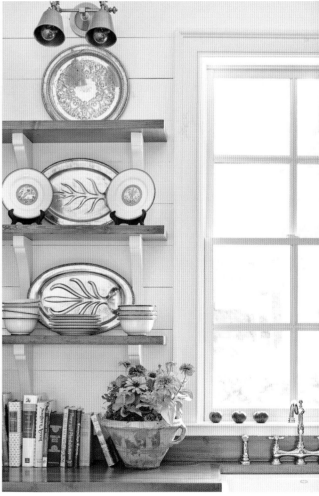

Pops of blue and white in flow blue platters, dinnerware and crockery blend with jade green McCoy urns. Local artwork, cookbooks and produce lend to the bucolic yet refined celebration of the growing season on the farm.

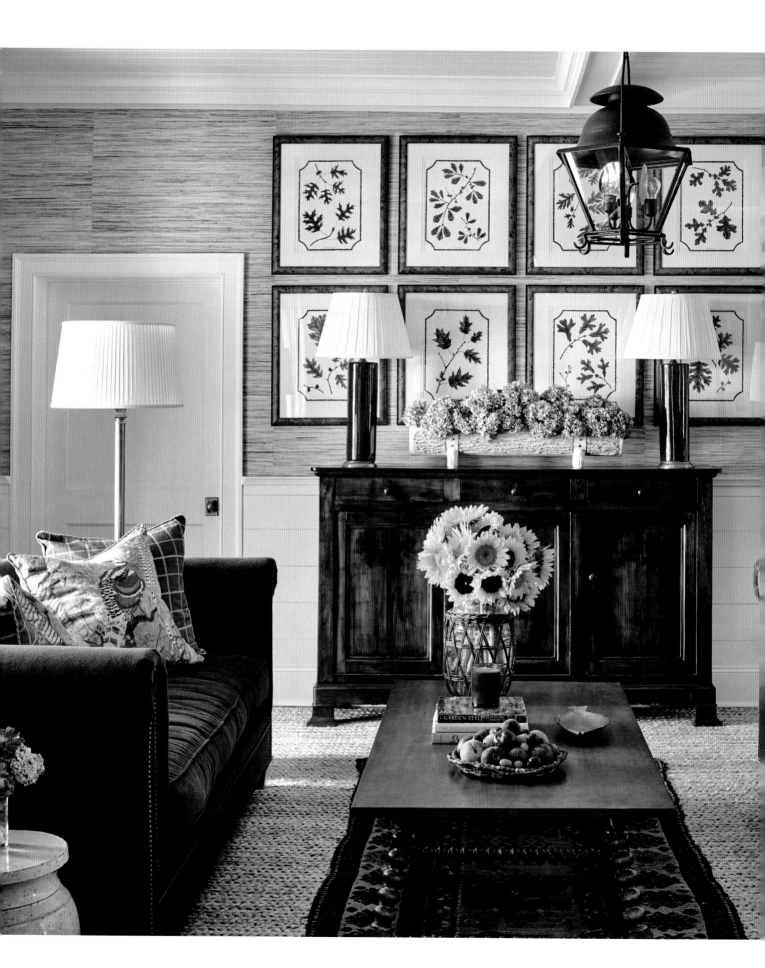

Natural raffia-hued grasscloth with shiplap up to chair-rail height envelops the room in a neutral feel. Layers of jute and seagrass rugs and an antique Persian runner add texture to the warm pine floors. Chocolate velvet Chesterfield sofas and deep-slung armchairs in a tobacco-hued windowpane plaid ensure a handsome look for the room and allow for artwork, lamps and seasonal touches to pop. The set of oak leaf prints are by local artist Laura DuPre Sexton.

Three key spaces were created in this large living room to accommodate a growing family and a host of friends. One seating area is poised for conversation, one for watching television and one is the main dining area.

Accents of red throughout the living room are handsome and sharp. Further accents of blue-and-white jars and lamps add a dose of classic Southern style. An antique French still-life depicting the trophies of a hunt commands center stage over the mantel.

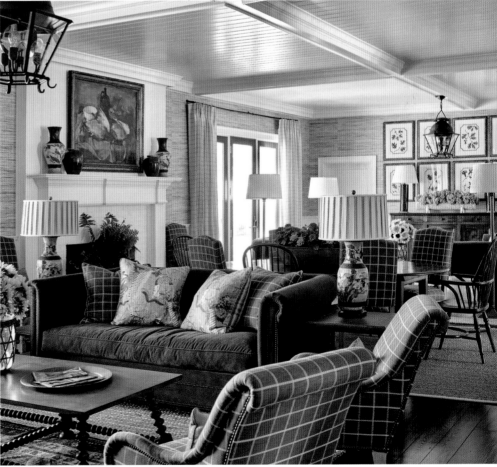

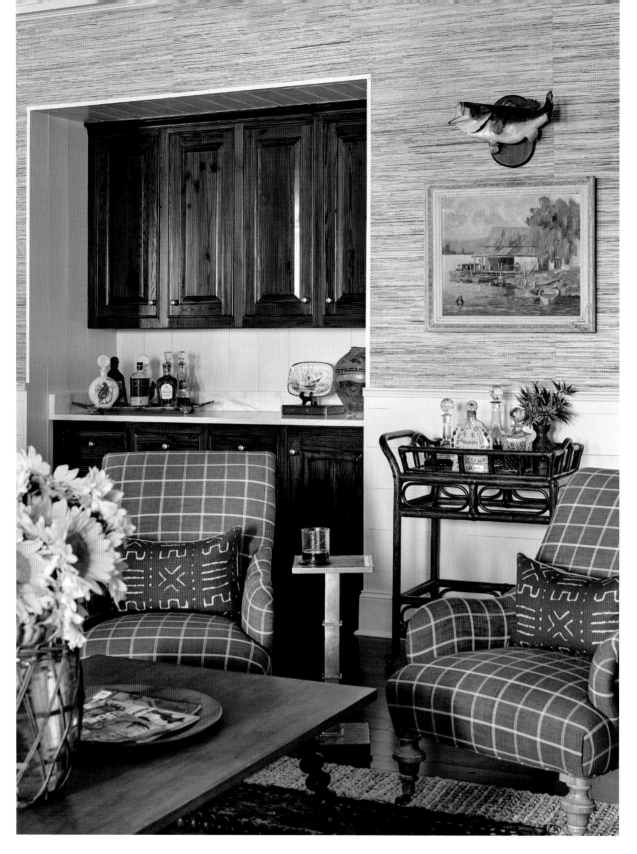

ABOVE: Heart pine and marble were used for the bar, and a collection of whiskey bottles and decanters awaits a thirsty hunter upon their return. The scene depicting fishermen, an old boathouse and a weeping willow is an antique find recalling vignettes seen throughout this land.

FACING: Windsor chairs and upholstered French side chairs create a dichotomy of seating around the English oak oval table. I love to mix chairs around a dining room table for a more relaxed look and feel, while adding some pizzazz.

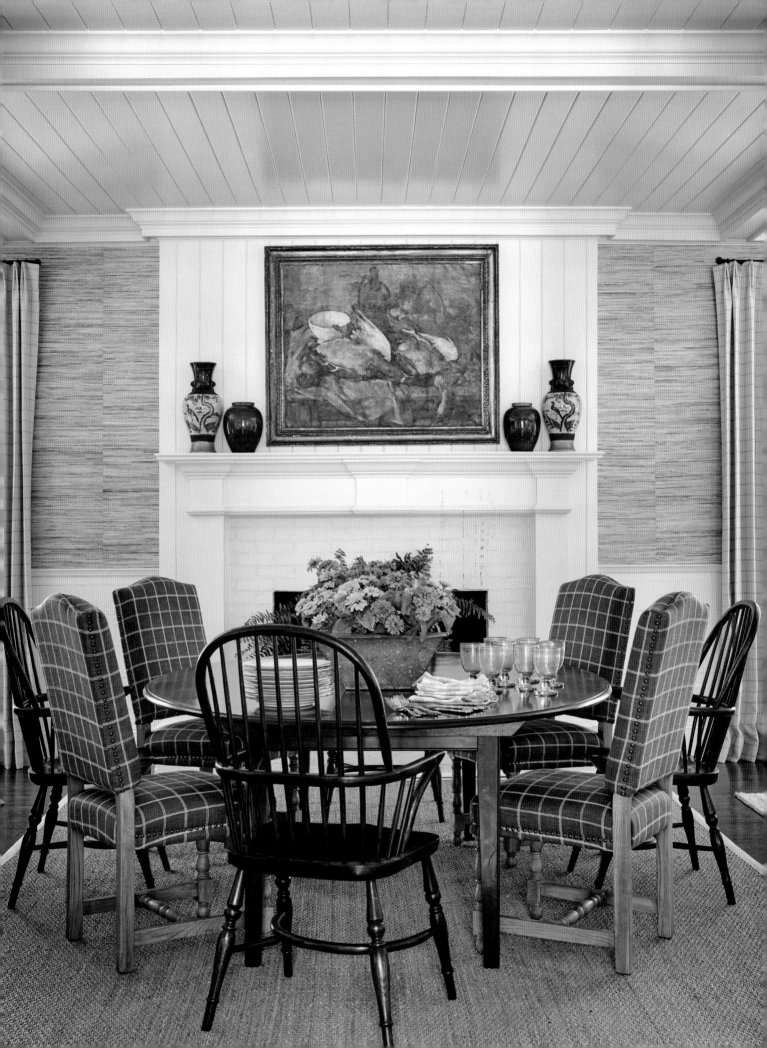

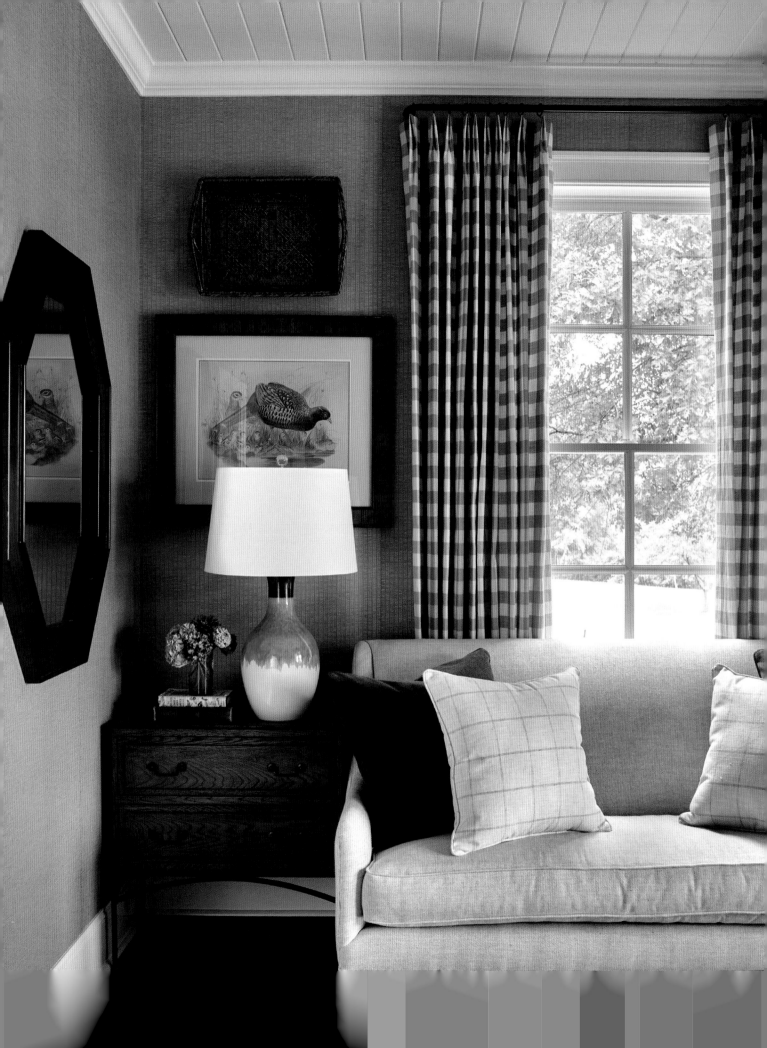

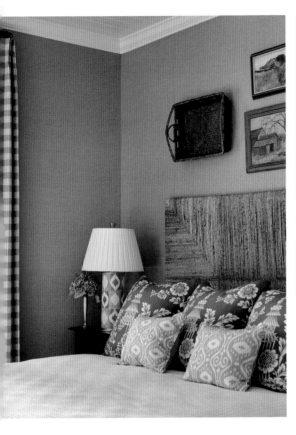

For the guest rooms, we chose soothing tones of blues and greens in woven threaded grasscloths. Country plaids and checks, rattan and pottery lamps all blend together for a comfortable, casual feel.

FACING AND ABOVE: An aqua crosshatch grasscloth, taupe check window treatments and a dose of chinoiserie in the pillows harmonize with the woven rush headboard. A collection of baskets and antique farm-scene oil paintings hang over the bed as a grouping. A sofa in light linen allows for a spot to sit and read or take an afternoon nap.

Prints from an old French classroom depict flora and fauna familiar to this farm too, and are shadowbox framed, which complements the navy raffia thread running through the grasscloth.

RIGHT: A pair of queen beds allows the family to double up on guests. A printed, slightly polished cotton depicting ducks accents the beds, which share an English pine chest as a bedside table.

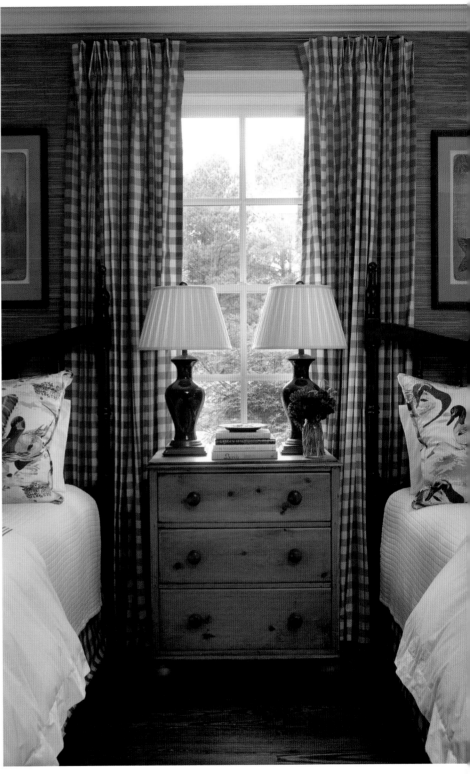

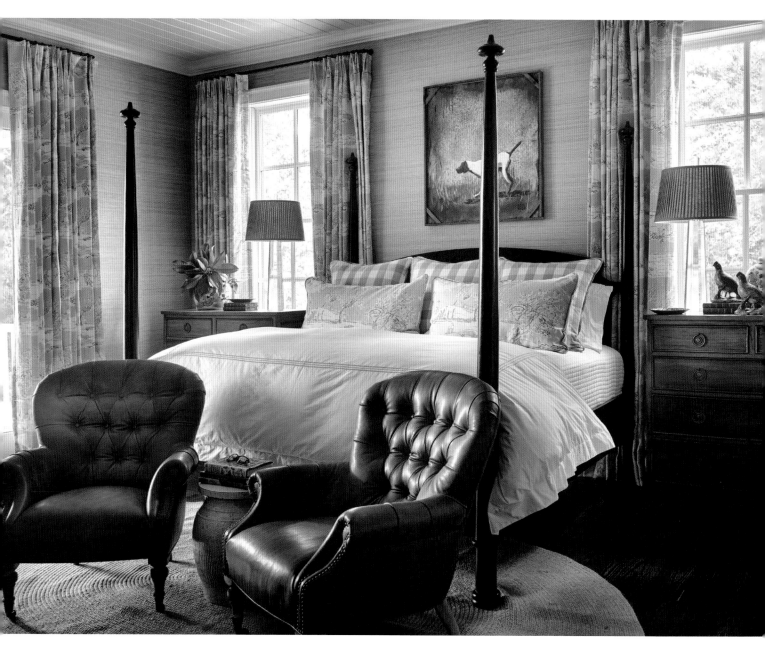

For the master, we selected a hayfield-hued, tightly woven grasscloth for the walls with V-groove wood ceilings. A French *toile de Jouy* frames the windows and swaths the room in grassy hues seen in the fields outside. Original artwork by local artist Derek Taylor is a contemporary twist on a hunting dog painting. Earthy-hued leather chairs provide the perfect place to sink into for a cozy afternoon read. An oval woven jute rug provides some softness to the hewn pine floors, while the ebonized bed contrasts with the soft browns and greens.

A touch of contemporary keeps a room fresh and from becoming too dated. Crystal cylinder lamps and taupe, pleated linen shades are tailored and "up to date" while balanced with antique blue and white melon jars, books and garden greenery—all grounded by a warm-finished bow front chest.

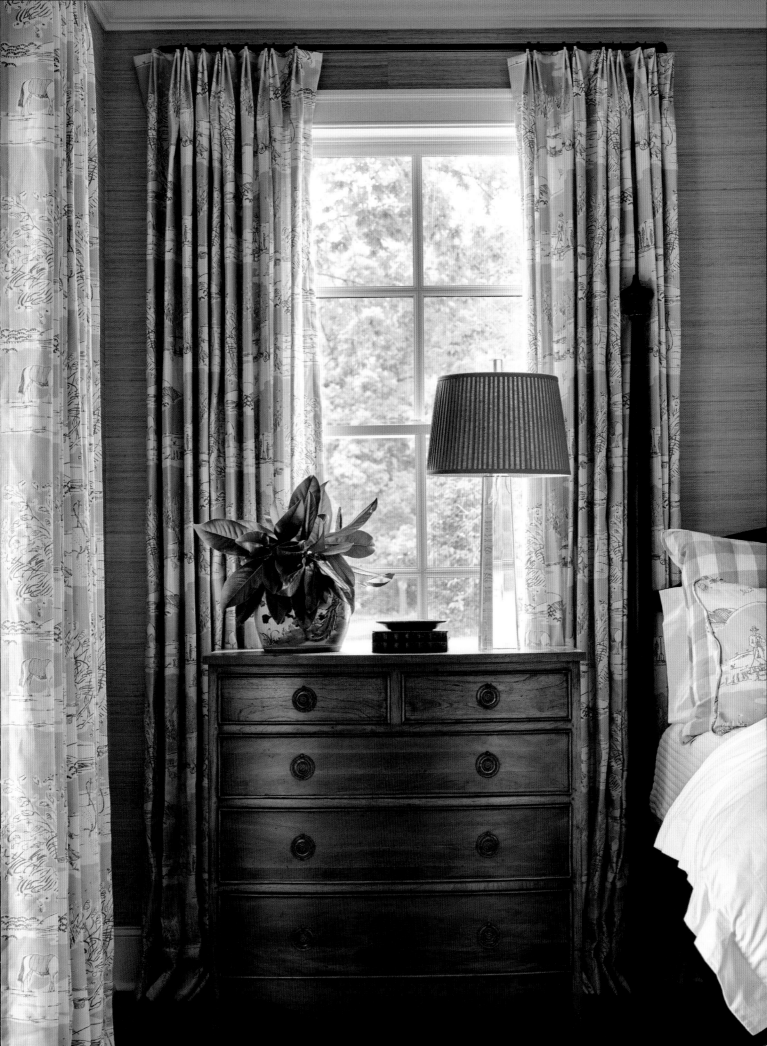

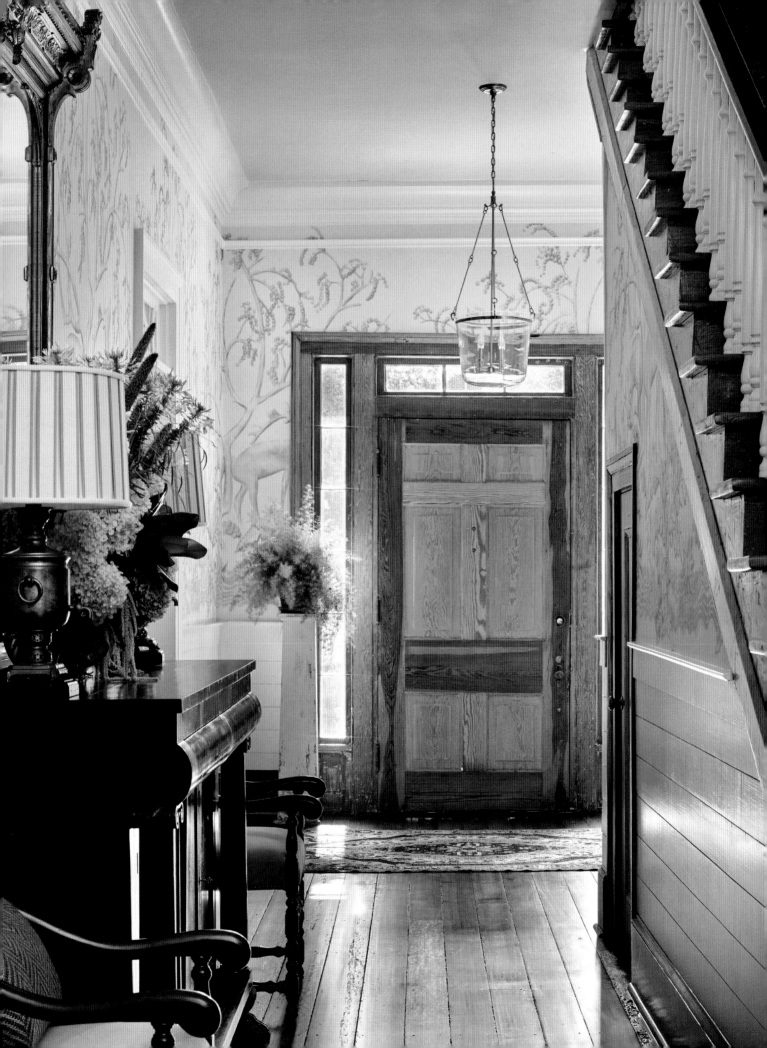

Antebellum Grandeur

There are towns across the Deep South that were not ravished by the Civil War but more so "hosted" a battle nearby, and, in turn, their homes and civic buildings became field offices, hospitals and battalion headquarters. One such town is Newnan, Georgia, comfortably southwest of Atlanta yet witness to history nonetheless. To this day, Newnan retains its antebellum calling card as the "City of Homes," with white-columned mansions dotting the streets and roads in and around town. A heavy dose of Victorian influence is found too, but the true authenticity of the Southern antebellum style of home remains vivid and prominent to this town's persona.

One such home on College Street has stood sentry as an anchor in the town since 1850. The same heart pine beams, floors, doors, window mullions and sashes still support the structure and welcome guests, friends and family as they have done for over a century and a half. Two amazing things about this house are that, one, it survived and has survived intact for so long—unscathed by wars

Many a fine Southern plantation home, townhouse and cottage have layers of moldings and trim; this home, however, was severely simple and almost stark when it came to woodwork and trim. In the foyer, I designed transoms appropriate for the period for the doors flanking the foyer walls, which gives height and scaled proportion to the existing, original front door and windows. Shiplap-style wainscoting provides another historically accurate wall treatment as well as the base for a scenic wallpaper. An Empire-style sideboard and mirror are period appropriate pieces for the foyer, while antique Oushak rugs, brass samovars turned into lamps and simple upholstered armchairs fill the space. Greenery and blossoms from the yard welcome guests and nod to the season.

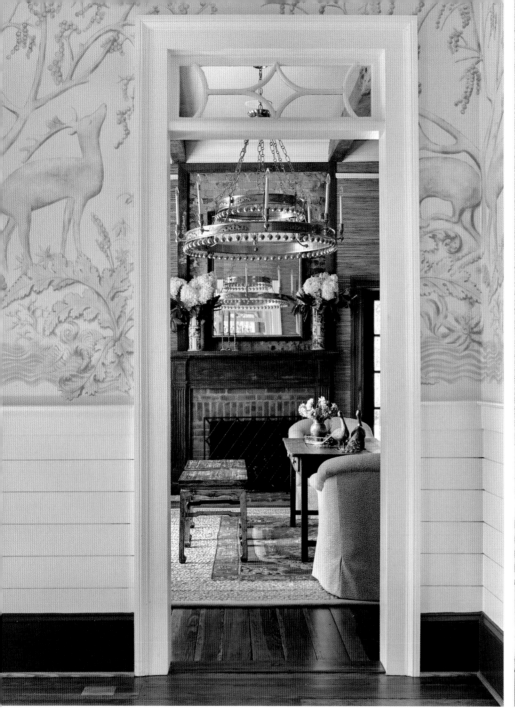

Civil and World—and two, it remained untouched by Victorian fancy, unbroken during the Depression, uninterrupted during Midcentury Modernism and was left in good care by only a handful of families all these years.

A couple with a passion to restore an older house in this town began their chapter with this home with full intent to restore the integrity and historic order of the home, while thoroughly modernizing it too. The days of fainting couches, segregated gentlemen's and ladies' parlors, detached kitchens and no air-conditioning are, thankfully, gone with the wind; but the desire for Southerners to create a home within the storied walls of history and heritage is as avid today as mint juleps are at the Derby.

As the interior designers, my firm was tasked with rearranging some rooms, preserving the historical integrity while keeping a modern lifestyle and floor plan in mind. What was once the detached kitchen, we thought, would be a great master suite, with the

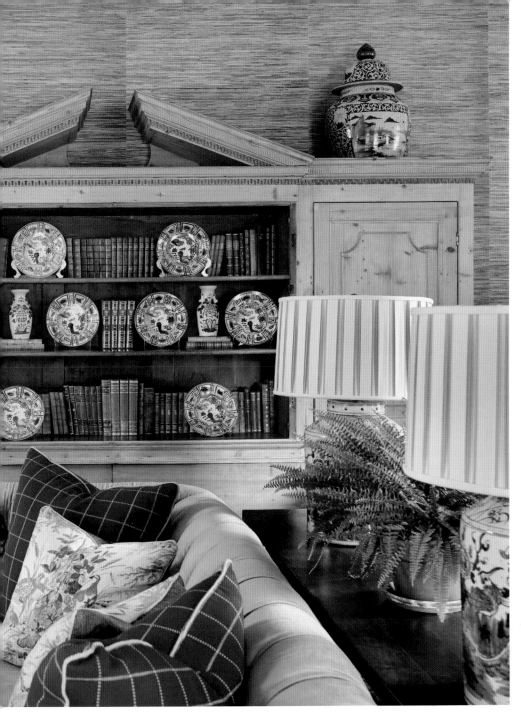

FACING: Stately homes across the Deep South greet their guests and families with scenic murals and papers in their entry halls and foyers, and I wanted this home to be of no exception. In a twist on tradition, I eschewed a dainty floral motif in favor of a bold yet soft palette statement for this entry.

LEFT: A Scandinavian pine, broken-pediment bookcase anchors the long wall of the great hall and is filled with antique books, blue-and-white plates and other treasures—plus it provides ample storage for board games and throw blankets. This was the first piece we bought for the house—a terrific find from one of my favorite stores, Foxglove Antiques in Atlanta, and I knew just where it should go. Good pieces such as this are rare, and if you "listen" they will "speak" to you and forever be chic and stylish and functional when well placed.

addition of closets, a modern bath and a laundry area: the old wash pot in the backyard would not suffice. By moving the kitchen from a historical placement to a contemporary locale off the dining room, an updated floor plan began to take shape. As for the ladies' and gentlemen's parlors, we parlayed an idea that would cause Miss Scarlett to say "fiddledeedee." I wanted to tear down the wall dividing the two parlors and create one large living space—a great hall filled with comfortable furniture, handsome antiques and, yes, a big

TV. Enter the architectural side of this project with Mitch Ginn.

Architect Mitch Ginn, along with our contractor extraordinaire Jarrell Griffin, simply hopped on board the idea and made it into a reality. They have restored and built many fine homes in Newnan, so working with them made this a dream team scenario—especially when I had ideas of tearing down original walls. In order to remove the wall and still provide structure, a center beam had to remain. That then inspired

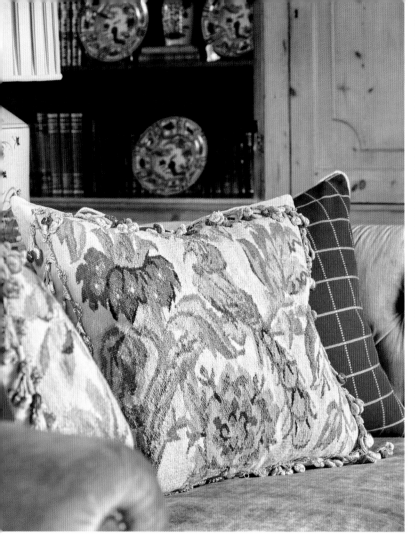

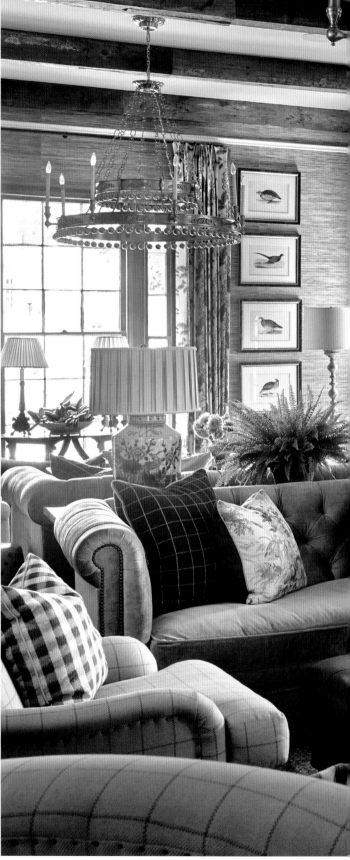

a ceiling spanned by antique, reclaimed heart pine beams completely apropos with this period of home.

What is so incredible to me about older homes like this is their skeletal and structural elements—prized specimens today but common and covered up back in the day. Heart pine joists, boards and planks were often plastered over, and handmade bricks from Georgia Red Clay were washed and stucco was applied to cover them up. We decided to embrace the graceful earthiness of these materials and celebrate our Southern heritage through architecture and design—all the while creating a harmonious, well-designed and finely appointed home. To me, that mix of fine fabrics, patina cloaked antiques and exposed elements like pine and brick are what make a Southern home an instant classic, visually appealing and warm.

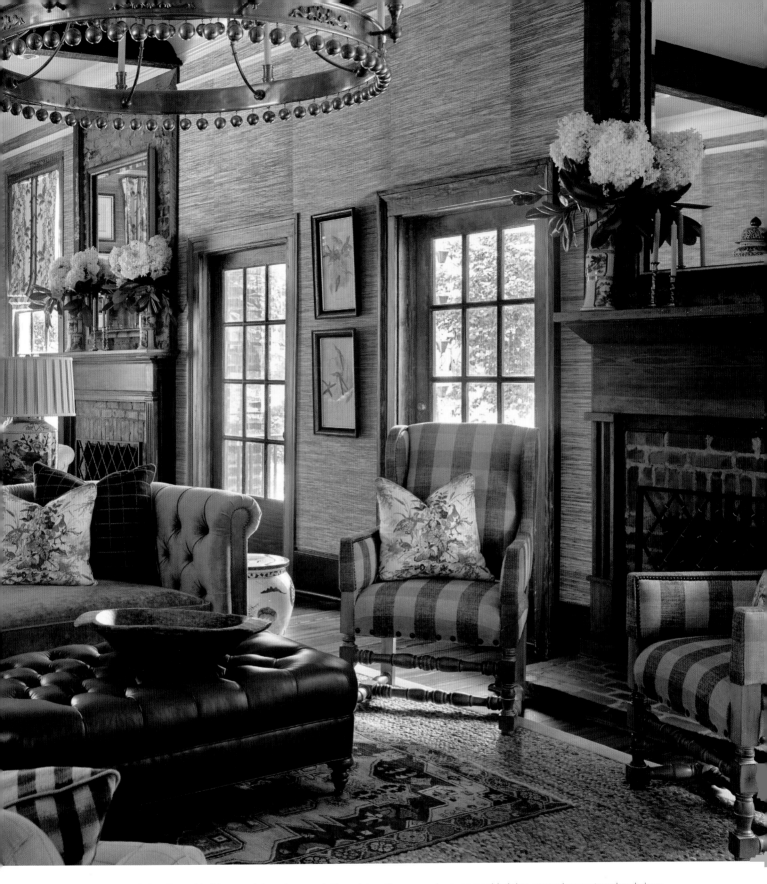

We wrapped the Great Hall in a red-hued grasscloth—giving the warm beams and brick a complementary backdrop from which to shine. Traditional yet with a twist—a style I gravitate towards for furniture—became the theme for the pecan-colored velvet twin Chesterfield sofas that back into one another, creating two large seating areas. Plaids in various sizes, a large jute rug, tribal rugs and scattered ottomans create layers of texture, extra seating and conversational moments within the main seating areas.

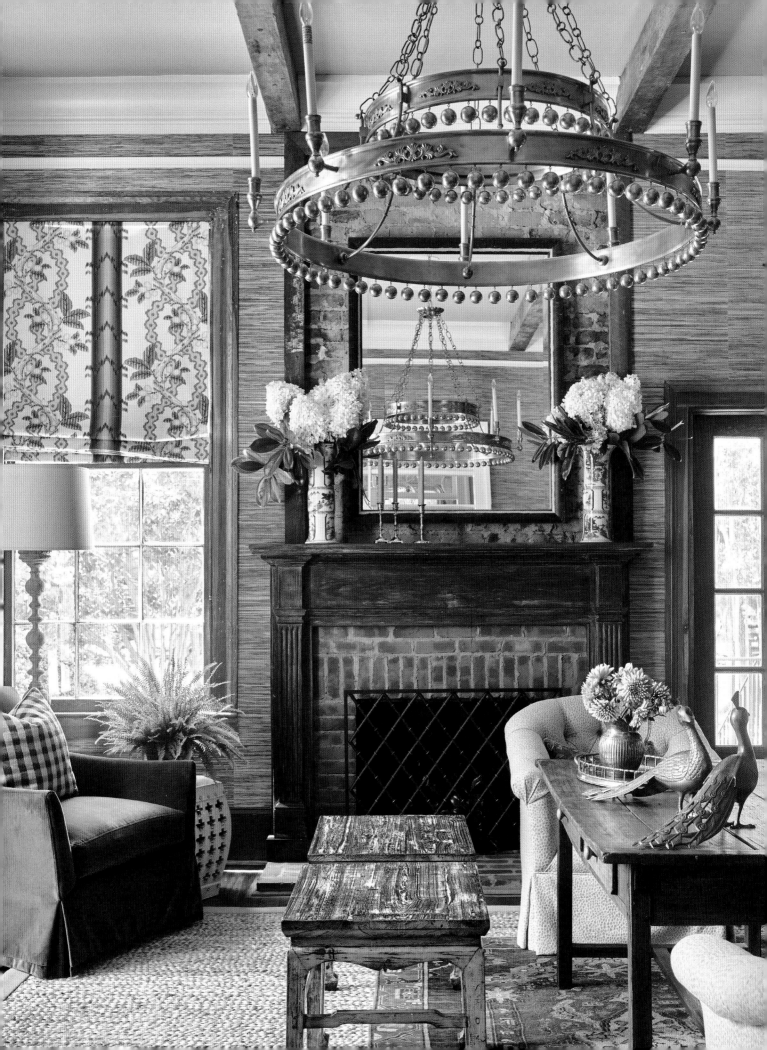

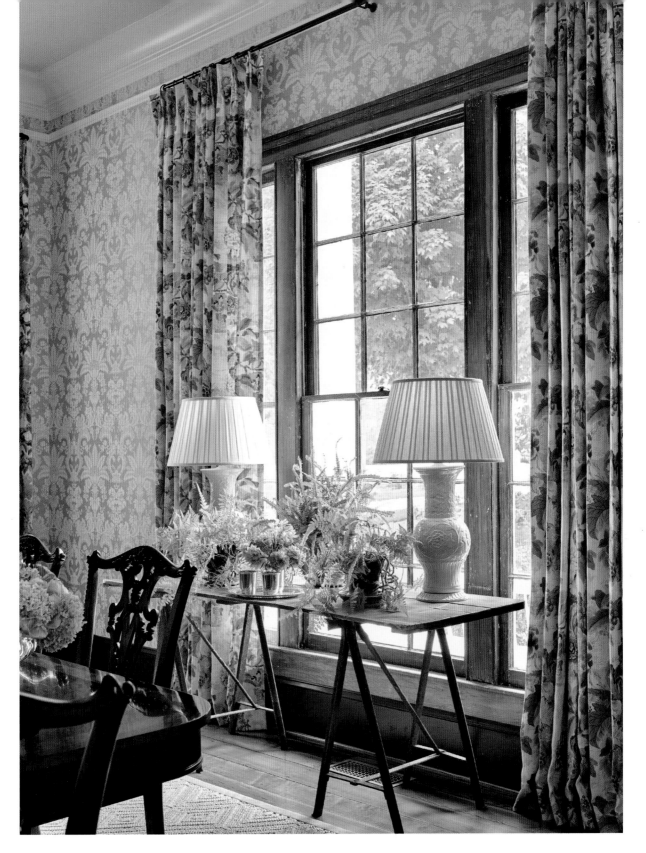

FACING: A classic Brunschwig and Fils floral and vine motif dresses the windows and was our inspiration fabric for the room's color scheme. I love starting with a fabric or rug for inspiration and working that thread of color throughout the room or home.

ABOVE: The tonal hues of the damask on the dining room walls allow for another contemporary twist on tradition: a hand-blocked Lee Jofa linen for the windows in salmons, corals, greens and neutrals rather than a fussy, expected silk. A sisal and wool rug keeps the room grounded and more simple.

The formal dining room and the modernized kitchen now are coupled on one side of the foyer, separated by a swinging door and new period-appropriate built-ins. A crystal chandelier brightens and contrasts with the sisal, linen and grasscloth.

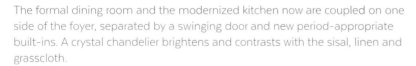

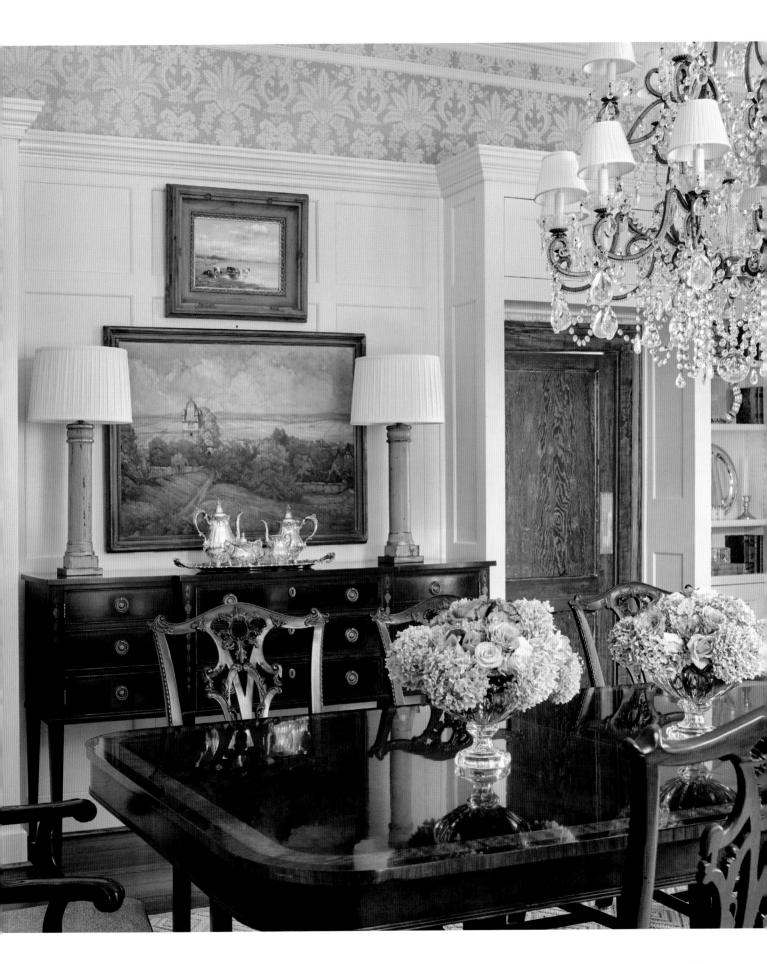

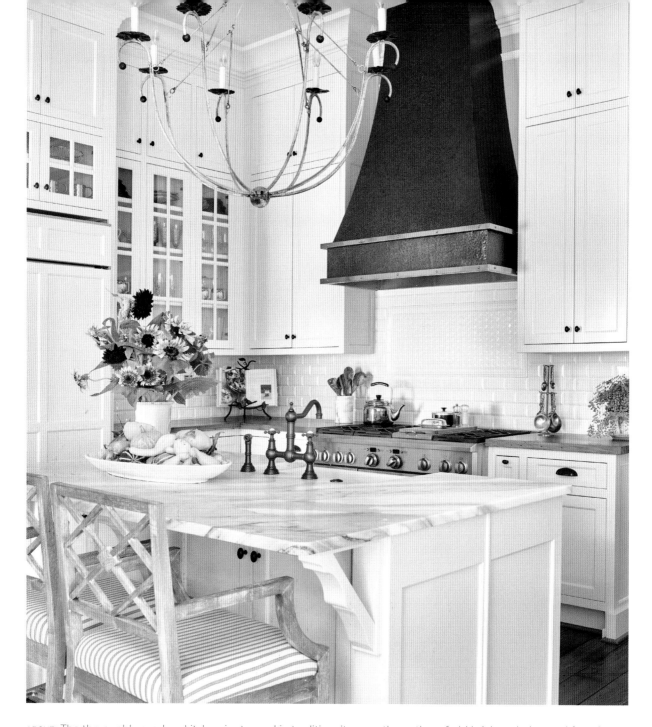

ABOVE: The thoroughly modern kitchen is steeped in tradition: it wears the patina of old brick and pine and functions perfectly fine for a Sunday dinner or morning coffee. Mixing metals with the hand-hammered copper hood, brass plumbing fixtures, a stainless steel range and a zinc light fixture breaks all the rules for matching and, rather, creates a cadence and rhythm within the room. Heart pine floors were the inspiration for heart pine butcher block-style perimeter countertops, while gold and pewter veins run through the Italian marble on the island. I love to bring outdoor elements inside—especially the Southern tradition of blue porch ceilings. Faint blue ceilings inside, rather than the bolder "Haint Blue" seen on antebellum and Victorian porches, is a subtle reminder of that tradition in a stylish approach.

FACING: On the exposed brick fireplace is an original acrylic oil painting created for the owners by artist Laura Dunn depicting the scene off the homeowner's dock from their lake house. The unframed canvas is a modern touch on ancient clay bricks—a perfect mix of high and low, old and new. A chunky, hand-hewn beam found under the house became the mantelpiece in the kitchen. As seen here and throughout the home, a century and a half of paint was removed to expose the gorgeous heart pine window mullions and casings. We kept many exterior windows and doors stripped down to the original heart pine and painted newer moldings and trim.

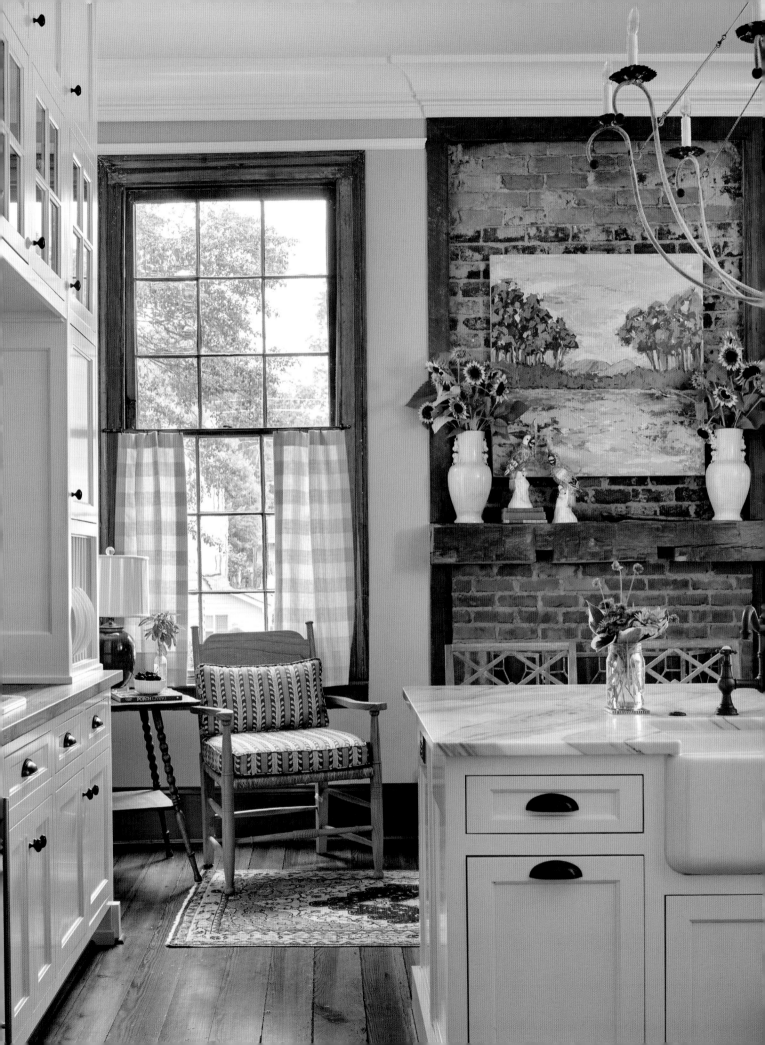

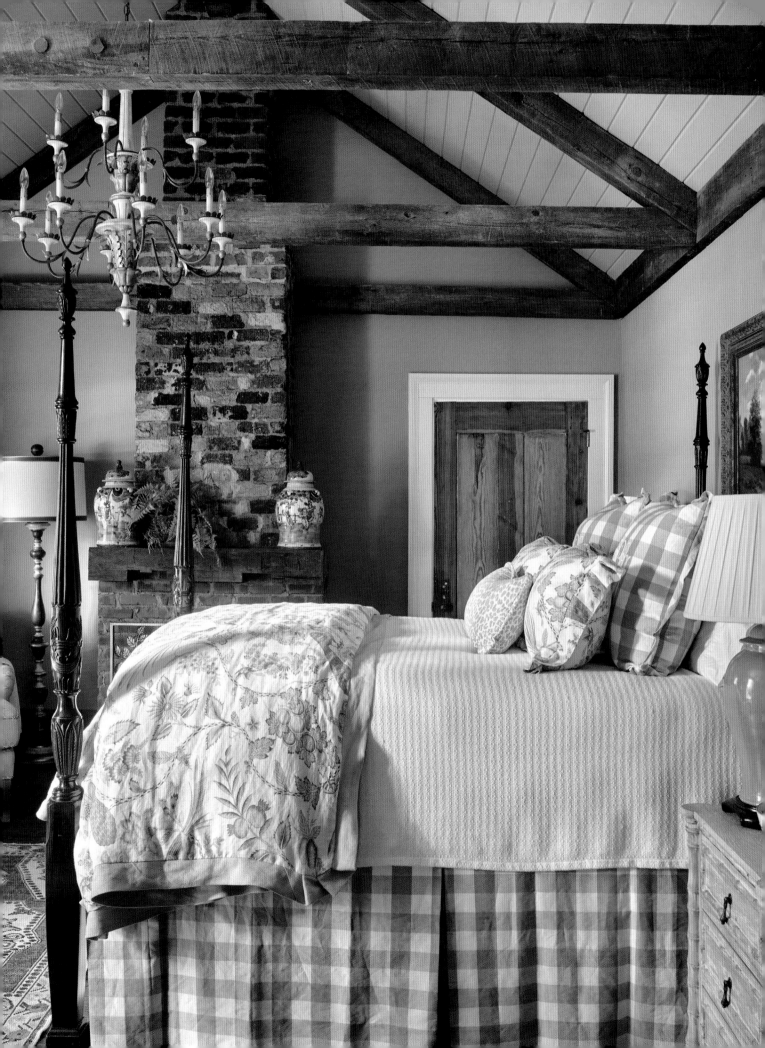

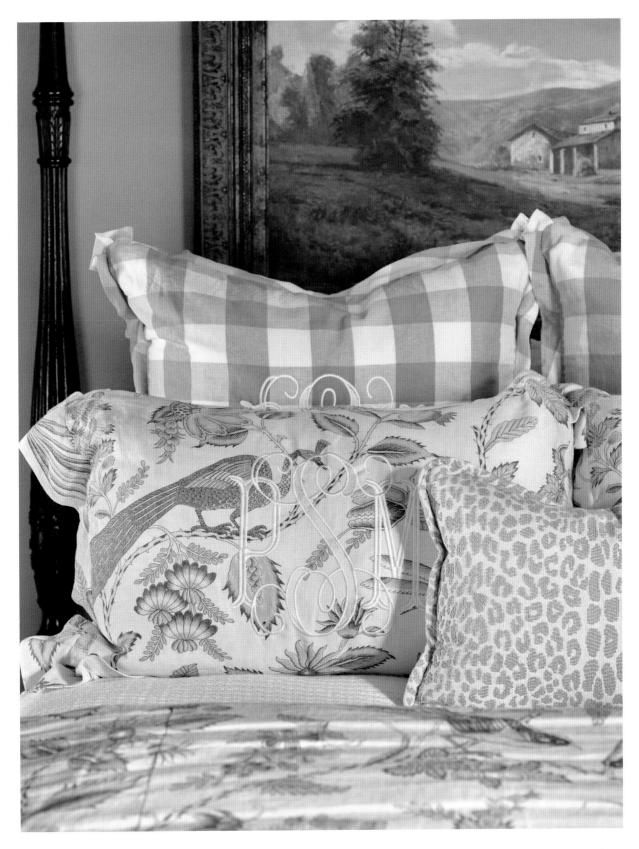

In the master bedroom, the original fireplace became the focal and the vaulted ceiling was accented with reclaimed beams. Just beyond the heart pine door is the new master bathroom. This door and two closet doors were the only "new" doors added to the home; older homes like this rarely lack in door quantities! Soft greens, dashes of citrine, monograms, plaid and a rice planter–style four-poster bed all blend together to create a tranquil room.

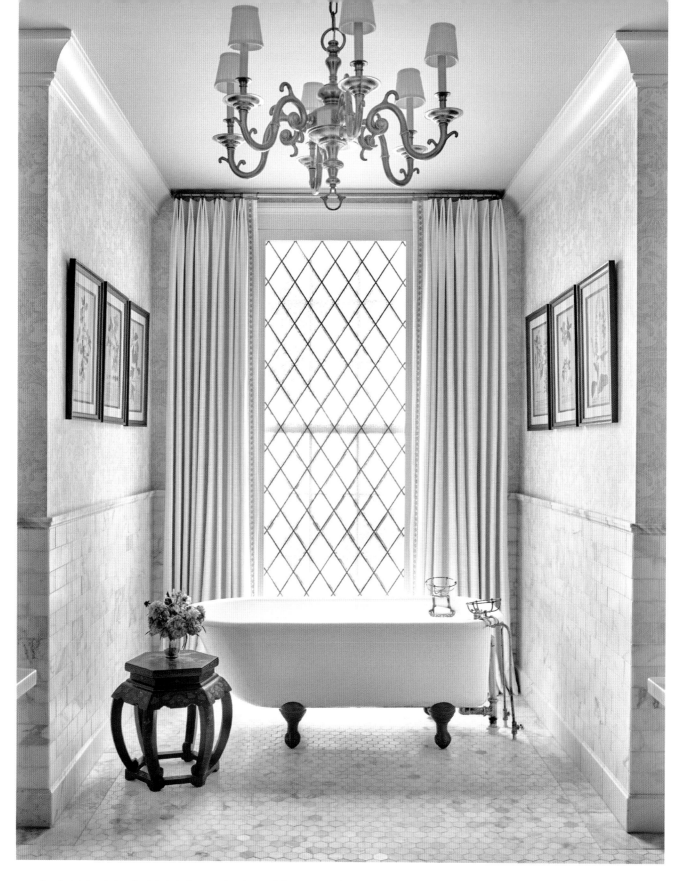

A refurbished clawfoot tub is the centerpiece of the room, with a leaded glass view into the garden and backyard. We love to treat master bathroom windows with outdoor fabrics so moisture does not prevent opening and closing the treatments. Gorgeous hand-tinted lithographs of flora framed and matted in soft gold tones contrast with the cool grays of the paper and marble.

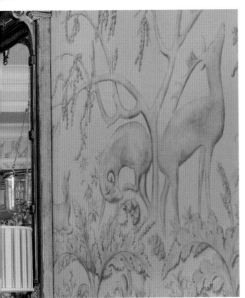

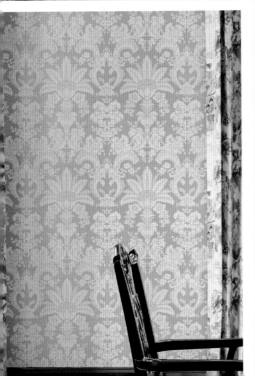

WALL
COVERINGS

Wallpaper has long been a signature of Southern style, a direct influence on our colonial roots and melting pot of cultures. Contemporary colorways of classic patterns and even printed on grasscloth give wallpaper freshness and a chic update.

I have two retorts to wallpaper and grasscloth comments from clients. Once a client's husband said he didn't like trendy things like grasscloth. I told him that when Cleopatra decorated her palace with it, it was a bit trendy, but since then it's remained a classic. The other, I use when a client says, "I see that wallpaper is back!" I reply, "It never left. Good wallpaper has always been *en vogue*—your old paper just happens to not be." Ha! Thus I have a job!"

A tone-on-tone chinoiserie Cole and Son paper in the bathroom covers the walls above the marble wainscoting and flooring.

Lewis and Wood, a British company known for their modern take on classic paper patterns, helped my design team create the perfect paper for the foyer with the a straw-tinted scene of deer, foliage and sky—an artistic interpretation of the Southern flora and fauna abounding nearby.

For the wall treatment in the dining room, I was inspired by classic damask patterns seen in England and the Old South, but I could not commit to their silk or shimmery or starkly formal applications and styles. Thibaut has reinterpreted some older patterns and printed them on grasscloth. This one is a fantastic balance to the great hall's wall treatment across the foyer.

Large terra-cotta pots bring the landscape onto the porch, while benches in a fresh coat of the updated porch ceiling color beckon folks to "sit a spell, y'all." A new garage and a guest apartment were constructed for additional friends and family, all treated in the same style of the main house.

For the exterior color scheme of the home, we went with a fresh take on a classic white house with large white columns. First off, we toned down the stark white with a softer touch of cream on the shutters and window trim. Benjamin Moore Clay Beige lifts the creamy hues from the body of the home and is a contemporary take on a white antebellum home. Typically, dark greenish black shutters would have been used but we wanted the original heart pine doors to "pop" and lead the eye toward the strong symmetry of the home and blend with the brick and cedar shakes. Nearly one-hundred-year-old photos show a grass path leading to the front door, bordered with boxwoods and perennials, so we kept that element. It is welcoming and unassuming.

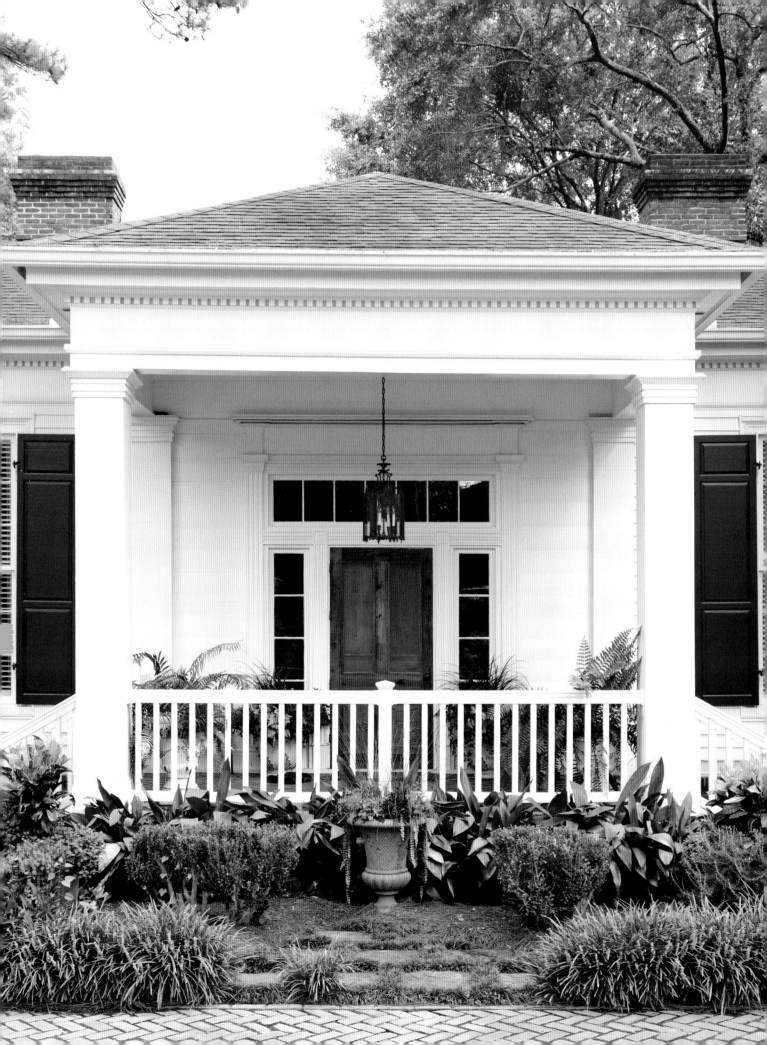

A Raised Cottage with Antebellum Roots

I was once asked what is my favorite tree. Unabashedly I answered, "The longleaf pine. I love the ecosystem they create, their growth habit and different stages of maturity. I love where they grow in particularly—the Deep South—and their lumber is unparalleled." I felt proud of my answer.

The questioner said, "Huh. Didn't realize there were different kinds of pine trees." My audible gasp may have offended that person, but my love for heart pine lumber, longleaf stands, and the intertwined history in Southern design is undeniable in my repertoire.

Longleaf pines begin their native growing territory in my part of Georgia. They are found in parts of Middle Georgia and flourish the farther south one travels. I have always been so proud that my neck of the woods is the gateway into South Georgia—rich farmland of row crops, yes, but in trees. Pines, pecans, peaches and dotted with native live oaks dripping with Spanish moss—nostalgically Southern landscape. My heart nearly skips a beat when an antebellum white house is set within this sort of scene. Orchards of peaches and groves of pecans line miles of red dirt roads, and then, akin to a precious egg within a well-placed nest, a home appears—an accent out of the reds

From the outside, simple dentil molding, transom and sidelights, and boxy, tailored portico evokes the basics of Greek revival and restraint of the Southern bucolic vernacular. A heart pine door has greeted guests and ushered in the family like a stalwart since day one. Dark black green shutters, white clapboard and old brick are a classic trio for the color scheme. An iron and glass lantern once would have been gas lit—electrified now but original nonetheless.

and greens and bark-hued colors of the land. This is the approach one finds when visiting Evanglen—the home of my clients.

Set within a glade of longleaf pines deep inside a farm with miles of peaches and pecans rests one of my favorite homes in my area. I may be biased, since the homeowners and their children are dear friends. A home where I attended birthday parties as a child becomes a design project after college—a thread of personal history woven with professional history too. This home even originally sat on another piece of the farm and was rolled to this location almost a century after its construction. Drifts of hydrangeas, azaleas and abelia abound. Clusters of pines, crepe myrtles and massive hollies cloak the home. This home has been the setting for weddings and parties, and through the trees and even upon first pulling into the motor court, the house seems to be a simple raised cottage. Yet in perfect antebellum architectural prowess, the scale upon entering the home wows its visitors and creates a perfect backdrop for antiques and furnishings.

Heirloom pieces such as the sideboard, chairs, and clock add generational fortitude to the foyer. Clippings from the yard and garden fill some of the antique blue and white pieces.

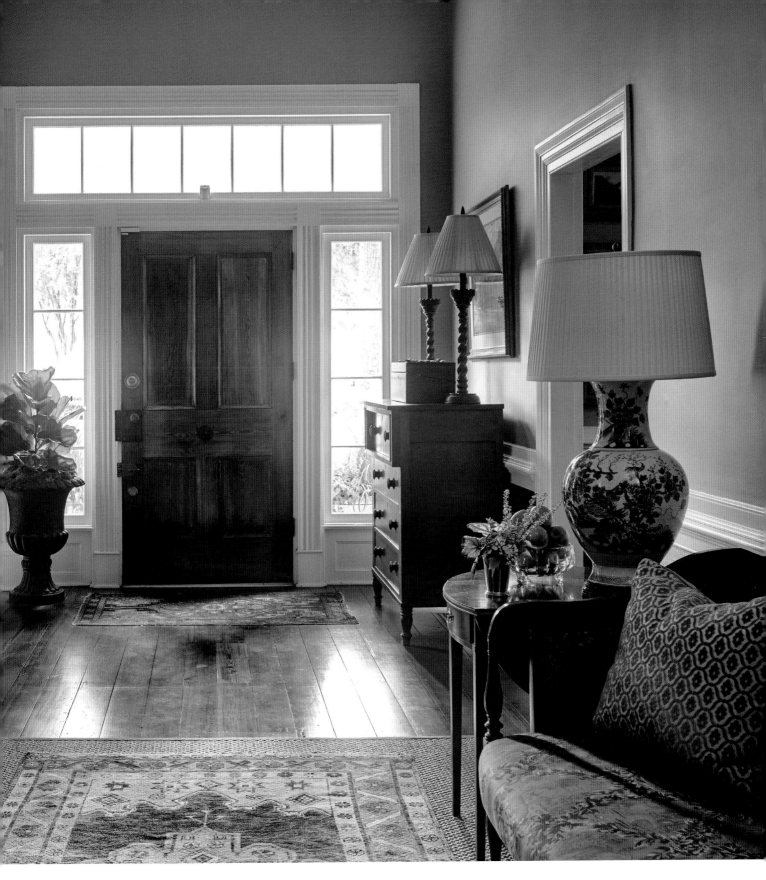

What I love about this home is the scale and unapologetic use of wide planked heart pine for floors, ceilings and walls that the original builders installed. Those walls not planked in pine are tall and plastered. The light coming in from the tall transom above the door looks magical down the long center hallway. A mushroom-hued greenish gray paint allows the heart pine to really shine, while accents of reds and blues add richness and classic Southern style. Layers of Oushak rugs with sisal create visual breaks in the strong axis of this space.

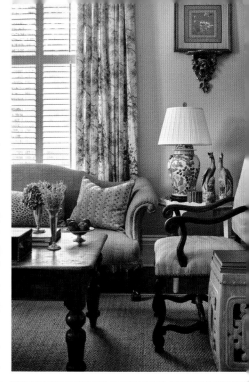

MODERNIZING HISTORIC ROOMS

The floor plan of this home is not unique to Southern cottages and mansions alike. A long, wide center hall, four rooms off the hall (parlors, study and dining room) and expanded wings for more family with bedrooms off the sides and back is a pretty standard arrangement for this style of home. When a home has two stories, then the rooms above are bedrooms as well.

One design challenge when decorating older, historically planned homes, is to not make formal rooms too stuffy, fancy or uncomfortable. For the front parlors of this home, we took a cue from the historic ladies and gentlemen segregated parlors, making one room a touch more masculine and the other a tad daintier. Yet nothing in the masculine room is too sacred or precious to prevent anyone from enjoying it for reading, a piano concert, a cigar or delightful conversation.

For the ladies parlor—a modern-day formal living room, really—we placed the baby grand with its curved side out and keyboard perpendicular to the wall. This exposes the "sexy" curve of the piano. A Schumacher hand-blocked and colored linen depicting quail dresses the windows—a masculine scene with feminine colors for a Southern-style mix. Pops of aqua in contemporary art, upholstery and garden stools adds pizzazz alongside the blue and white and antique porcelains displayed in the breakfront and around the room.

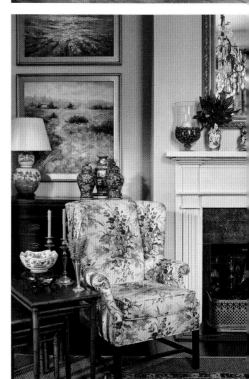

The seagrass rug covering the floor is accented with a smaller Oushak that pulls out the handsome colors in the window fabric and wing chair, while the coffee table warms the space and keeps it from being too delicate of a room. The chandelier is from New Orleans—a Southern tradition I love of "finding a chandelier in New Orleans." This one is not original to the home, but I made sure it was of the same time period. Glass and crystal hurricanes are filled with polished Southern pecans—a Canadian market-demand cash crop.

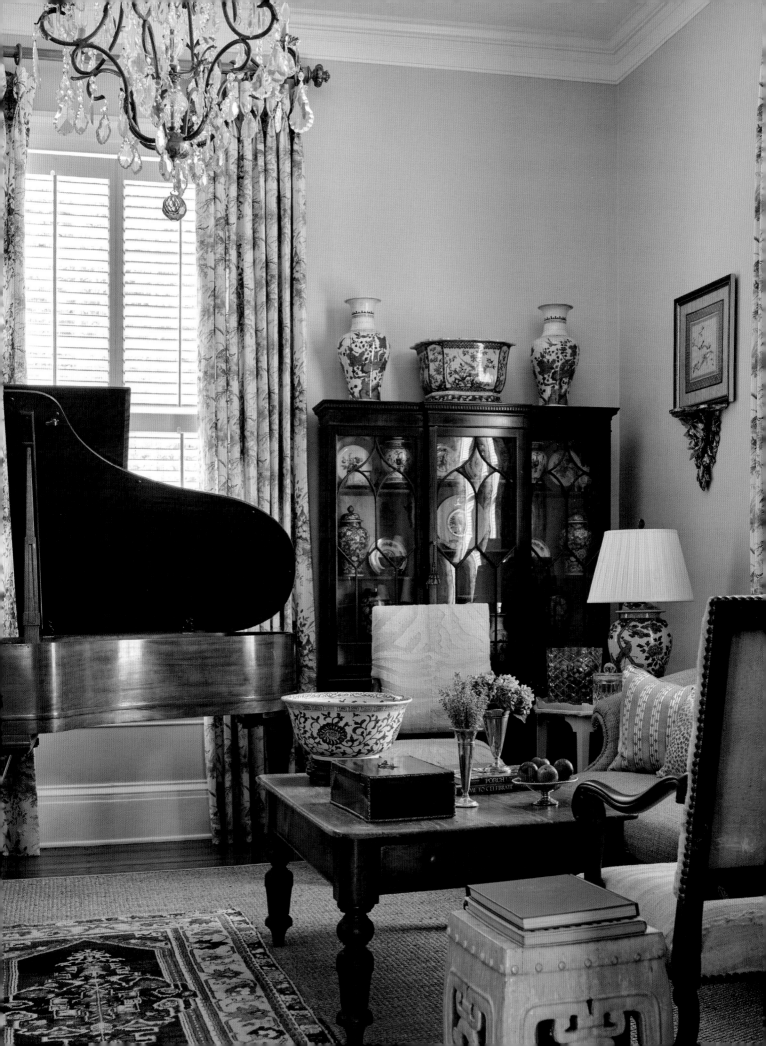

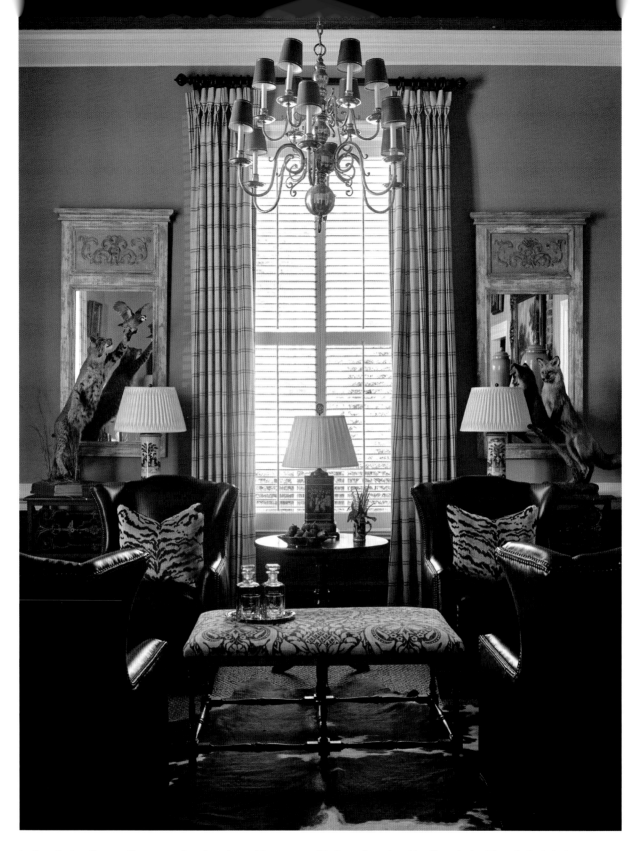

In the study—the gentlemen parlor—I anchored the room with four vibrant red leather chairs. The chair style is a contemporary version of a classic wingback, the foursome creating a central seating area ripe for sipping whisky and smoking cigars. Scalamandré "Le Tigre" is the perfect lumbar pillow to sink into while relaxing in this handsome room. The original fireplace bricks stripped of their plaster along with the deep honey and reddish hues of the heart pine wainscoting and mantel were the inspiration for the leather chairs. Mounts of prized taxidermy abound in the room, as is apropos in any Southern gentleman's study. A patterned terra-cotta-toned Schumacher linen tops the ottoman and adds a lighter note in a room filled with heavier elements.

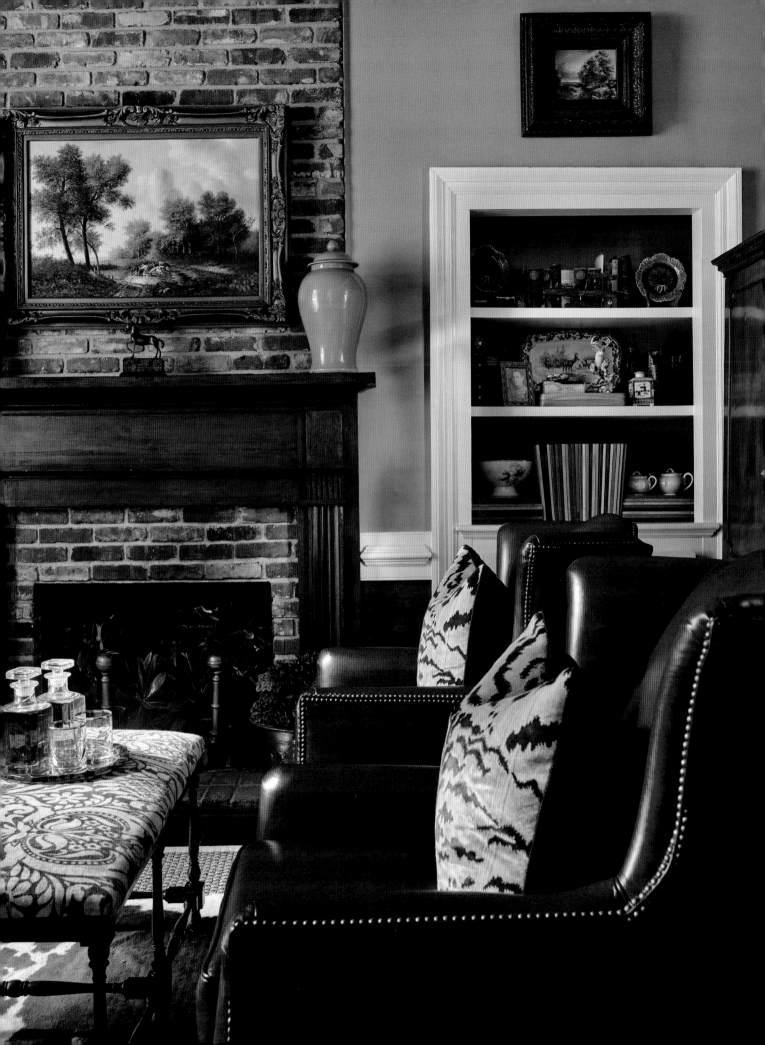

ABOVE: The original back of the house is now the wall that separates the kitchen from the dining room. It is solid heart pine from floor to ceiling. I love a staircase in a kitchen—it evokes memories of children in socked feet and pajamas bebopping down for a pancake breakfast. Though this kitchen had been updated, it is not brand new. The original, of course, was detached; this space and the adjacent great room were added after the home was moved. A set of antique bird prints framed in burled wood and grasscloth mats depict Southern and East Coast birds. The mix of higher formal style, though toned down with the glimpse of the dining room from the heart pine–clad kitchen, is a favorite of mine.

FACING: In the dining room, the original crystal chandelier (or at least the one that has been there for as long as anyone in the family can recall) is toned down in its formality with a woven-pattern grasscloth wall treatment, which along with the antique brick fireplace surround tones down the higher polish of the table and chairs. A couple of antique sideboards flank the fireplace and its painted chinoiserie mirror, while a pair of antique hurricanes flank either side of the mantel. Blue and white temple jars turned into lamps, jardinières and antique delft tiles on the mantelpiece carry the blue and white accent theme in from the foyer. A more casual Blue Willow pattern appears in the kitchen and back hallway. An Oushak rug with a lighter field of blues and creams and pops of coral, red and sage helps set the color scheme for the adjoining kitchen.

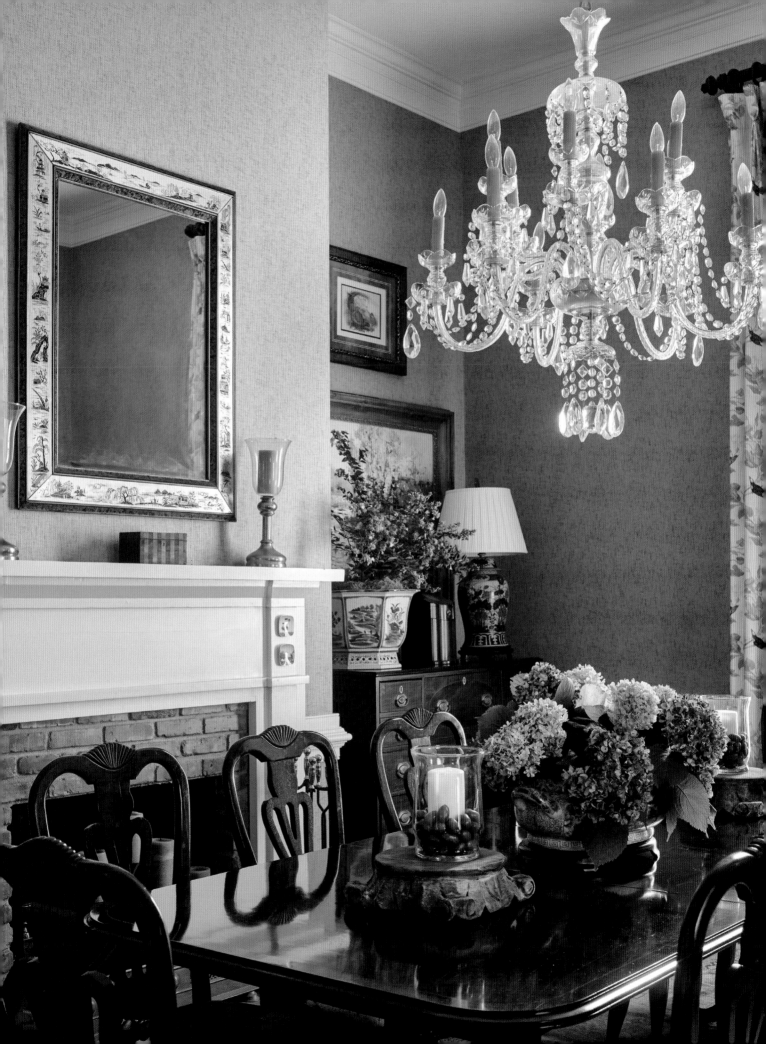

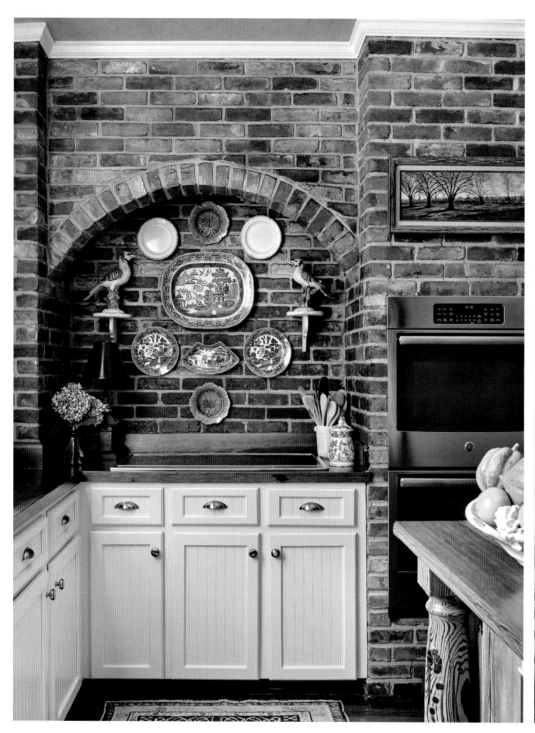
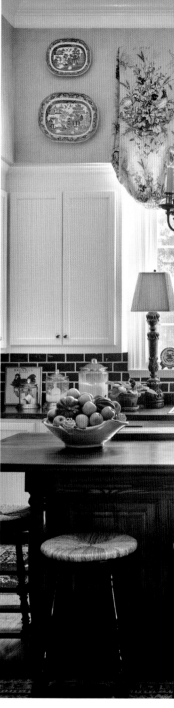

LEFT: Antique bricks were used in the kitchen to create the cooking and baking hearth wall and niche. Shaker-style bead board cabinets and pewter cup pulls meld with the stainless appliances. A display of Blue Willow, majolica and feathered-edge plates is guarded by a pair of midcentury Italian birds on brackets. In a plate hanging, I like to incorporate brackets, sconces or shelves for added dimension. Heart pine was used on the floors and countertops.

CENTER: Red tribal patterned runners parallel the heart pine island, and a scattering of rush-topped stools flow perpendicularly around the island—a perfect perch for grandkids to help with dinner prep. For the kitchen sink wall, we used a glazed green "brick" in keeping with the brick style of the historic cooking hearth. Scalamandré "Edwin's Covey" is a standard in Southern décor, here used as a valance for added height in this space. Large Blue Willow platters stand as sentries posted on either side of the valance. A brass chandelier used formerly in another part of the home was added over the island; its warm glow fits with the classic, faint trellis-pattern wallpaper.

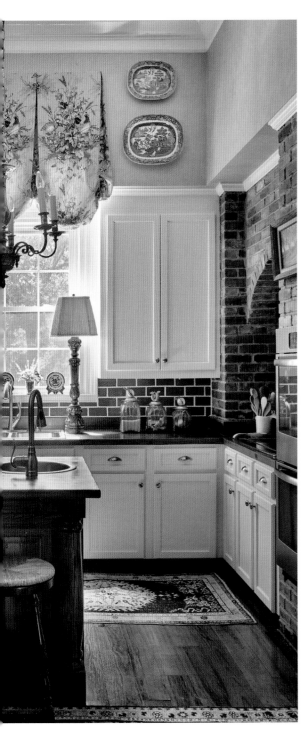

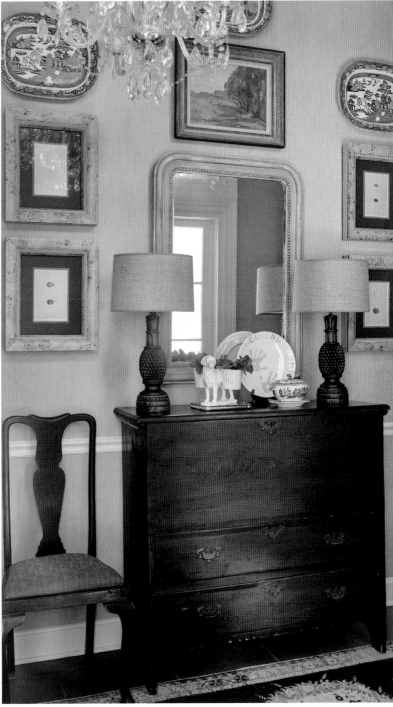

RIGHT: The back door leading from the back porch into the kitchen gallery frames a scene of treasures. A blanket chest long held in the family serves as the welcoming standard in this space, which is lit by a crystal chandelier. One of the gracious sidelights of the back door is seen in the provincial Louis Philippe mirror, which serves as a focal point over the blanket chest and is flanked by egg prints, Blue Willow platters and an antique oil painting. A pair of antique carved pineapple lamps say "welcome," as the symbol has done for centuries. A runner with the same tribal patterns and color veins runs across the old slate floor. I firmly believe that entryways should be jam packed with things you love to usher you into a welcoming, recognizable place.

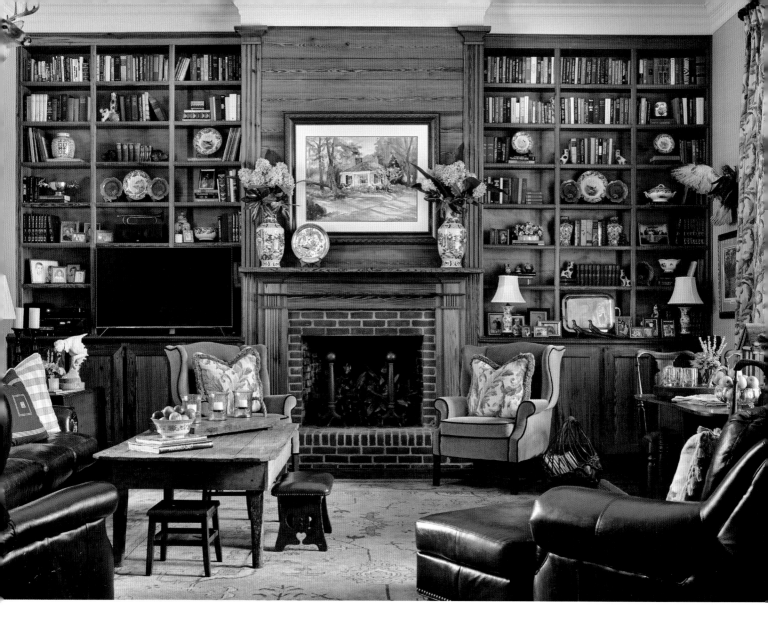

ABOVE: The great room in this home is the most modern addition to the home. It was constructed to accommodate a growing family of children, which in turn became a growing family of grandchildren. Keeping the home's historical nature and provenance in check, reclaimed heart pine was used for the mantelpiece, shelving and floors. Family photographs, books, and collected accessories fill the shelves. A pair of large blue and white vases proudly boasts seasonal greenery and garden blossoms. A watercolor rendering of the home holds a prominent place over the mantel—it was painted by Georgia artist Phoebe DeVaughn.

Deep, comfortable leather seating is arranged in this room for watching television and conversation too. Good leather will last for decades, and like shoes, handbags and gloves, well-made leather furniture gets better with age. We love to use leather in dens, family rooms and studies for the buttery aesthetic and warmth it creates and for the elegant way it ages. Our other go to deep seating fabric is velvet—especially a strié velvet. The "hand" or texture and weight of the fabric is so strong and lasts for years.

FACING: An arabesque scrolling pattern from Schumacher dresses the windows and sets the tone for the room's aesthetic. Soft greens, golds, browns and pops of blue and white are carried throughout the room, and a playful array of patterns finds its way onto the sofa with stripes, buffalo check and an animal-print throw. The use of waxed heart pine window components, antique side and coffee tables and ample pillows, soft textures and familial objects makes the room a haven for relaxation and enjoyment. Every home needs a family room—that one room where the folks in the house can be a family at home.

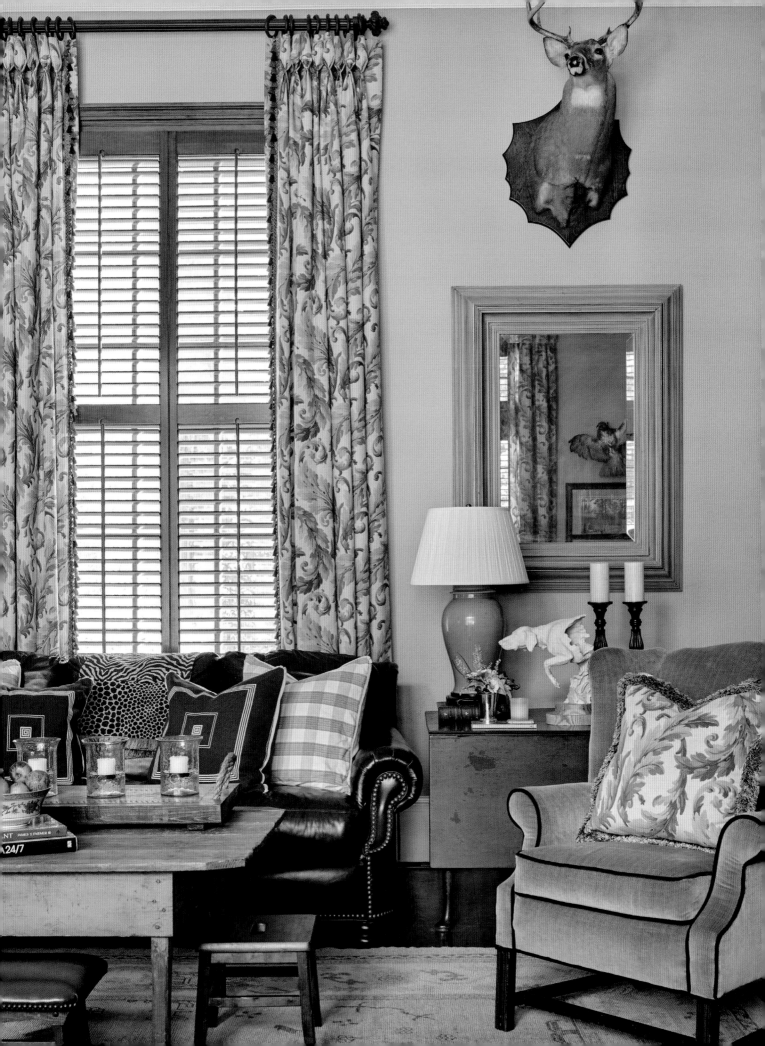

Porches are the hybrid of home and garden spaces—and Southern porches hold high regard in sentimentality and, before air-conditioning, functionality. The original back porch of this home would have been a true breezeway to connect the main house to the detached kitchen. Today, a gracious outdoor room hosts comfortable seating and dining space for overflow seating and entertaining. My friends who grew up here said that the kids' table at Thanksgiving was always out there, but once I got a hold of the porch, it's now the head table and VIP seating!

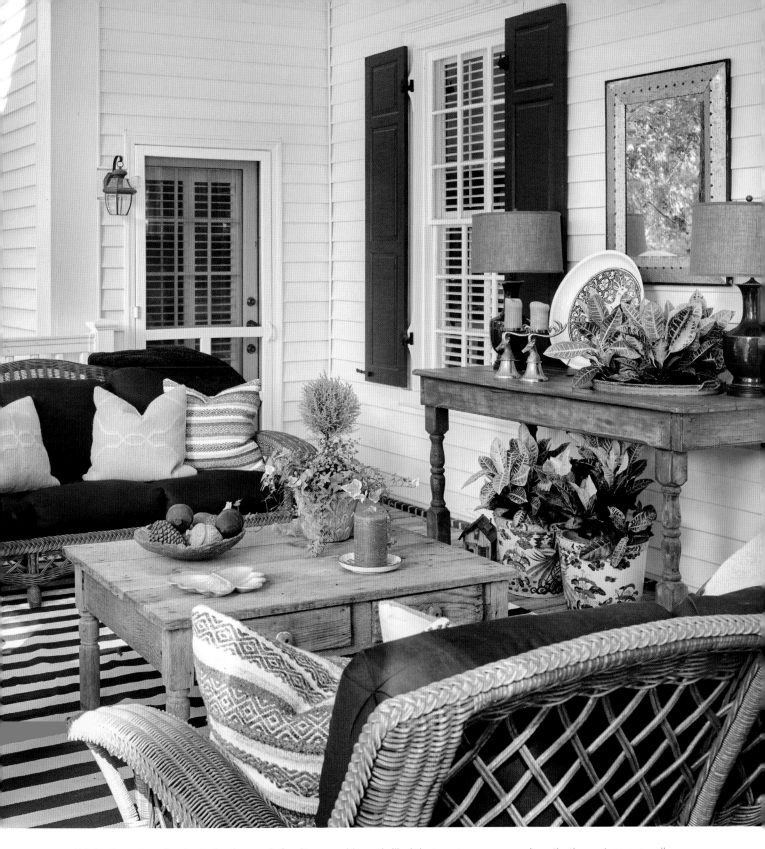

Wicker is such a classic choice for porch furniture, and I am thrilled that contemporary and synthetic versions are well suited for outdoor spaces and longevity of use. The Southern environment can be hard on some materials, while some others age gracefully. I love to mix wicker, rattan, bamboo and wood, like teak, for outdoor spaces. Here on the back porch at Evanglen, deep-seat sofas in Sunbrella navy fabric are dotted with plump pillows making cushy nests. Once summer's fever breaks, Southerners can be found on their porches morning, noon and night! Seasonal color and greenery links the garden element to the space. Lamps, rugs and garden stools add creature comforts from indoors to the porch.

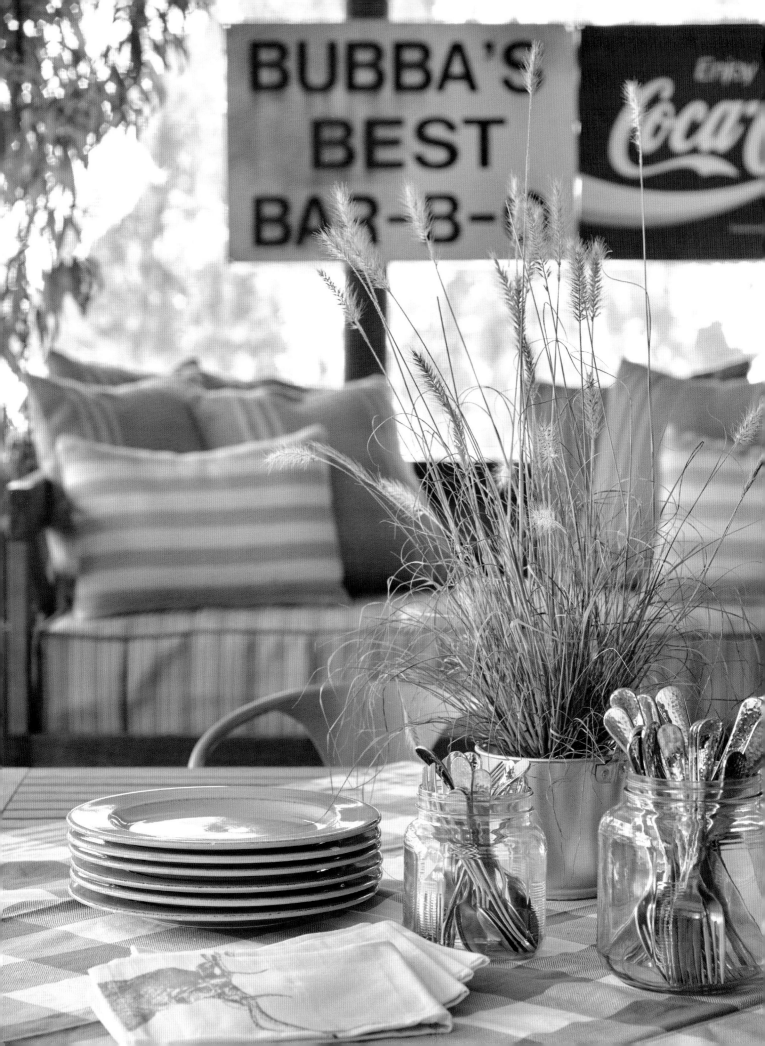

Whispering Oaks Camp House

When a good buddy of mine showed me the property he and his wife purchased to build their future home, I was immediately enthralled with the ancient oaks, stands of pines and entrance allée the previous owner had planted. The land spoke for itself—natural and beautiful with plenty of room to cultivate and plant, create a pond and build a lovely home. Plus, the land is not far from my home, so that meant my friends would soon be my neighbors!

Towards the back end of the property, a one-room "camp house" stood half built—unfinished and nearly neglected. There was a screened-in porch, a summer kitchen/smokehouse, kitchen and bathroom. All it needed was to be brought together. My buddy handed me the task to make this cabin into a jewel box of a destination where he and his wife could escape for the weekend or where visiting hunters could stay. Deer, turkey and dove abound on the property, and my friend's list of hunting buddies started a waiting list to be guests at the Whispering Oaks Camp House.

My design team took a slightly different approach with the aesthetic of this wood cabin with wood floors and walls set in the middle of the woods. Just as nature cloaks its bark in leaves, we took the same theme for this design. Greens in shades of oak leaves, pine needles and field grasses became the color palette for the cabin. For pattern and texture, we emphasized the vertical wainscoting and painted the horizontal shiplap walls inside.

A vintage Coca-Cola sign, a table set for a porch dinner and a bedswing bring the comforts of inside to the outdoors. A porch is the hybrid between home and garden, the perfect extension of the home.

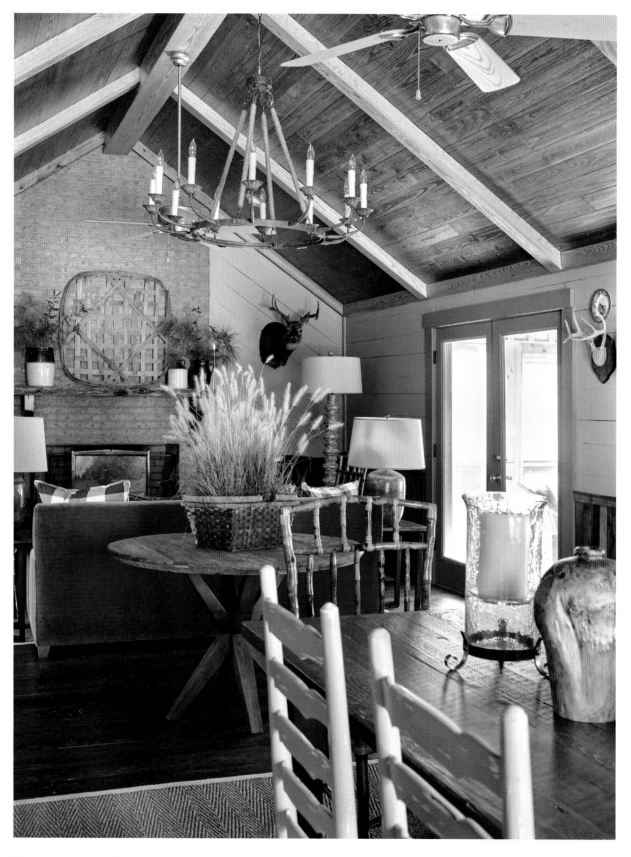

We divided the one long room into three spaces—entry, living and dining. The entry table, of course, serving as additional dining space. Extra seating for a half dozen folks can be pulled up to the round table. For the gabled ends of the room, the shiplap was run diagonally for interest and rhythm.

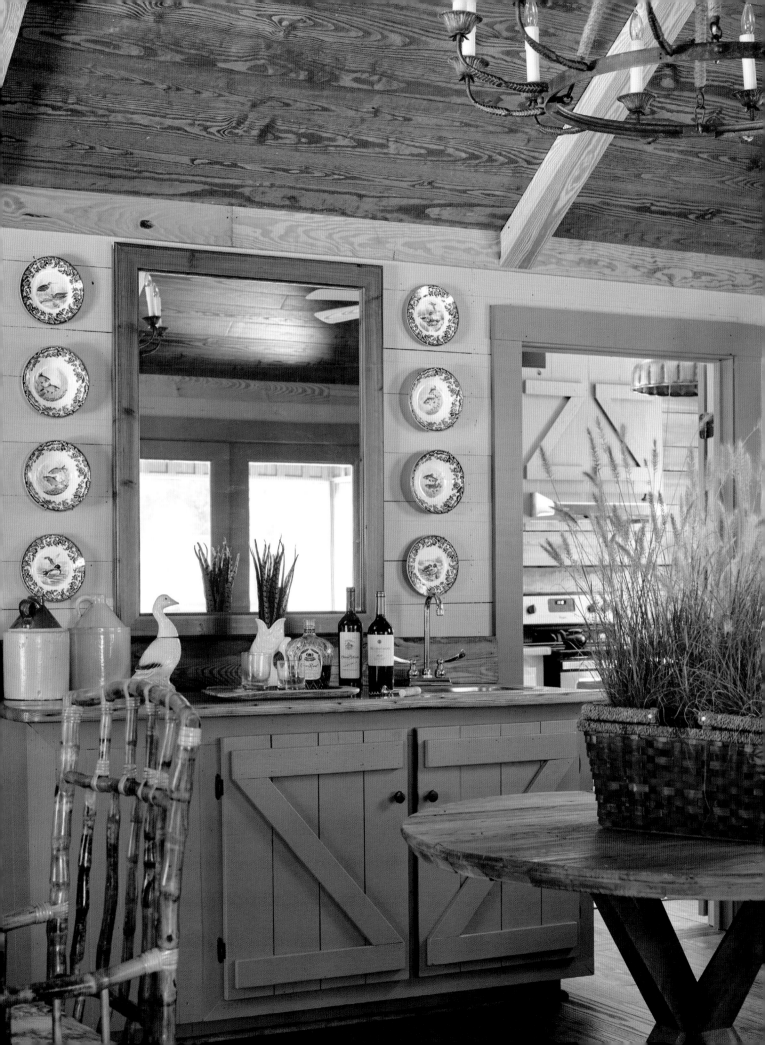

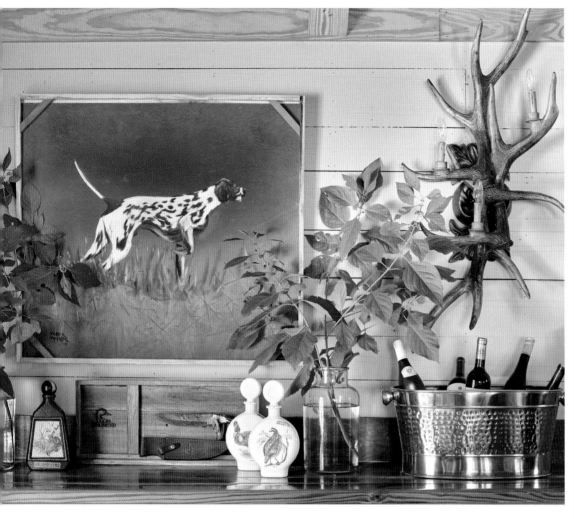

ABOVE: Along the dining end of the room, a long built-in bar with a heart pine countertop ensures spirits will be high and provides ample space for the feasts cooked and served in this house. The homeowner is an avid hunter and chef who serves wild game dinners paired with elegant wine vintages. It is truly a treat to be invited to dine at this table—especially at the cabin! A contemporary take on an English style dog painting by Georgia-born artist Derek Taylor presides over the bar and dining sideboard.

RIGHT: Leather, wood and bamboo chairs gave the room plenty of seating for comfort and mobility, for the bed is an old-fashioned sofa bed to pull out for overnight lodging. Trophy mounts adorn the room, and nods to the homeowner's agricultural heritage abound too, with the tobacco basket as mantel art. Antique crockery holds pine branches.

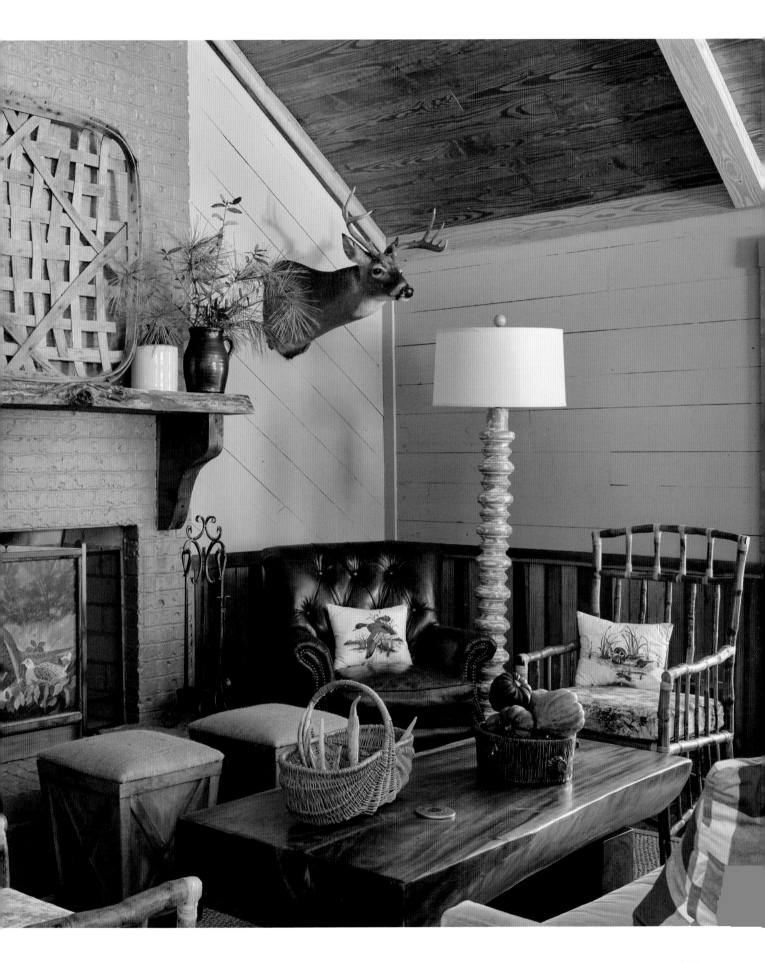

Whispering Oaks Camp House | 127

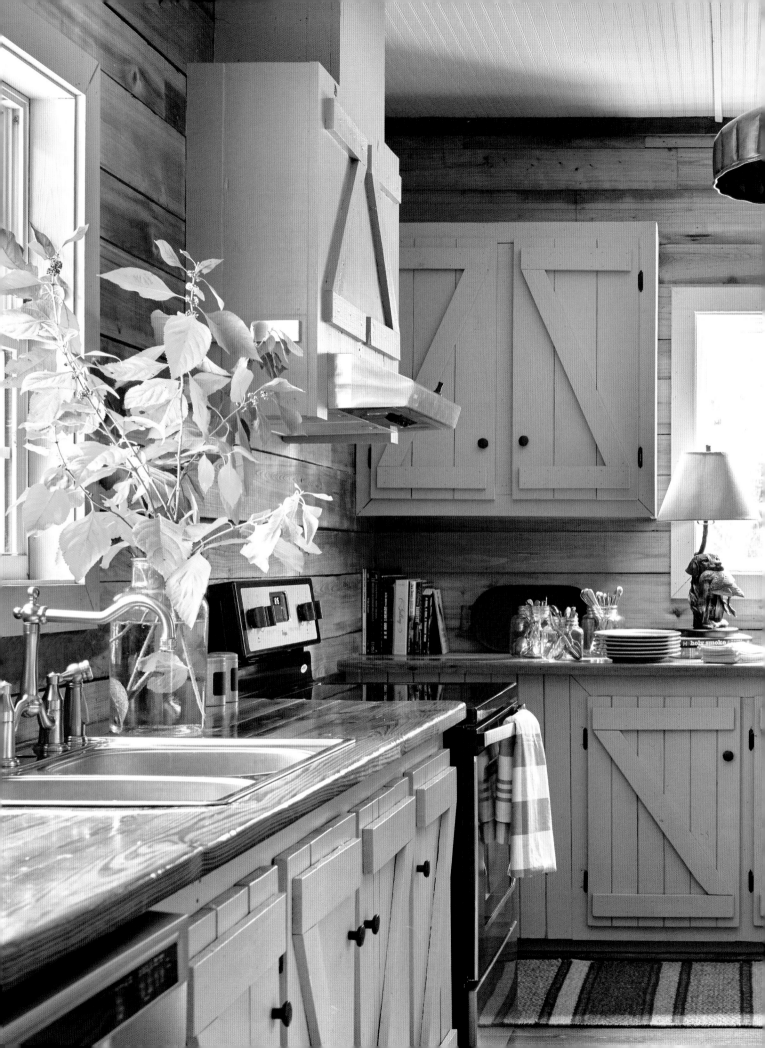

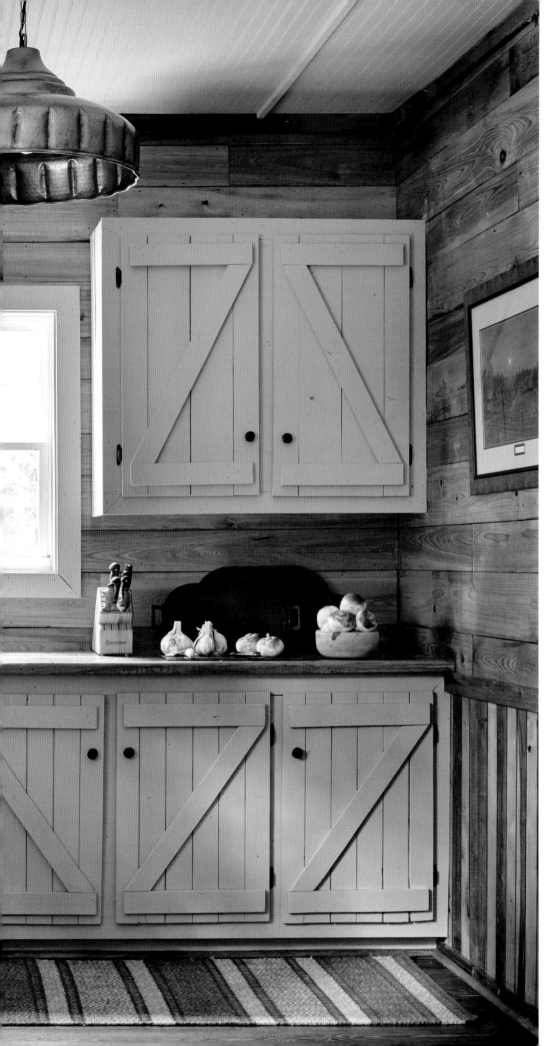

The kitchen became a fun space to design. Hardy Z-pattern cabinet doors created some architecture in the room, and their sage green finish blends handsomely with the pine walls and countertops. Beadboard, which is often used on porch ceilings, was used on the ceiling, while industrial barn lighting floods the room. Cast iron and Dutch ovens are used quite a bit in this kitchen and make for perfect utilitarian accessories too. One counter in the kitchen is for serving and/or prep and the other for cooking.

129

The porch runs across the front of the cabin and is the outdoor version of the large room inside. It has a swing bed for lounging and cat napping, a dining table for eating and entertaining, and on the other end, a Ping-Pong table and TV. The bed swing, from Low Country Originals, is a true twin bed size and is a great place to lull to sleep on a fall evening. The vintage Coca-Cola sign is a favorite find of mine on my forays into antique malls across the South. I saw it and knew exactly where it needed to hold prominence.

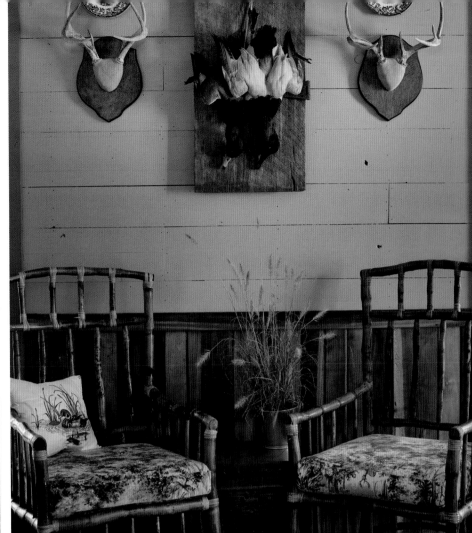

Southerners have long had camp houses, pond houses, river houses, bay houses, mountain escapes, deer and fish camps as escapes for recreational hunting and fishing. What I love about many of the camp houses I've been to is that they are not far from one's primary residence. The idea of being able to escape, recharge and relax but not drive hours to get there is very appealing. Whispering Oaks Camp House has already hosted its fair share of football games, dinners with friends and hunting parties, as it will for years to come. I'm thankful for clients who allow me to flex my creative prowess, but even more thankful for friends with camp houses who invite me over for dinner!

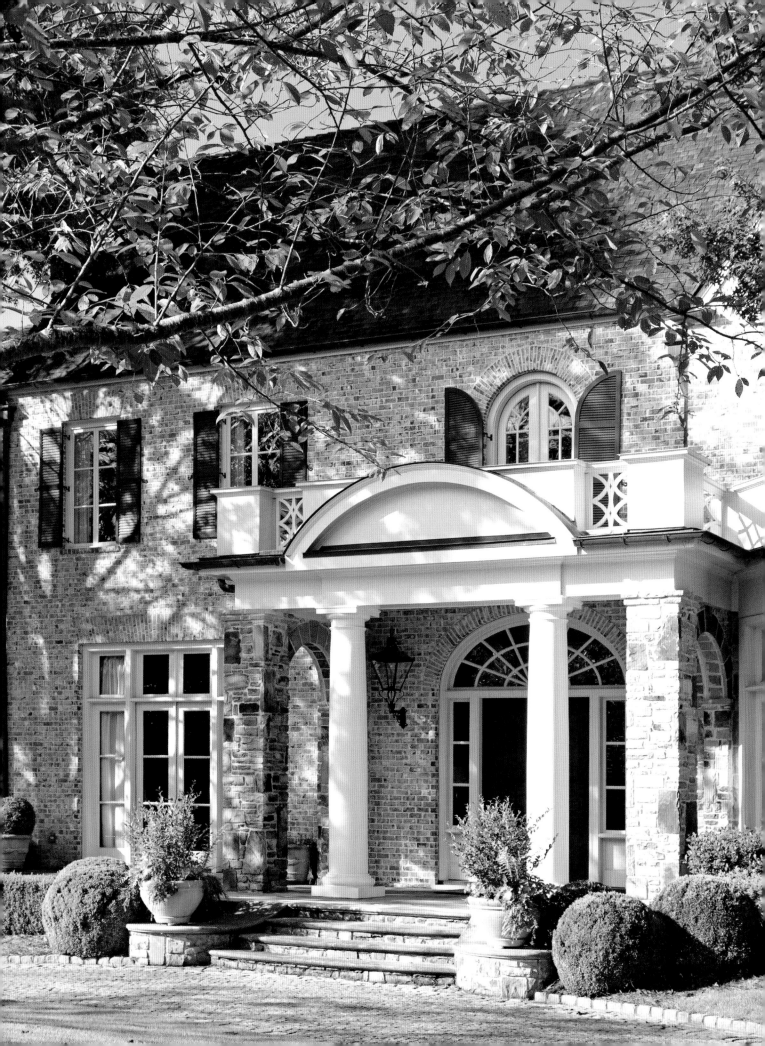

Best of Town and Country

I firmly believe that the best gift a client can give an interior designer is calling a fantastic architect first. An interior designer's job often starts with addressing a problem that exists in a home and solving it with furniture placement, space planning, color schemes and even complete and total construction overhauls. This is why being invited to work on a home that has a fabulous architect and their team is a divine blessing! Enter the firm of Spitzmiller and Norris. Now, I may be biased, since they designed my home, but working with them and in homes they have drawn made that decision even easier and pleasant. For clients just outside of Atlanta proper, with family land running along the Chattahoochee River, Spitzmiller and Norris designed a rambling English hunt country-style home with Southern vernacular elements and signature style. A mix of stone and wood, brick and cedar shakes, this home is tucked into a piece of the land with trees framing vistas and drives and the lake. The clients built this house as a young couple and decorated and furnished the home with gorgeous antiques and classic elements.

With the initial assistance of Don Easterling, the young couple made wise investments in forever pieces, such as Chinese porcelains, English and French furniture, art and antiques and silver from

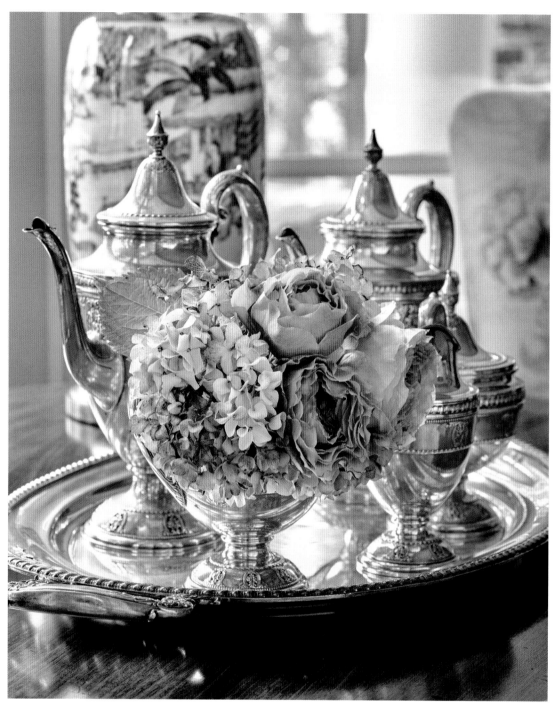

the esteemed Atlanta silver shop Beverly Bremer. Mr. Easterling's prowess for fine antiques and art has established him a respected name in Atlanta. So, years later, when the time came for some renovations and redecorating for this home to suit the family's needs, lifestyle and tastes, my design team simply inherited the best scenario any designer could inherit: flawless

pieces, great art and phenomenal architecture all in one home. The challenge, then, became of just how to guild the lily and make this showcase of a house into a warm, intimate home.

As with most of my projects, the clients are friends of mine, and I already had some idea of how they lived in and used their home. I quickly realized that it

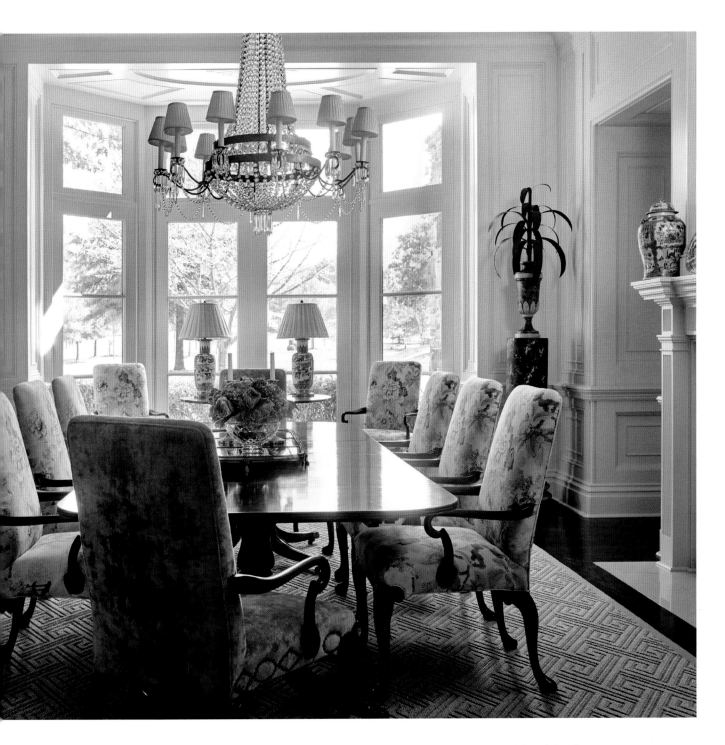

Dining rooms are probably my favorite rooms to design and decorate. I love setting a table, adding flowers to a room and displaying silver. Though dining rooms are very formulaic—table, chairs, sideboard, etc.—they do not have to be boring or expected. Beautiful antiques with deep, rich patinas needed fresh accoutrements in this room. Heavy window dressings hid the gorgeous bay window's trim and details, while silk made the chairs too sacred for sitting. I love mixing chair styles and upholstery. A Lee Jofa velvet with handsome nail head trim in a fresh pattern now anchors either end of the table, while Lee Jofa "Chinese Lantern" covers the side chairs—creating pattern and rhythm around the table and accentuating the color and cadence of the fabulous antique coromandel screen. Crisp accents of blue and white Canton ware and Chinese export china pop against freshly painted walls. A sisal and wool rug grounds the floor and keeps the space fresh and chic but classically rooted with a Greek key pattern.

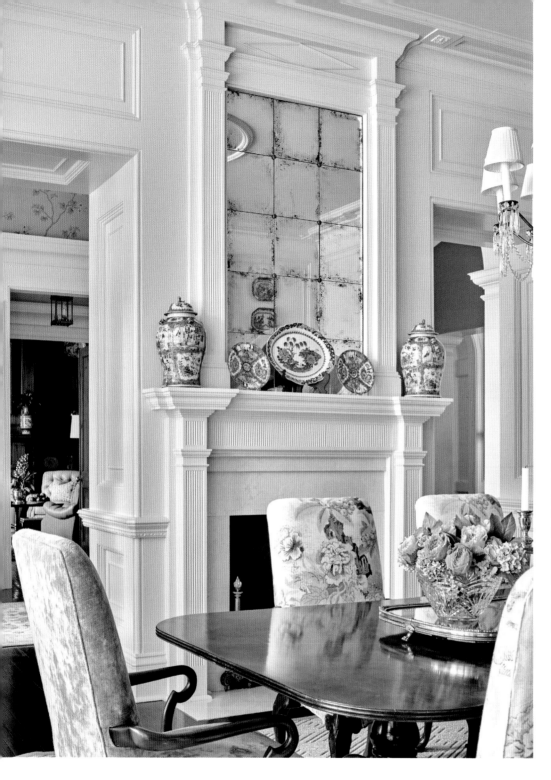

Blue and white china is so neutral, in my opinion, that mixing it with other styles and colors creates gorgeous harmony within a room or tablescape. Pulling from the soft peaches, salmons and greens in the chair fabric, rose medallion, or "Famille Rose," china adds another depth of color against the white wall. Peach and salmon roses in crystal bowls set on silver continue the color accent. In this room, classic and fresh, traditional and contemporary, old and new all pair together for truly grand and hospitable living.

was not square footage but room spacing and layout that could solve some of the family's lifestyle needs. The family felt cramped in the keeping room, and the dining room and study were never used. The TV was hard to view and the family found themselves sequestered in other parts of the house to watch television or piled atop one another around a dated built-in cabinet with limited seating and too small a screen. When

it comes to piling in and watching TV, carrying on conversations or simply all being together in the same room, my own family has made the state of leisure into an art form, I'm afraid—"wallering," we have dubbed it. Every home needs a room for the folks to be a family. That means a place dedicated to eating off TV trays, reading, napping, catching up and simply being in fellowship together.

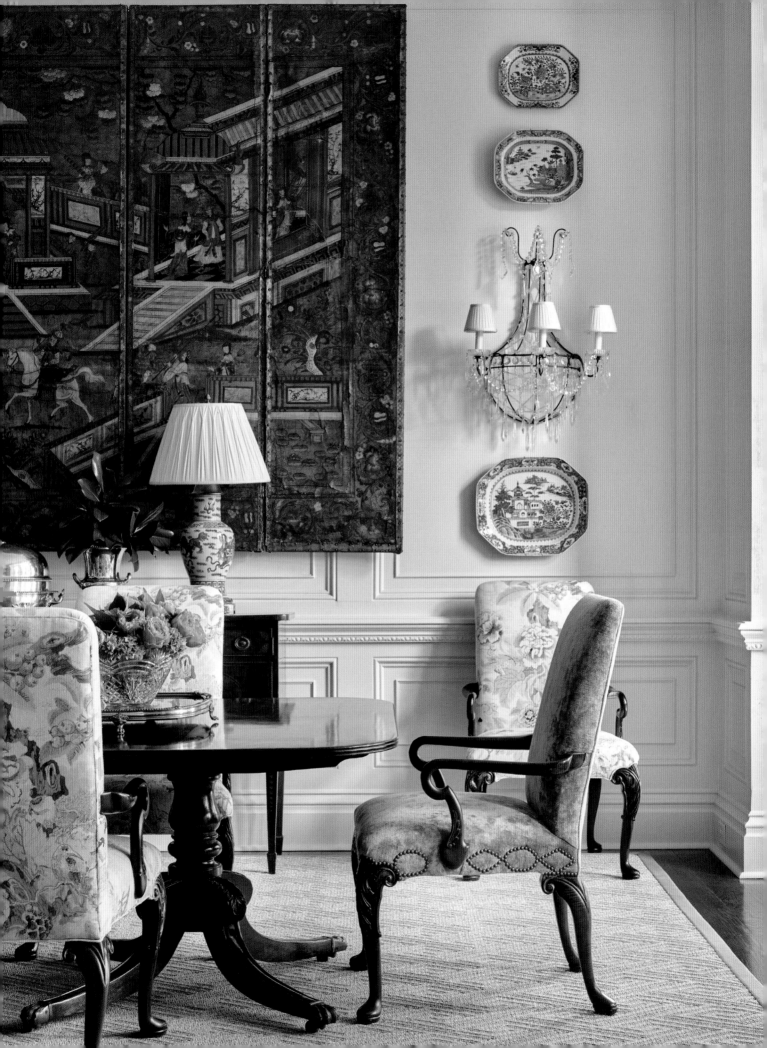

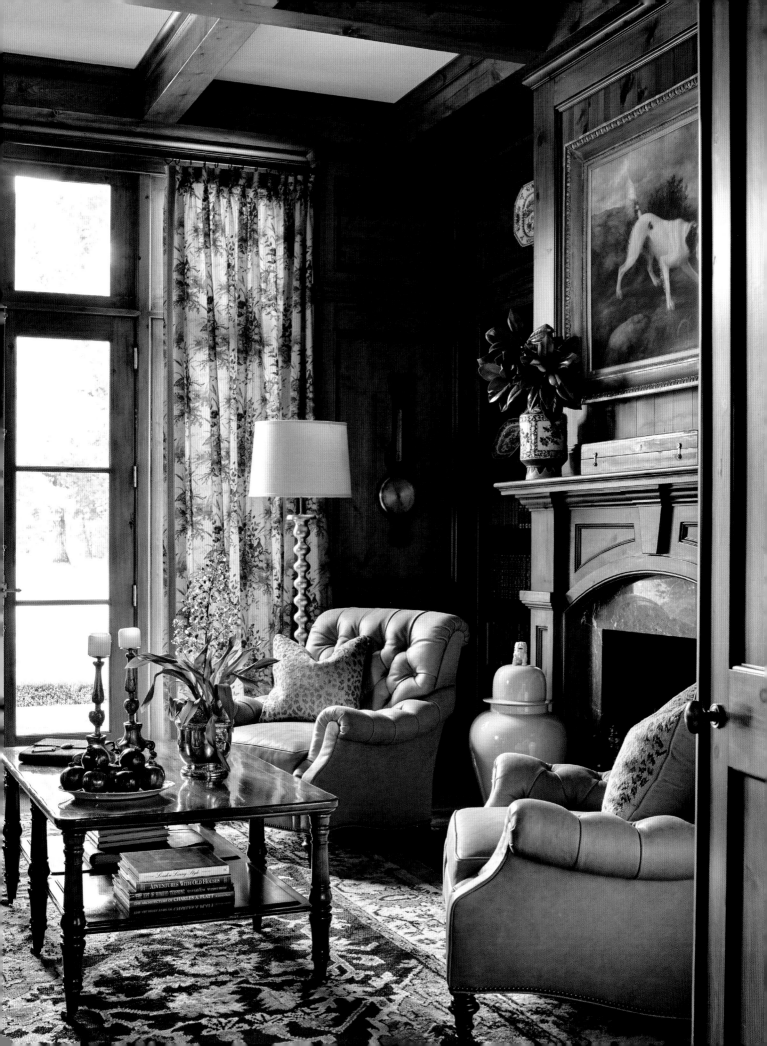

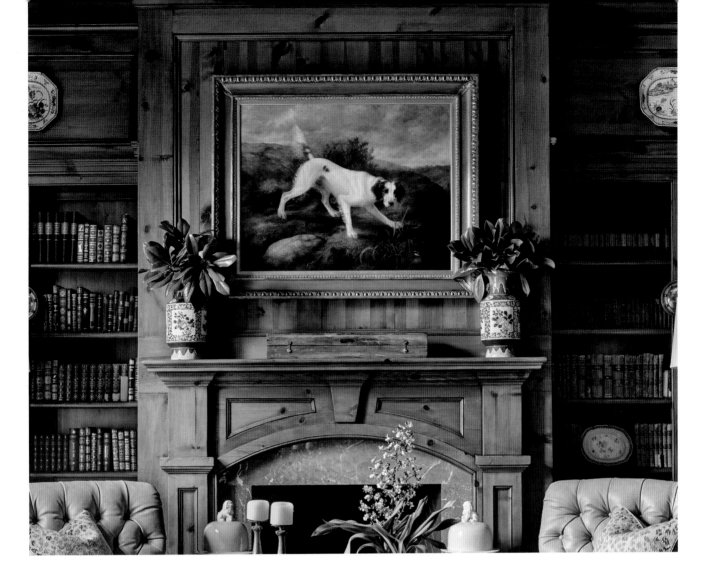

In this home, I decided to remove things that were flouncy, fancy or stuffy and to redecorate the rooms to become friendlier, inviting and yet still be very stylish. As in many design projects, one room leads to the next, and so on and so forth. Getting to know how a client lives and how they spend time in their home is paramount to good design. So began this home's redesign and next chapter.

My great-grandmother always said, "There isn't a barn that a little paint wouldn't help." Granted, she and her generation spray painted many things gold (cotton, hydrangeas, magnolia leaves, etc.), but she was right! Paint does cover a multitude of sins. The first step in this home was toning down the peachy hue on the walls that dated the house; this family needed a fresh palette for their lifestyle. Adding a touch of pizzazz with the faint blue ceilings and

embracing cream and white and softer hues allowed for art, antiques and fabrics to really stand out. We were able to highlight the arches, woodwork and moldings and bring out the best of the incredible architecture.

An antique Oushak rug is the foundation of the pine-paneled study; it is visually heavy enough to balance the incredible wood paneling. Schumacher's "Quail Meadow" printed on linen makes a simple pleated window dressing hung on contemporary metal return rods.

The leather chairs are accented with gold bobbin-style lamps, crisp white temple jars and needlepoint animal print pillows. The handsome woodwork is timeless and is well balanced with hundreds of antique leather-bound books that add weight and provenance, patina and texture. A fine English painting of a hunting dog presides over the mantel and is guarded by two blue and white jars holding magnolia leaves. A rustic wooden box tones down the formality and adds a bit of "crunch" or earthiness to a highly styled vignette.

A grouping of plush, tufted, buttery leather chairs became instant invitations to sit in the room hardly used before. Grouped for conversation, and working with the cross-traffic flow of French doors leading out to the terrace, this grouping became the anchor for living more comfortably in a handsome, architecturally rich setting.

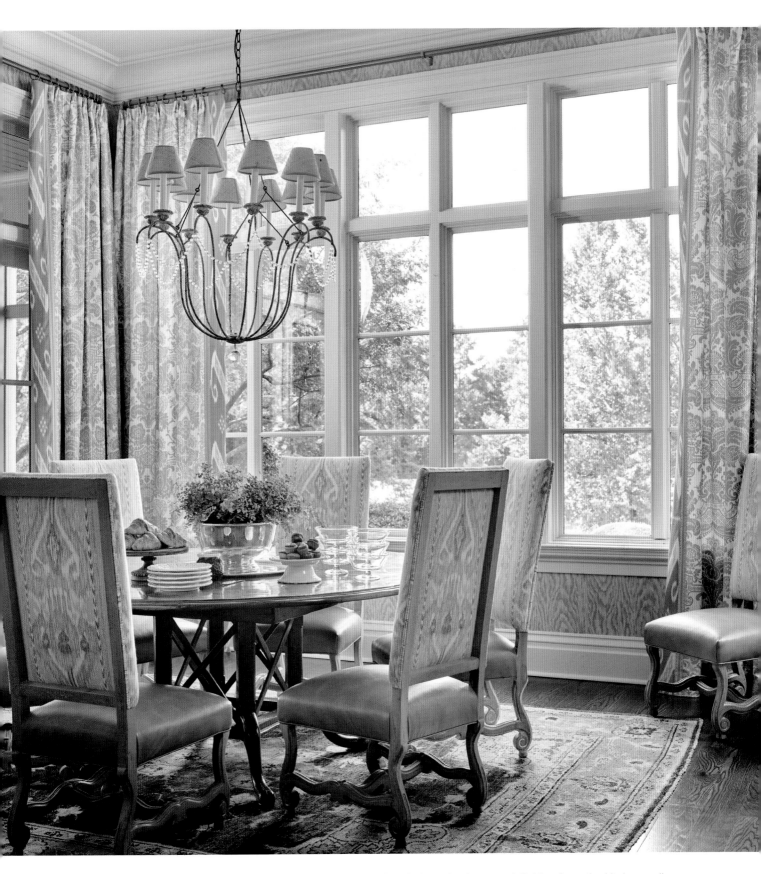

For the breakfast room, we papered the space in a Stroheim *faux bois* to give it some definition from the kitchen walls. The updated damask on the windows boasts an ikat lead edge, while leather and linen complement one another on the chairs. An antique Oushak rug grounds the breakfast room in deep garnet and ruby tones with pops of aqua.

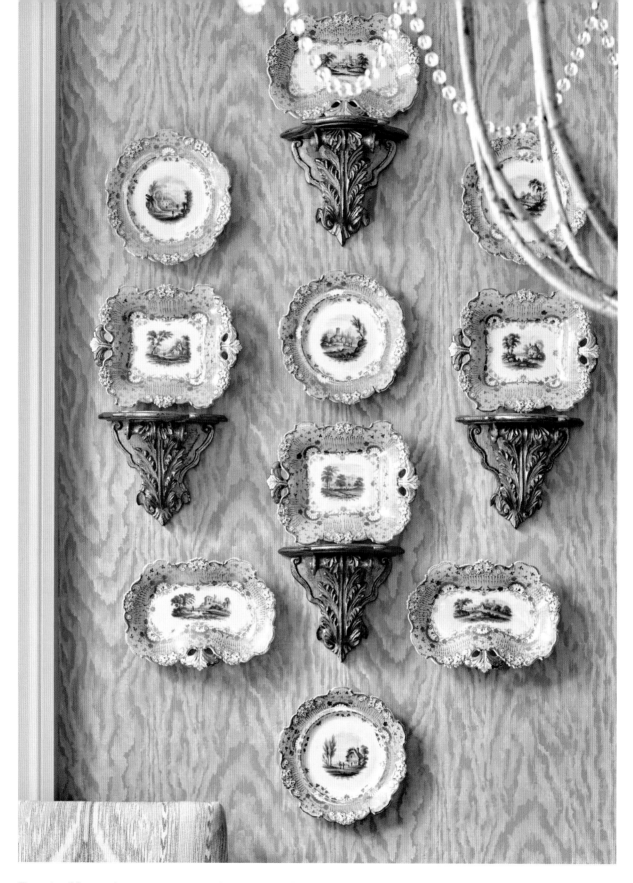

The mix of fine and common, tones and textures, modern and old all come into play in this room. Hand-painted French porcelain and Italianate brackets are paired down with the faux bois paper yet create a harmonious scene. Artwork, modern and older, above the antique French Louis Philippe sideboard is lit with contemporary pottery lamps and pairs ever so lovely with crystal bowls of fruit and vases of garden flowers. Give me a fine antique, some modern art, and a buffet set for brunch any day!

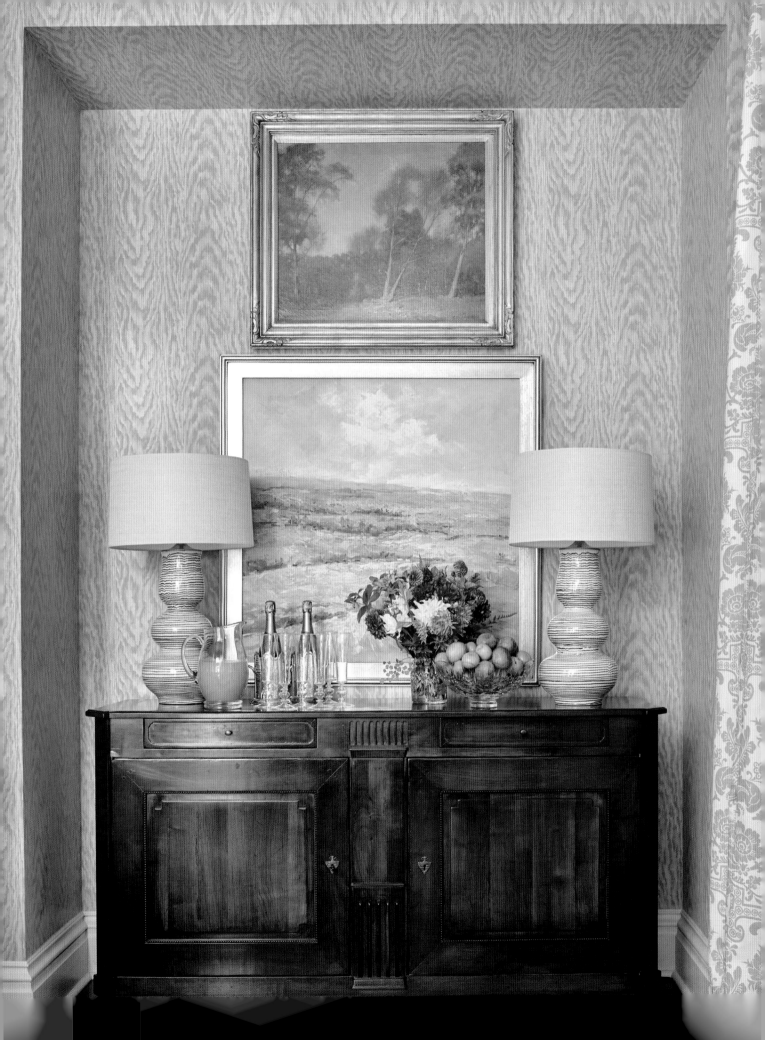

A TIMELESS
KITCHEN

We all acknowledge the kitchen as the heart of a home. Yet trends, appliance fashions, decorating schemes and themes too all can date this room very quickly. I love a classic all-white kitchen but with a twist. The shade of white must be selected in consideration of the locale and the family's lifestyle; once this is achieved, accents and art and personality can be brought into the picture. Glazed white cabinets—more cream than stark white—run the perimeter of this kitchen. A new island in a duck egg greenish gray-blue with butcher block top now serves as the centerpiece of the space, breaking up the expanse of stone surrounding the room. It is our "stuff," our paraphernalia, that makes our homes and rooms personal—but stuff can make or break our homes too.

I like stuff—I like a full nest but there is a limit. In a kitchen in particularly, I like to create vignettes or scenes for what the task is at hand—after all, the kitchen is not only the heart of the home but the biceps too! A hardworking space that must meet form, function and fashion, the kitchen must flex its muscles and look good doing so! Plants, greenery, flowers and garden offerings are a must at a kitchen window or island centerpiece. When possible, I prefer built-in garages for countertop appliances so that seasonal displays can take center stage.

I love a kitchen window in particular. Framing it with topiaries, seen here with fig ivy in antique sardine jars, is like framing your dining room sideboard with great lamps. An updated damask in cream and aqua bordered in a fun tape regulates light through the window. Brown transferware is used in accentuating places throughout this kitchen.

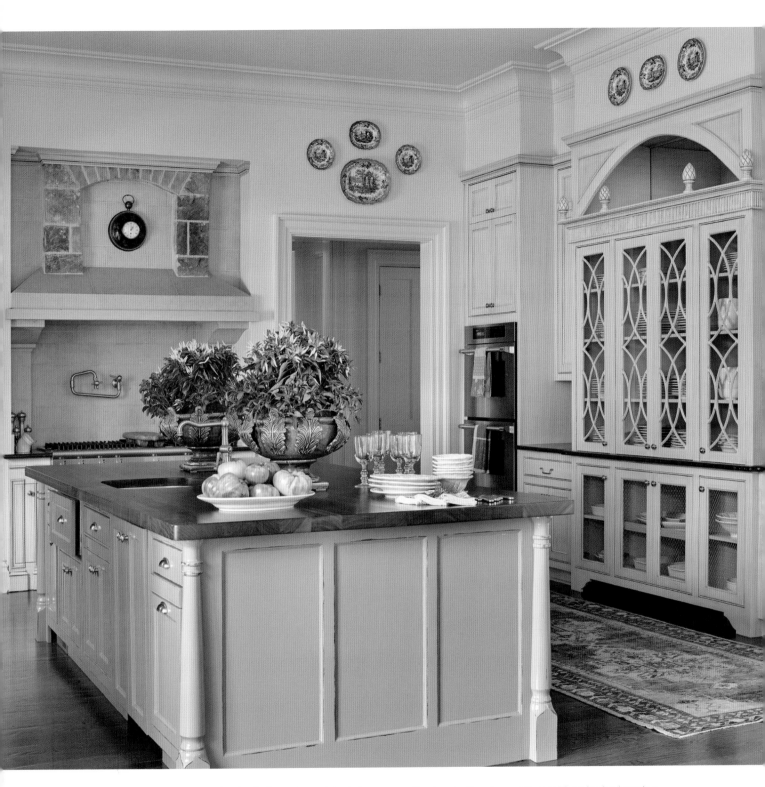

The interlocking ellipses on the butler's pantry cabinet doors were the inspiration for another cabinet in the keeping room, and the breakfront-style glass shows off the kitchen's inventory of plates and dishes—many of which are monogrammed pieces from Provvista. An Oushak runner of muddied ruby and gold tones with soft browns carries the traffic flow through the kitchen and into the adjoining keeping and breakfast rooms with similar-styled rugs.

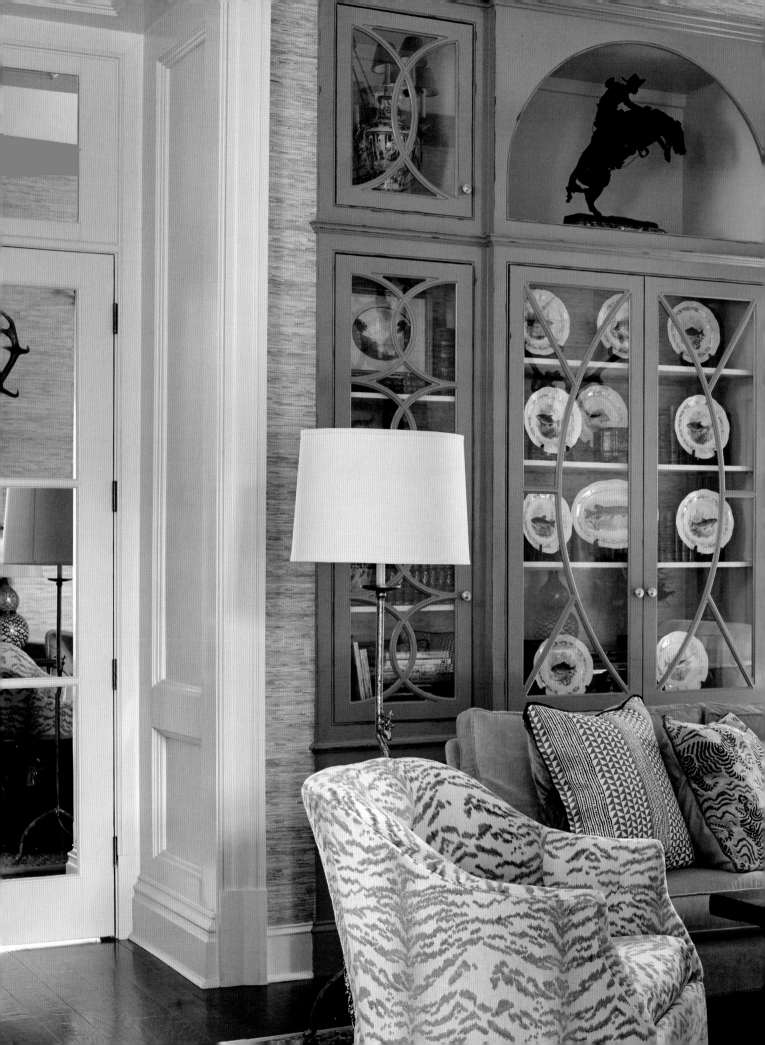

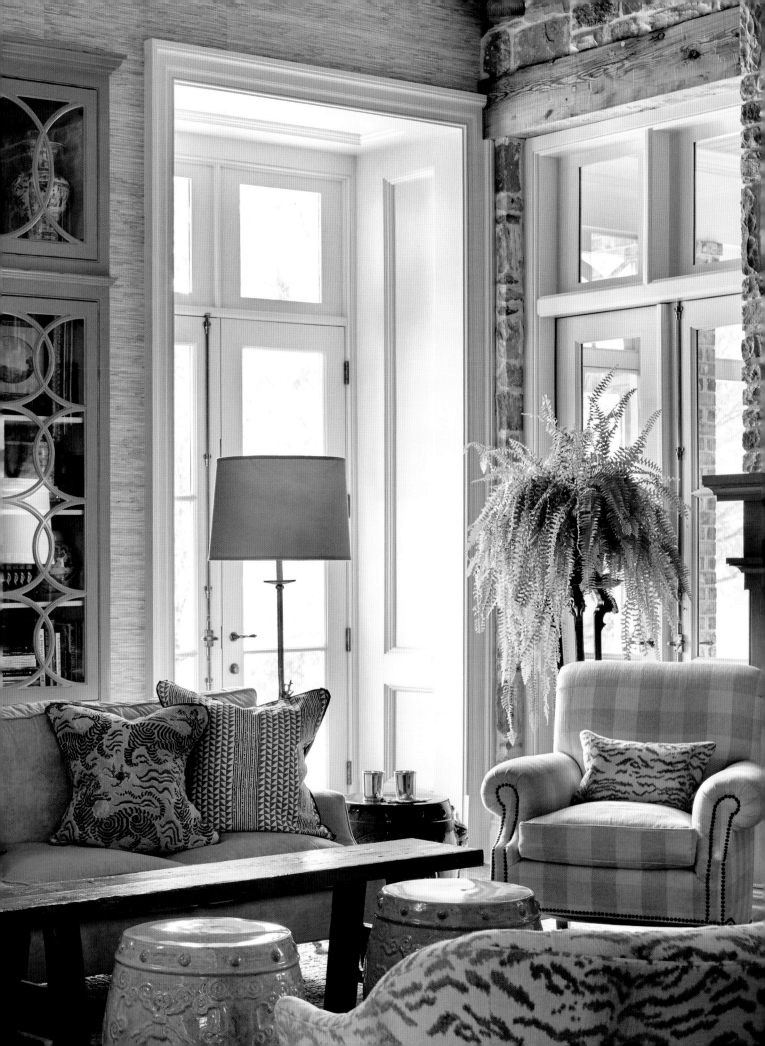

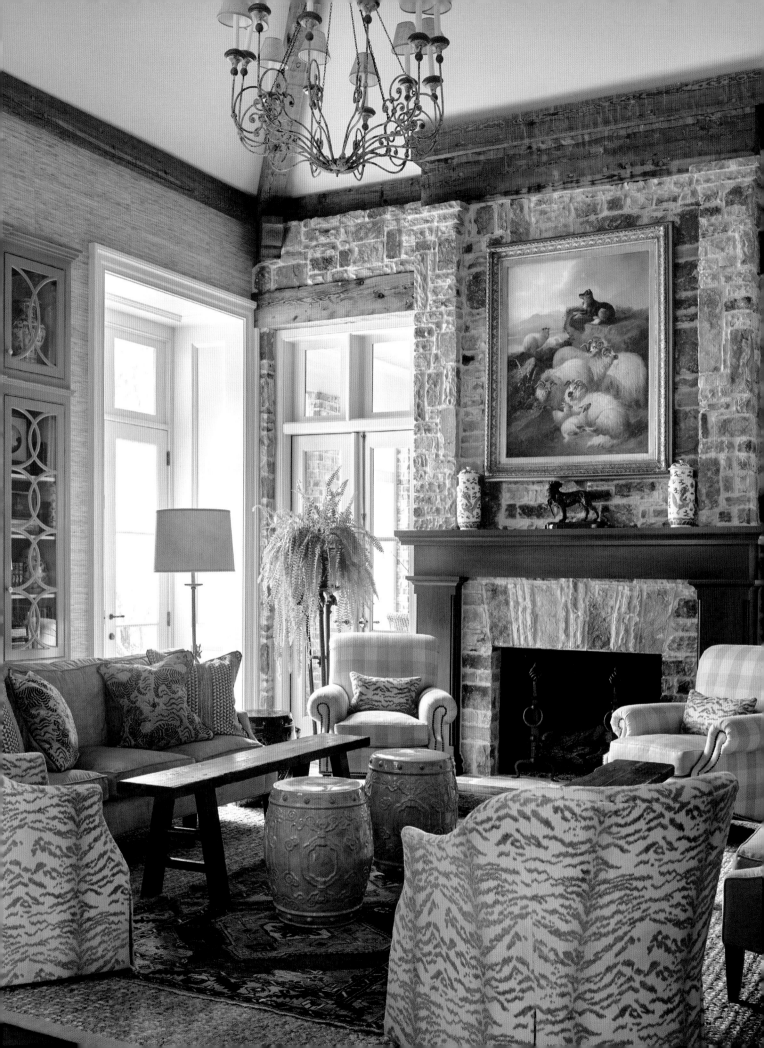

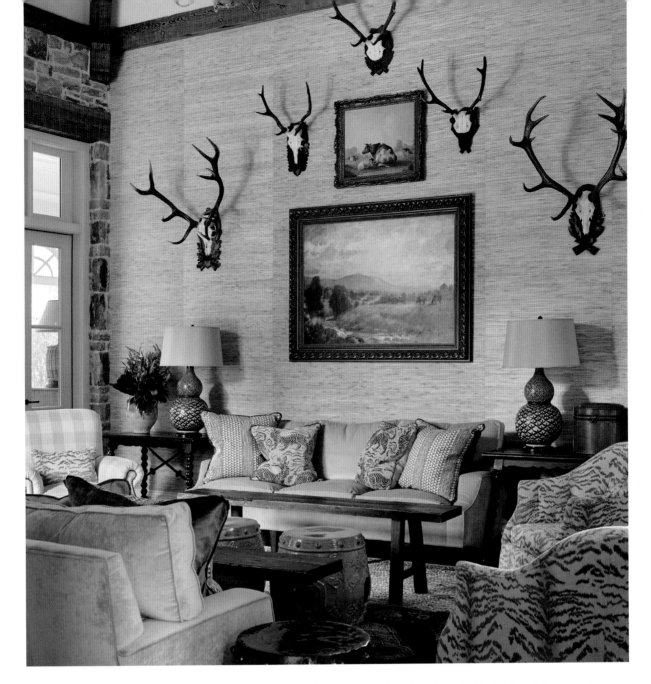

PREVIOUS OVERLEAF: Taking inspiration from the nearby kitchen cabinets, I designed an elliptical fretwork to make the once dark-stained cabinets into a fresh new set of cabinetry but rooted in classical design and furniture styles. Cowtan and Tout plaid covers the club chairs at the mantel, and a tiger print from the same fabric house covers swivel chairs—giving television viewers additional seating or the ability to turn towards one another for conversation.

FACING: I love the arrangement of two sofas and four chairs—it fits this scenario so well and suits many families. The blue velvet sofas with silken accent trim and piping are meant for deep seating or a good nap. An updated colorway of Clarence House "Tibetan Dragon" adds a punch on sofa pillows.

ABOVE: For the keeping room in this home, a very neutral raffia grasscloth was applied to walls. A soft jute grounds the space, which is layered with a tribal runner in bold colors. In a room so architecturally savvy with antique heart pine beams and hand-chiseled stonework, the grasscloth is a good wall treatment and palette for the furnishings and art—including Western art and a French cow painting. Black Forest elk mount trophies are hung in a constellation around the oils, while Spanish trestle tables flank the sofa with pottery lamps and fresh snips from the garden.

The keeping room turned out so pleasant and inviting that it was the catalyst for the home's makeover and future updating. Southern style isn't necessarily using all of your grandmother's old furniture and sweating on the veranda—it is about mixing the styles we inherit and appreciate with the modern comforts at hand.

Bluestone is the flooring material for the back entry. Handsome woodwork, trim and paneling add further architectural interest. Outdoor lanterns dot the ceiling and an assortment of English oils are hung on the stairwell.

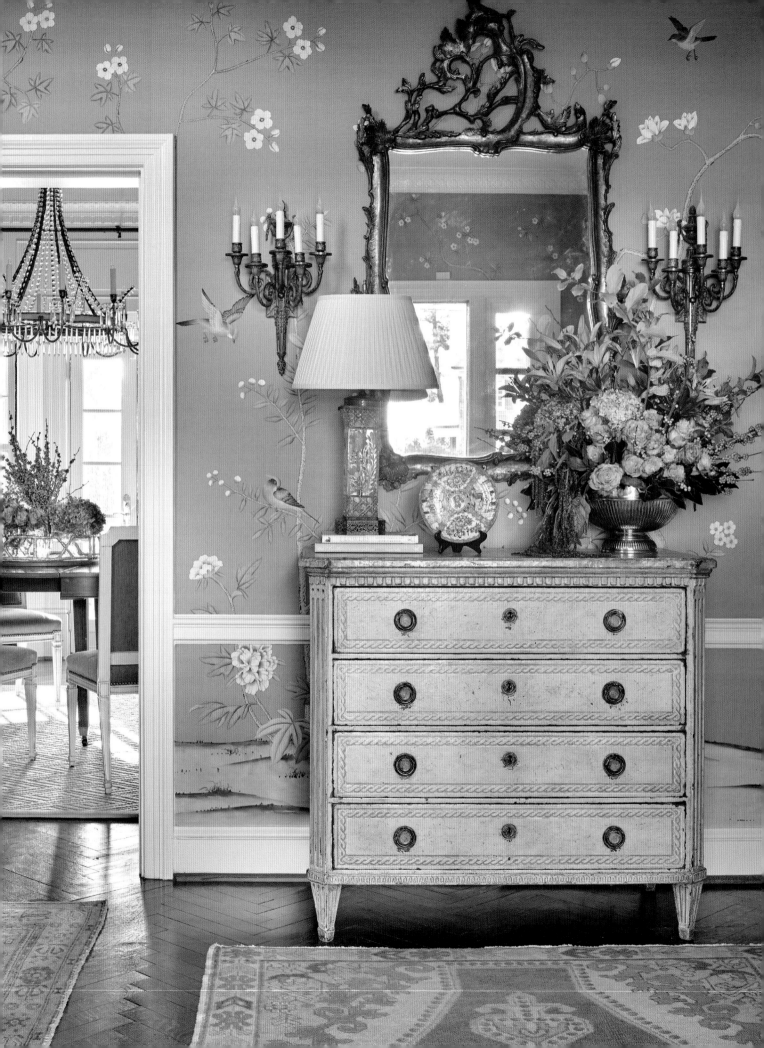

Meet Me in Saint Louis

For these client/friends in St. Louis, Missouri, a renovation of their 1920s red brick, Georgian home in the Ladue suburb became a renaissance and celebration of Southern style. The wife and mother of this family, a native Mississippian, married and then raised her family in this beautiful house and neighborhood. As time progressed and the family lifestyle changed, the couple became empty-nesters and had a decision to make: "Do we sell and move away? Do we downsize? Do we stay and ask James to swath our house in grasscloth and de Gournay?" Thankfully, the latter won the debate.

Through connections across the South, this family became dear friends of mine, and their home in turn became my landing pad for when book tours or speaking engagements took me to St. Louis. We bonded over Sea Island, cotton farms, mutual friends in Memphis, Richmond, Atlanta and Dallas. The couple have hosted dinner parties including other displaced Southerners when I've been there, and they have toured me around lovely homes of Southerners who found their way to St. Louis. The South is really just a small town; and in a matter of time, measured in

I wanted a dramatically Southern yet fresh and chic moment for people upon entering the foyer. Oushak rugs in faded, muddy jewel tones anchor the traffic patterns atop the original oak parquet floors. An antique mirror, chest, crystal lamp and sconces adorn the wall centered with the front door.

Southern cadence—like a duck on a June bug—relationships and friendships form and bond quickly and effortlessly.

On my trips to St. Louis, I found myself rearranging the living room of my friends' home and hanging mirrors and paintings in different locales. We hunted for treasures at antique malls and stores, and eventually made a game plan for the house's redecoration. Family pieces from Mississippi, an antique chinoiserie screen, classic fabrics in fresh colorways all became inspirational elements for the project. For the foyer, I envisioned a scenic paper as often seen in Southern homes. Whether a Lowcountry plantation, a South Georgia hunting lodge, a West Paces Ferry mansion or a Savannah town house, murals and scenic papers have been Southern hallmarks since our ancestors brought the notion across the pond. A pattern by de Gournay on custom-colored, painted silk panels changes with the light from blue to gray to green.

The handrail, painted in Pratt and Lambert "Obsidian," is a nod to English town houses and serves as an elegant architectural movement upwards along the stairwell. A diamond and trellis-pattern needlepoint runs upwards with the stairwell.

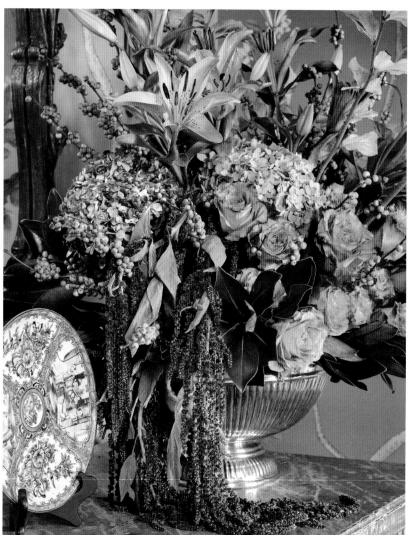

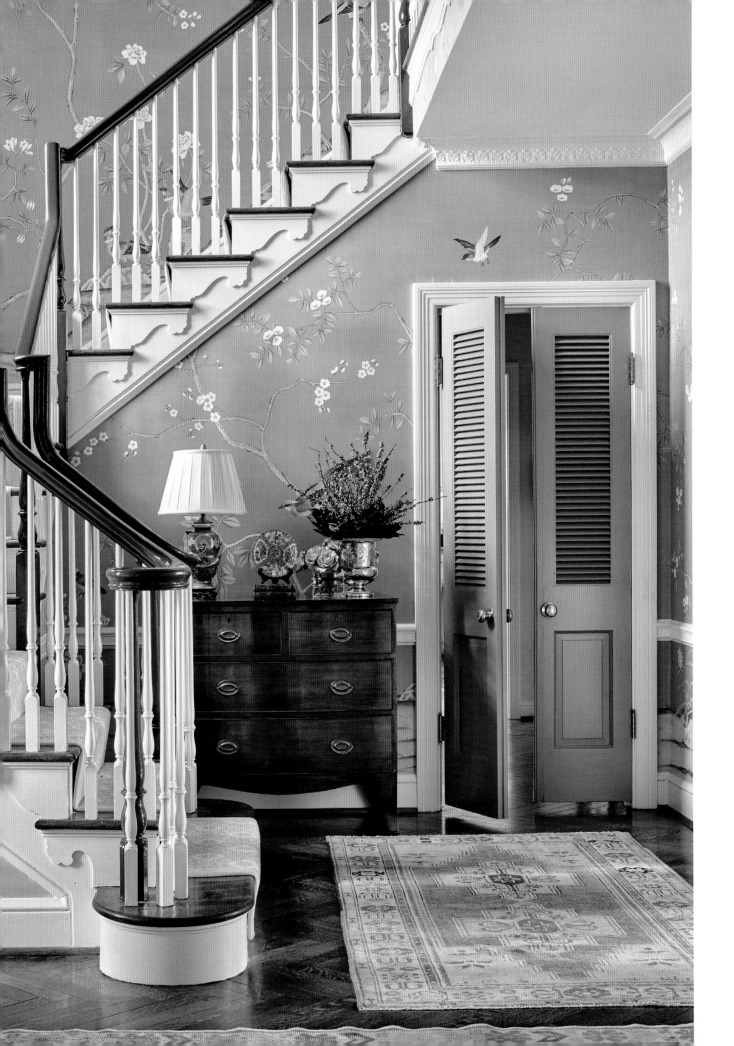

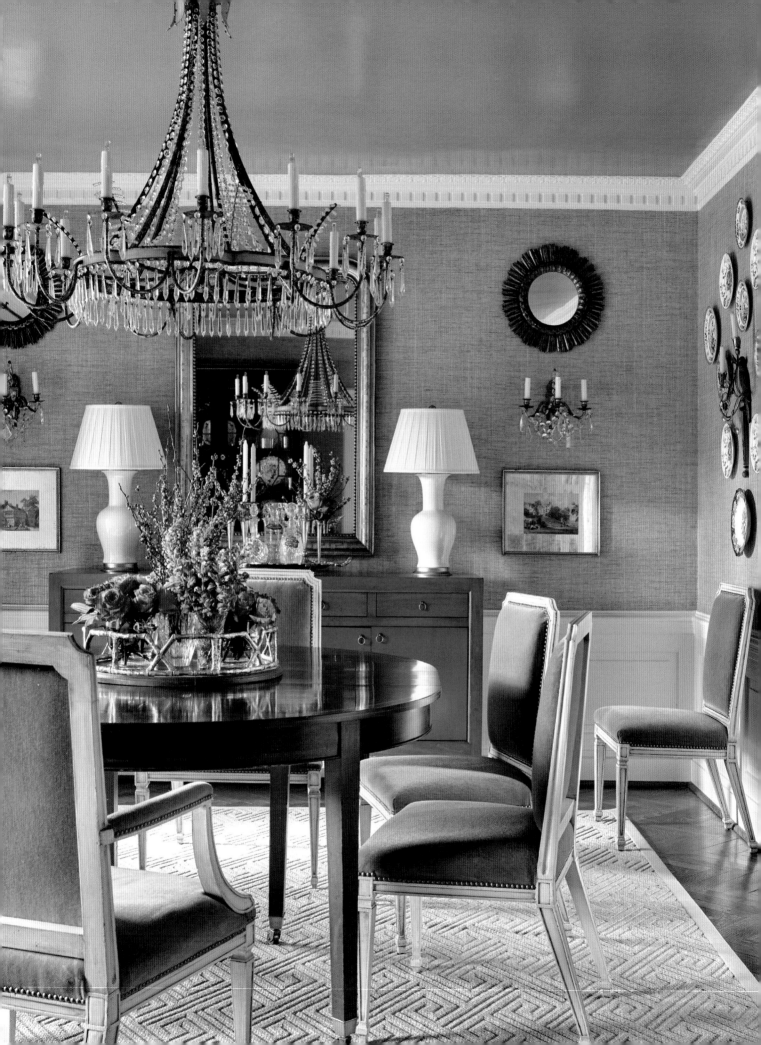

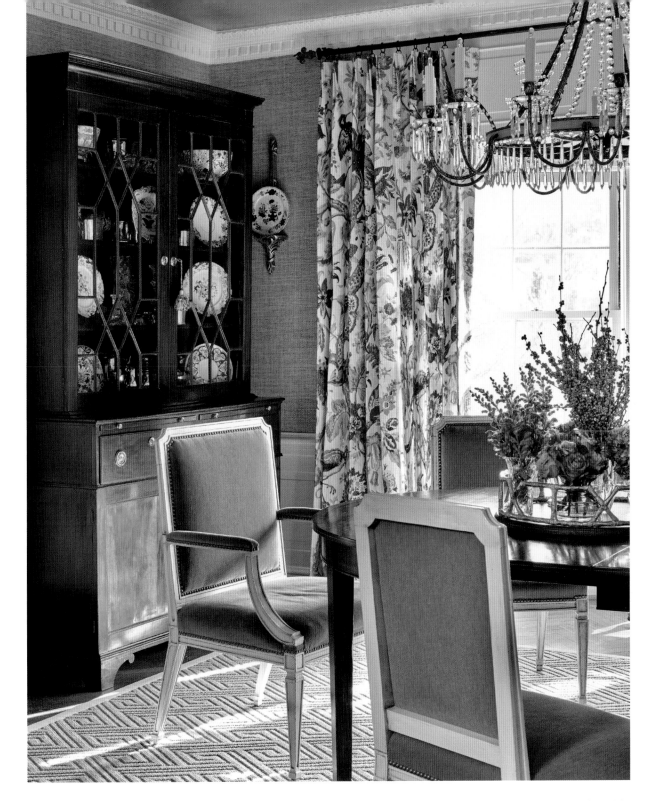

Open to the foyer through a large cased opening, the dining room is papered in a grasscloth threaded with a light gold metallic piece that gives just the right shimmer for candlelit dinners; a touch of glam in the form of metals reflecting light adds warmth and elegance for mid-winter entertaining. The ceiling is lacquered in a peacock feather blue to also reflect light when entertaining. The antique secretary boasts a collection of found treasures, and was a honeymoon purchase in Portugal by the homeowners. A sisal rug brings a more relaxed feel to the room, while a contemporary Asian-inspired sideboard balances with the antique Louis Philippe mirror and antique table and chairs.

Antique French sconces add a touch of glitz along with the rock crystal chandelier. Sprays of Imari, blue and white Canton ware, brackets and family silver accessorize the room. Lee Jofa "Tree of Life" at the bay window and French doors leading to the terrace seems to incorporate every color one can imagine.

TIMELESS
CHINOISERIE

To the right of the entry foyer is the formal living room and the sun-room beyond it. One of our tasks was to make this room more livable and comfortable for the family, for use more often than Christmas morning or for Deb ball portraits to be taken. Painting the original paneling a warm white with the right amount of cream gave us a clean backdrop to group seating arrangements and hang the color palette-inspiring chinoiserie screen and other art and antiques. I firmly believe interior doors should be painted or stained if they're a handsomely grained wood. Here, Benjamin Moore "Gunsmith Grey" holds just the right balance of gray, green and blue to accentuate the room's furnishings.

A contemporary yet comfortable take on wing chairs, as well as two antique Italian chairs all sport velvet upholstery for comfortable wear and tear. The fireside chairs have a light saffron-hued leather ottoman that serves as a perch for a tray of cocktails, stack of books or extra seating by the fire. An antique pier mirror that the homeowners have owned for years reflects the room and main seating area opposite the fireplace. In this grouping, a sofa scaled long enough to host a crowd or a Sunday afternoon nap is balanced with the fabulous chinoiserie screen.

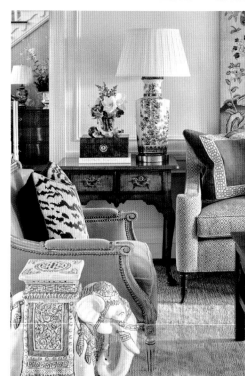

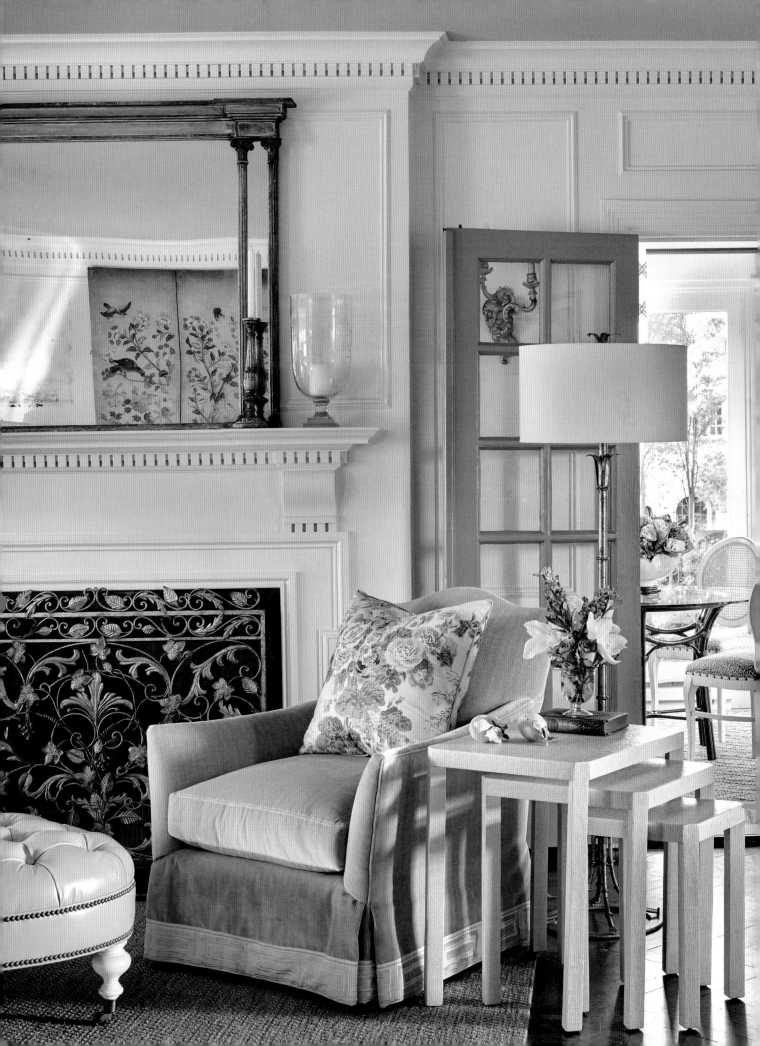

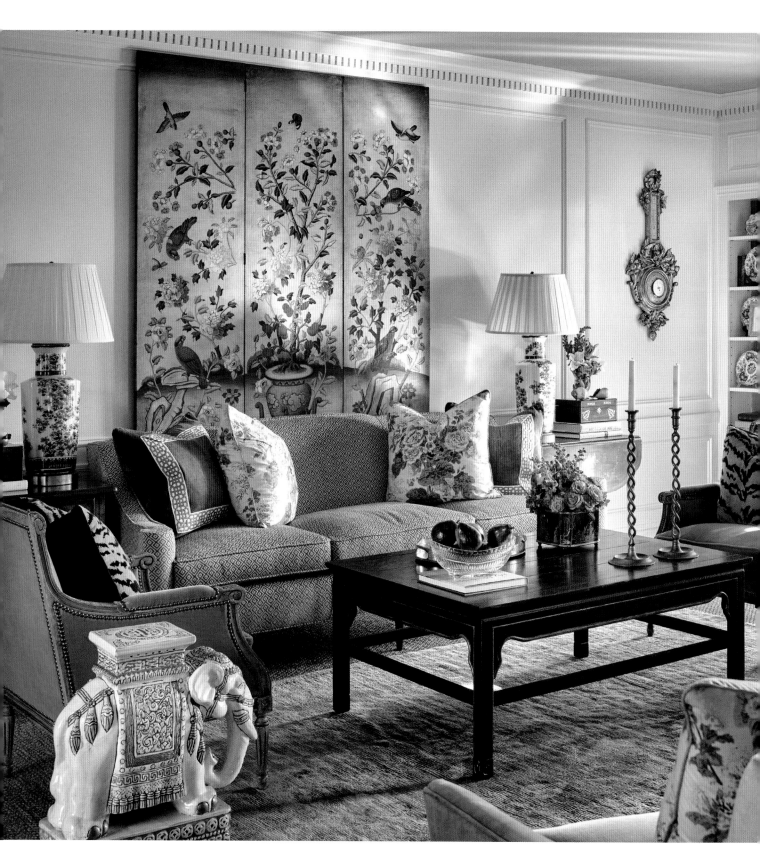

Antique Imari orange-and-white lamps flank the Lee Jofa upholstered sofa. The shelves hold treasures and antiques from travels and family members; the back of the shelves is painted a warm red for contrast. Atop the jute rug is an antique Oushak that brings out the peaches, salmons, greens and aquas of the classic chintz seen on throw pillows. A custom cocktail table in a deep red, from John Rosselli, brings handsome color and weight to the room.

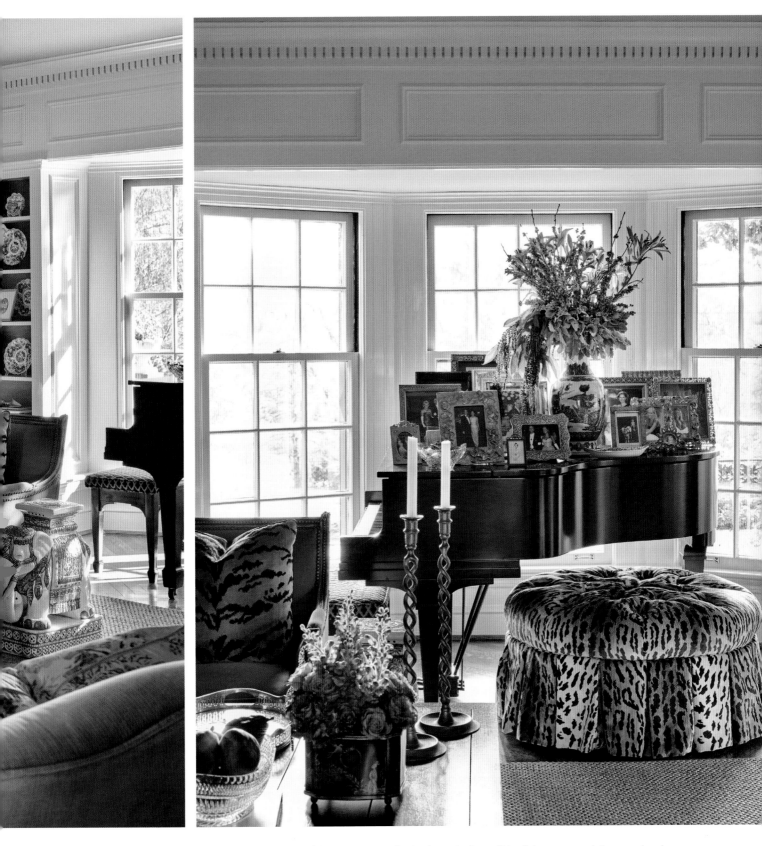

A baby grand piano holds center stage in the bay window of the living room, while an animal print ottoman is tucked underneath its curved profile for extra seating and front row viewing of an impromptu piano concert.

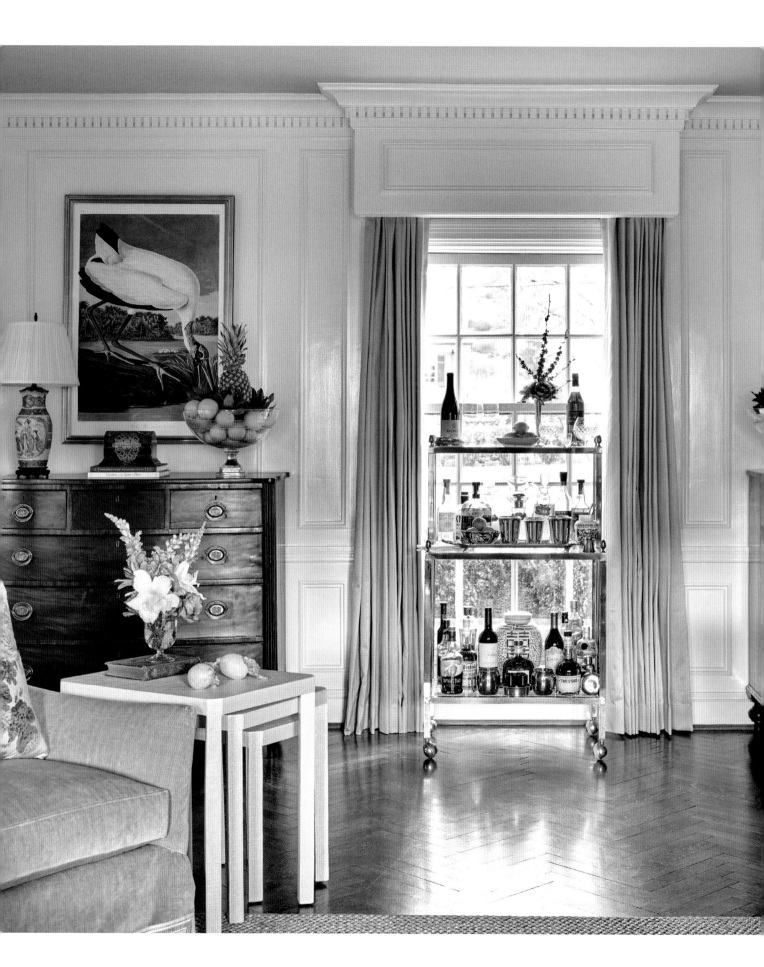

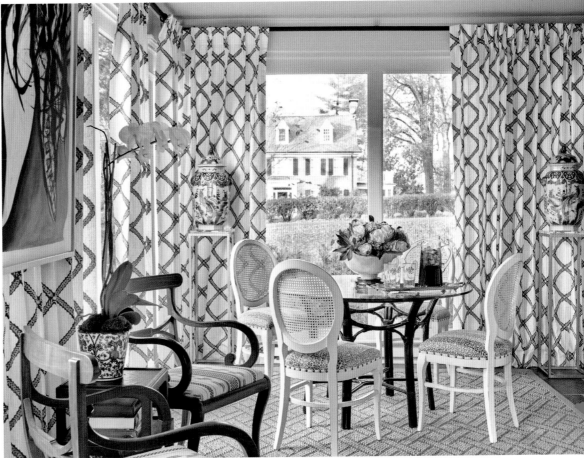

LEFT: Opposite the piano are two English chests with gorgeous brass escutcheons. A pair of John James Audubon prints are gracefully framed and blend harmoniously with the chinoiserie porcelain lamps and crystal compotes.

ABOVE: Open to the living room most of the time is the light-drenched sunroom, painted in Farrow and Ball "Matchstick." The windows are dressed with a blue-and-white trellis pattern. A seagrass rug covers the old slate floor, and a bamboo table and antique caned chairs await a game of cards or a ladies luncheon.

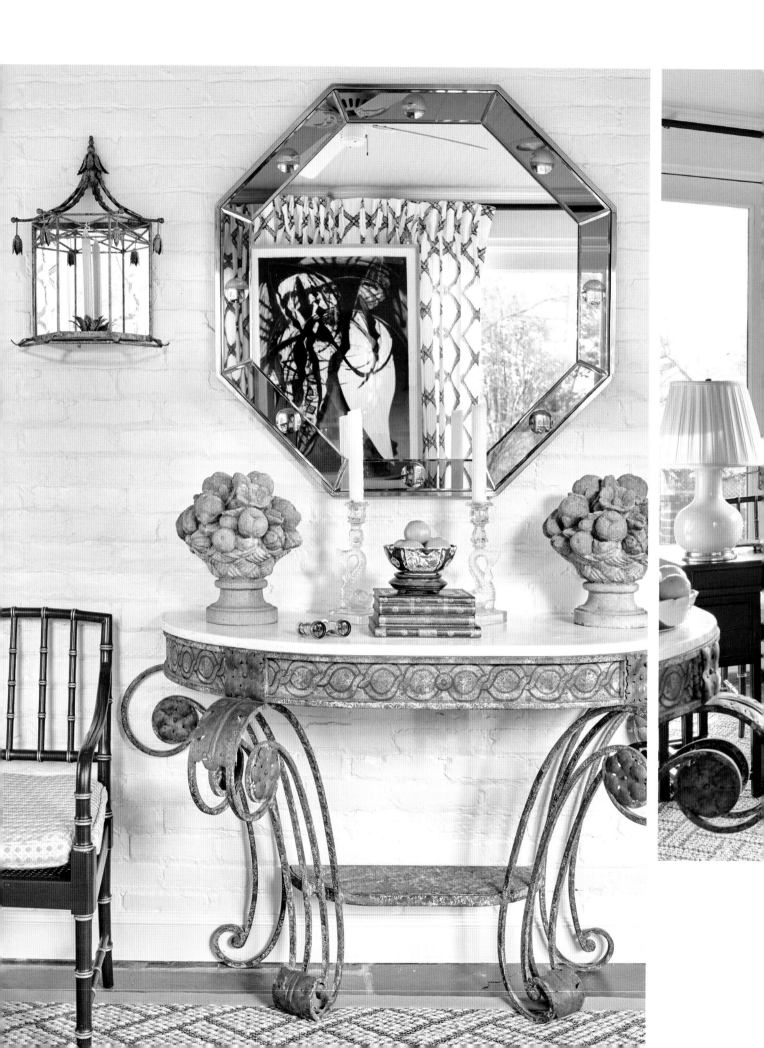

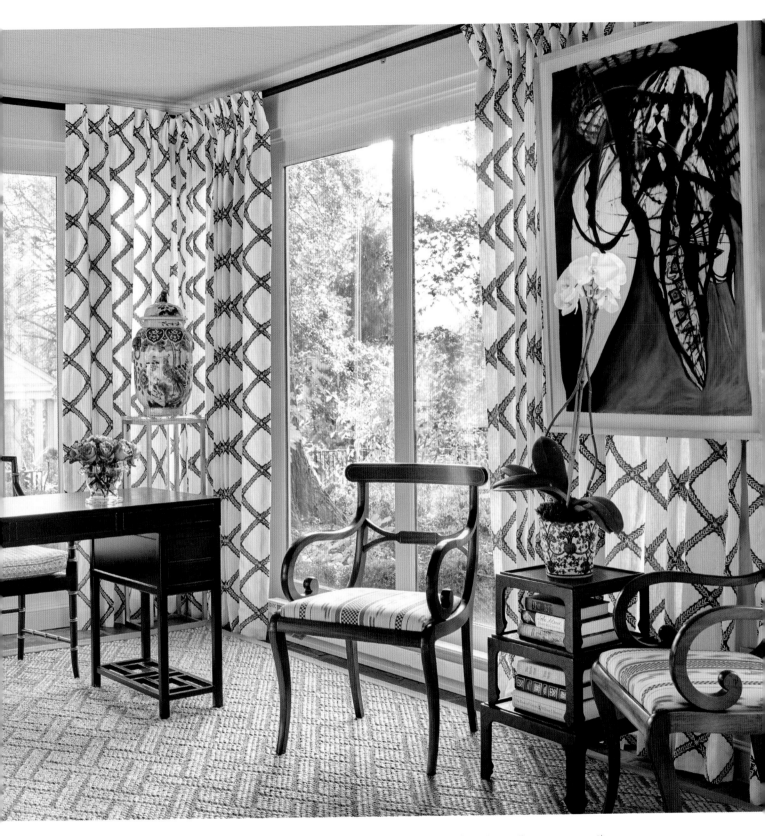

A desk and scattering of chairs makes the room truly multipurpose for desk work, reading or conversation. Contemporary art melds with antique garden ornaments and blue and white temple jars while a punchy blue mirror reflects the room and garden beyond.

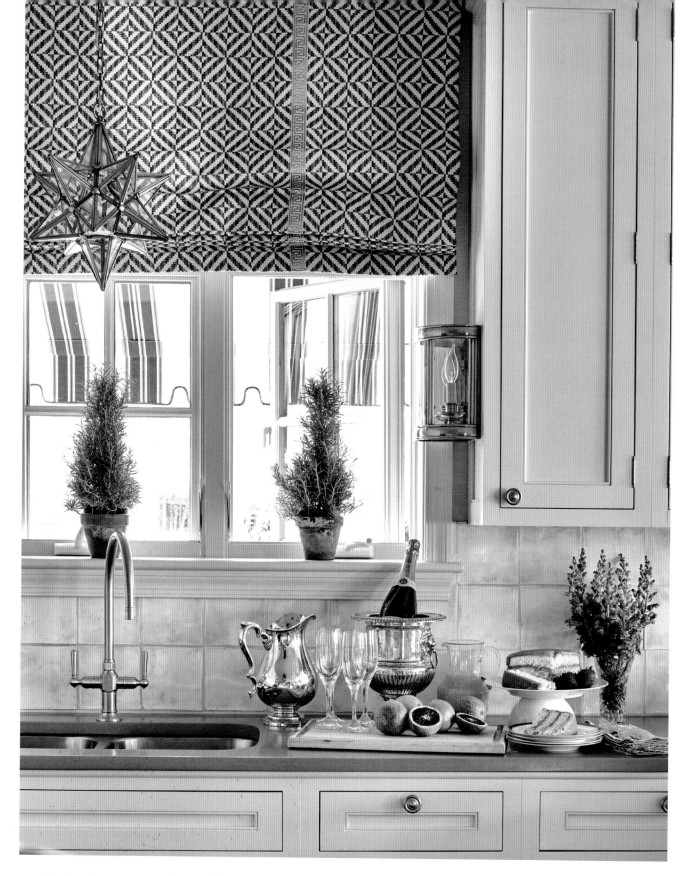

The family room is a modern addition to the home along with the updated kitchen. For these rooms that open onto one another, we treated the walls with a very light, tightly woven ivory-hued grasscloth. The kitchen cabinets and family room shelves are Benjamin Moore "Bone White," which allows accents like the island color, tiles from Portugal brought back from the couple's honeymoon, furniture and art to really stand out. Pops of Hermès orange in garden stools, fabrics and china keep the room fun and spirited.

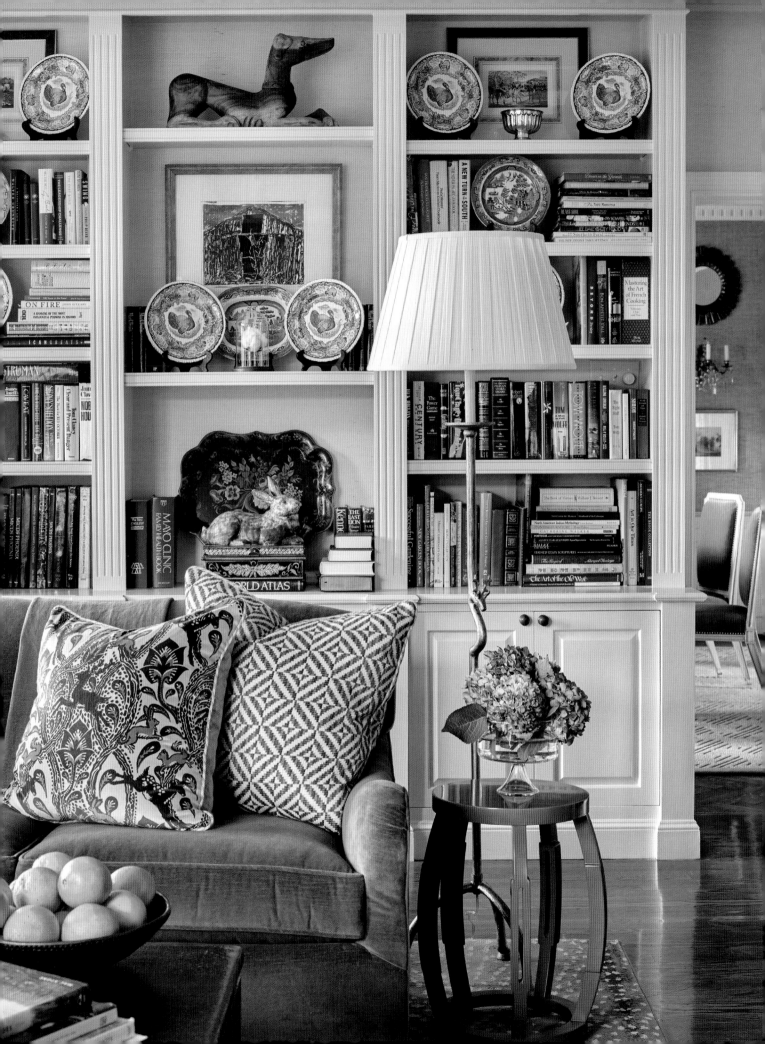

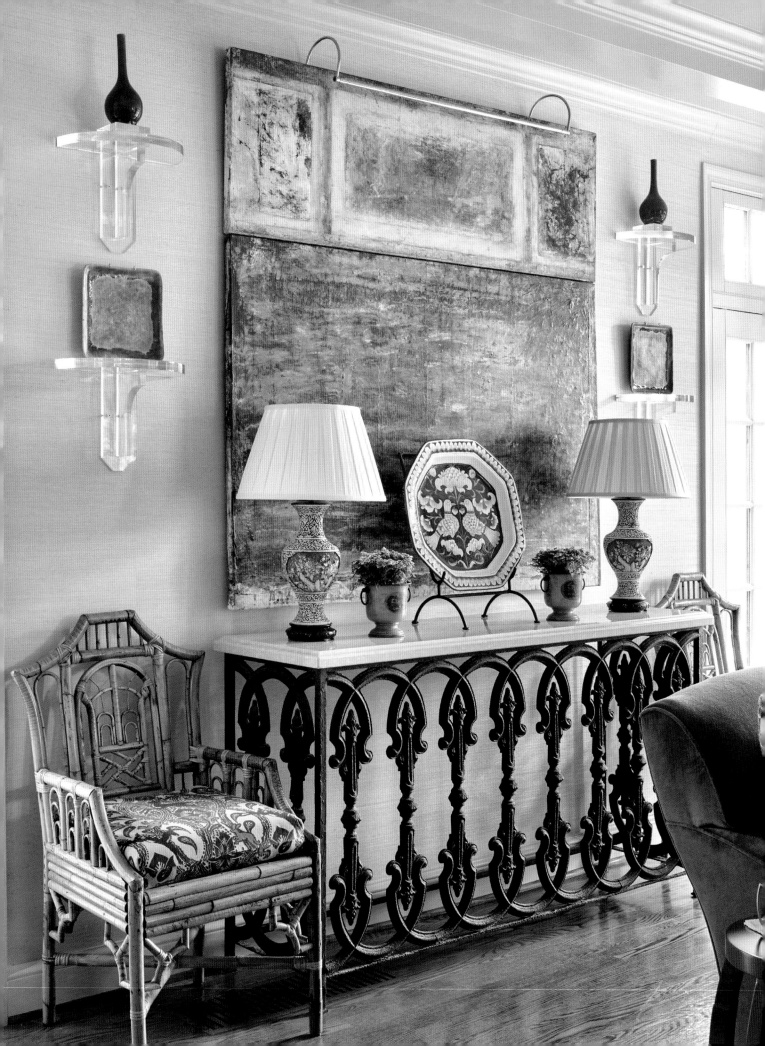

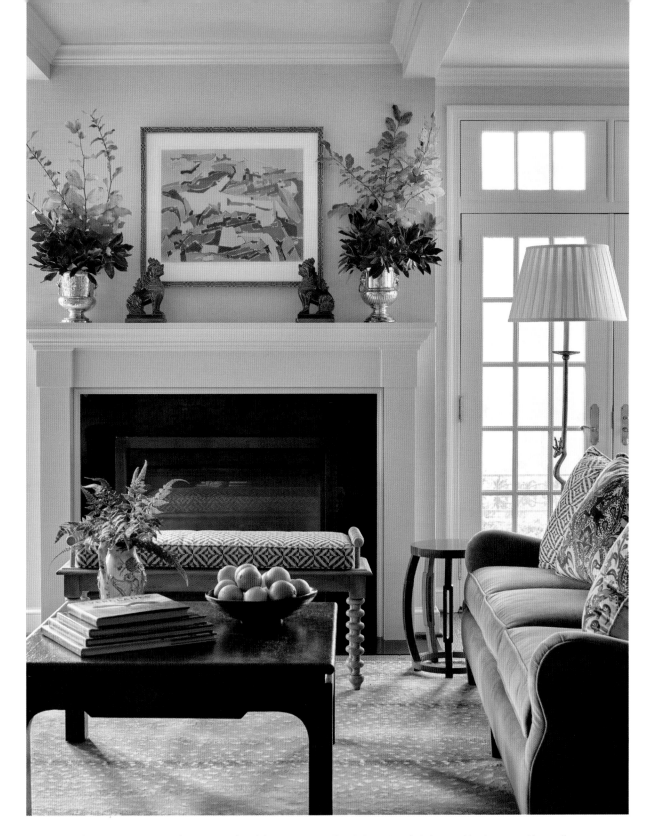

FACING: Modern art over an antique console table creates a mixed vignette of styles and textures on the wall.

ABOVE: A pair of mossy green velvet sofas center the family room. I don't always like to hang a TV over a mantel, but adding *l'objets d'art* is one of my favorite ways to decorate. I love that these Chinese foo dogs and brass candlesticks adorned the same house for decades in Atlanta and now will continue to work in tandem as chic reminders of classic taste and style. Hermes orange garden stools add pizzazz atop the Stark "Antelope" rug. A vintage grasscloth-covered coffee table holds down the seating area.

Home for the Holidays
in Southern Style

Many of my clients are what I like to call "party clients"; they have worked with another designer or decorator in the years past and will call me to help them fluff for a party—"fluff' being a highly technical design term in which pillows and flowers are the major elements, not tearing down walls and renovating entire kitchens. That is fine by me, especially when the client has worked with a phenomenal design team beforehand. This literally makes my job one of gilding the lily—and orchids, hydrangeas, garlands and wreaths.

We have had the opportunity of working in homes designed by architectural and interior design greats such as Philip Shutze, Frank McCall, Charles Faudree, Norman Askins, Stan Dixon, Jack Collins, Jane Smith, Cole and Cole, Bobby McAlpine, Richard Keith Langham, Spitzmiller and Norris, Kathleen Rivers and one of my personal design icons, Jackye Lanham.

I have admired Lanham's work for years, having toured homes she has designed and decorated in Atlanta and Highlands, and swooning over groupings of prints and china hung elegantly on walls, falling in love with colors she uses that run somewhere among ochre and putty and green. I've

Magnolia garlands and wreaths from Weston Farms in North Carolina were custom made of Southern flora and horticulture specimens to adorn the doors, doorways, tables and staircase.

attended parties wide-eyed, looking over antiques and collections of pottery at mountain houses and the Driving Club alike, and I have loved visiting with dear friends in the home that she did for them in Atlanta.

The old adage "Let me know if I can do anything for you" has been enacted by friends in my life. One Atlanta family, in particular, has been great friends since my college days, and, in turn, I have become friends with the extended family too. From dinners to a place to stay when I am in Atlanta to allowing me to photograph a cookbook at their home, this family has graciously been there for me through the highs and lows of life and supported me in every way you can imagine.

So when the daughter of this family was to have her wedding shower in Atlanta, her aunt and uncle quickly volunteered as hosts. I immediately jumped on the bandwagon and wanted to do the flowers. It became a perfect state of affairs, for I was able to be a part of a dear friend's celebration. The season was Christmas and the house had been the bride-to-be's grandparents' home, recently renovated by her aunt and uncle with the guidance of Jackye Lanham. I was more than excited about these "party clients," to say the least!

The general foundation of the interior scheme is a crisp yet warm white, which allows the fantastic artwork to take center stage. Upholstered walls, pecky cypress and handsomely carved moldings and mantels, pops of blue and white, colorful and warm

In keeping with the exquisite collection of blue and white porcelain within the home, I filled "double happiness" ginger jars in the front foyer to the brim with winterberry holly. *Sang de boeuf,* or "oxblood," pottery was then used for mixed arrangements of holiday greens, roses, orchids and hydrangeas. The stairwell banister was draped with a simple yet very full magnolia garland, while magnolia and cypress wreaths were hung on the doors.

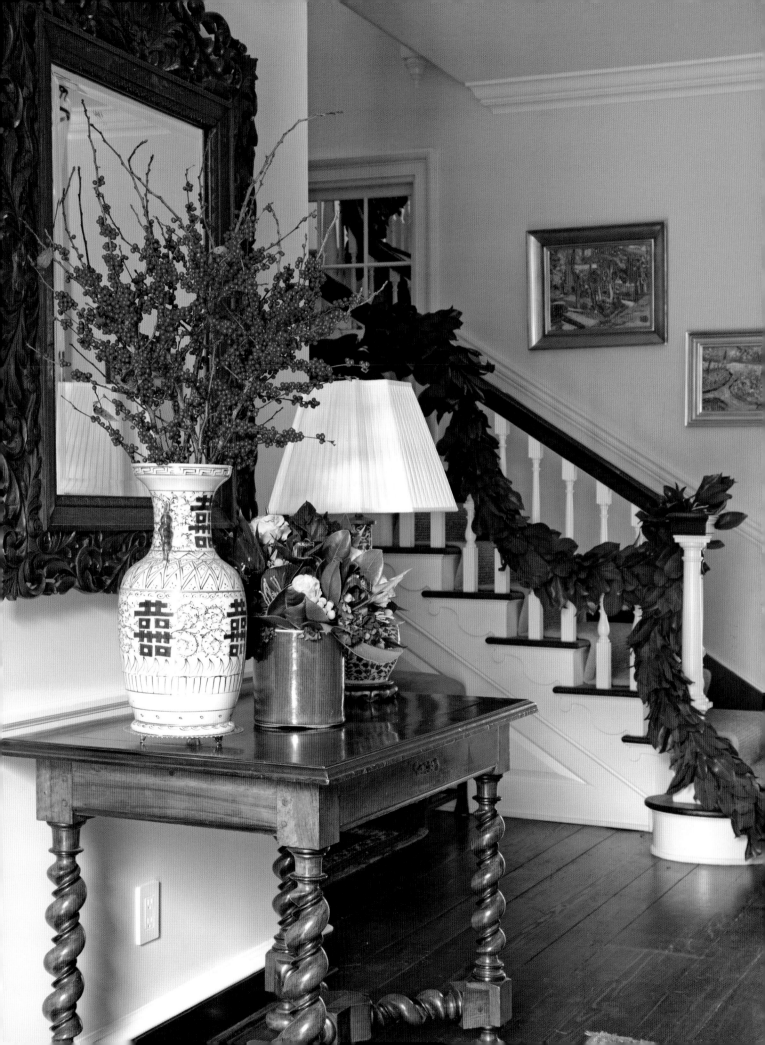

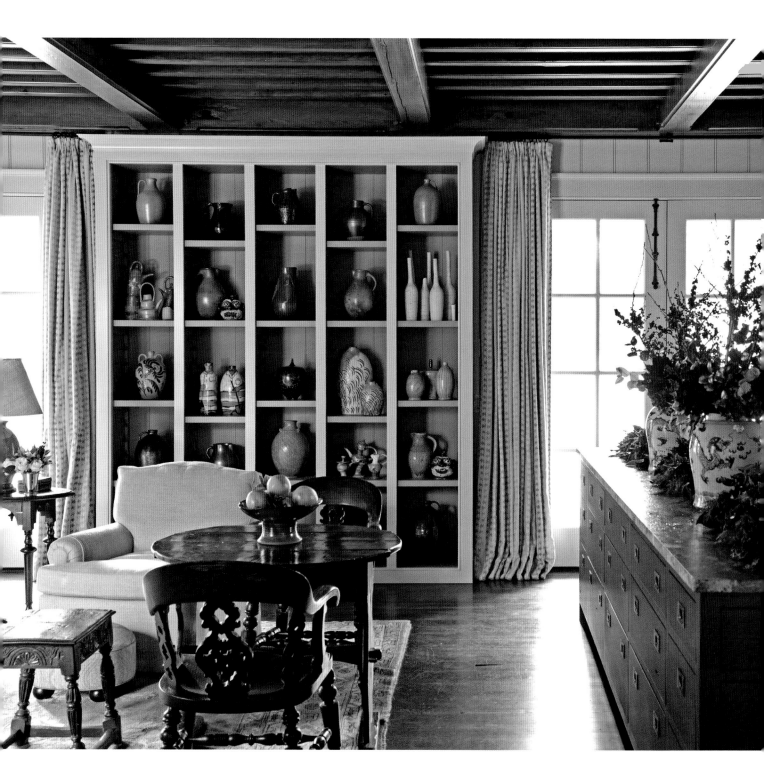

rugs, and considerable collections of North Carolina, Georgia and Southern pottery abound throughout the home. Decking theses halls was a true pleasure in anticipation of the upcoming wedding—a time to celebrate with great friends and family! I wanted the warmth of the host couple to exude through the holiday and floral décor and represent the bride's mother's love for nature and beautiful flowers.

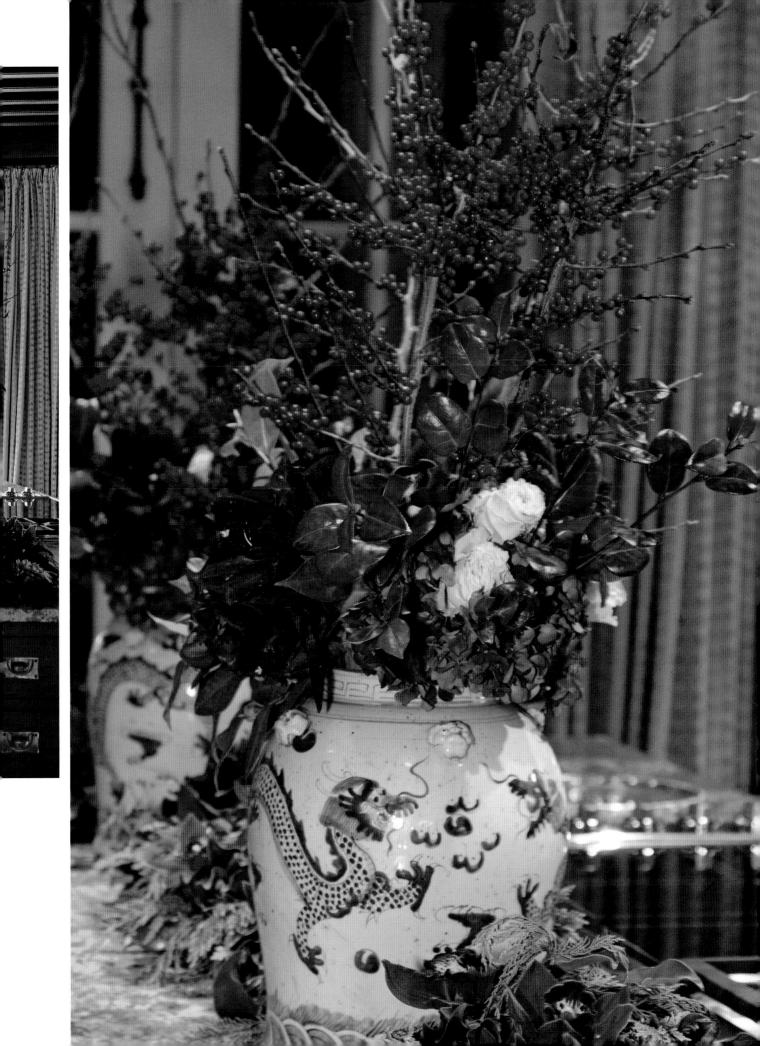

Deep crimson red amaryllis and magnolia branches were arranged in oxblood vases for height, while raspberry-hued cymbidium orchids stole the show as centerpieces for the dining room and breakfast room.

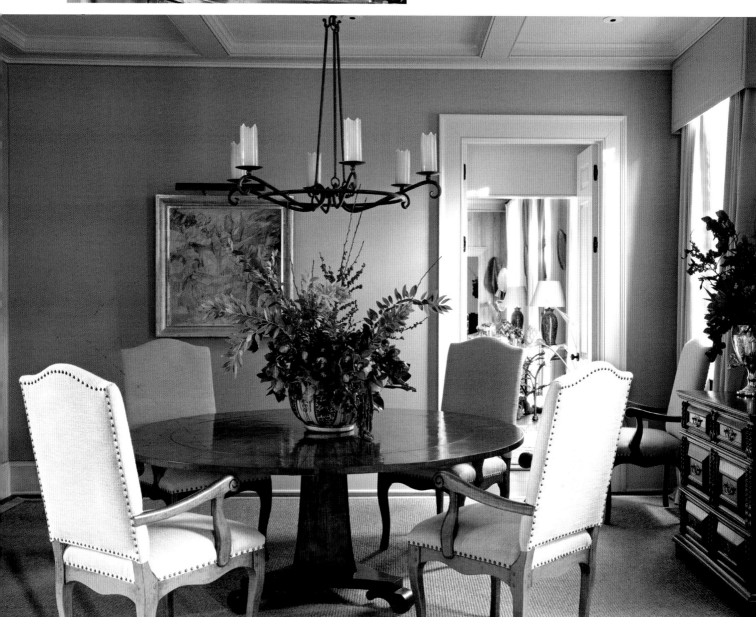

Garlands of magnolia and arborvitae draped the entryways and ran down the dining table and kitchen island—both used as serving buffets for the party.

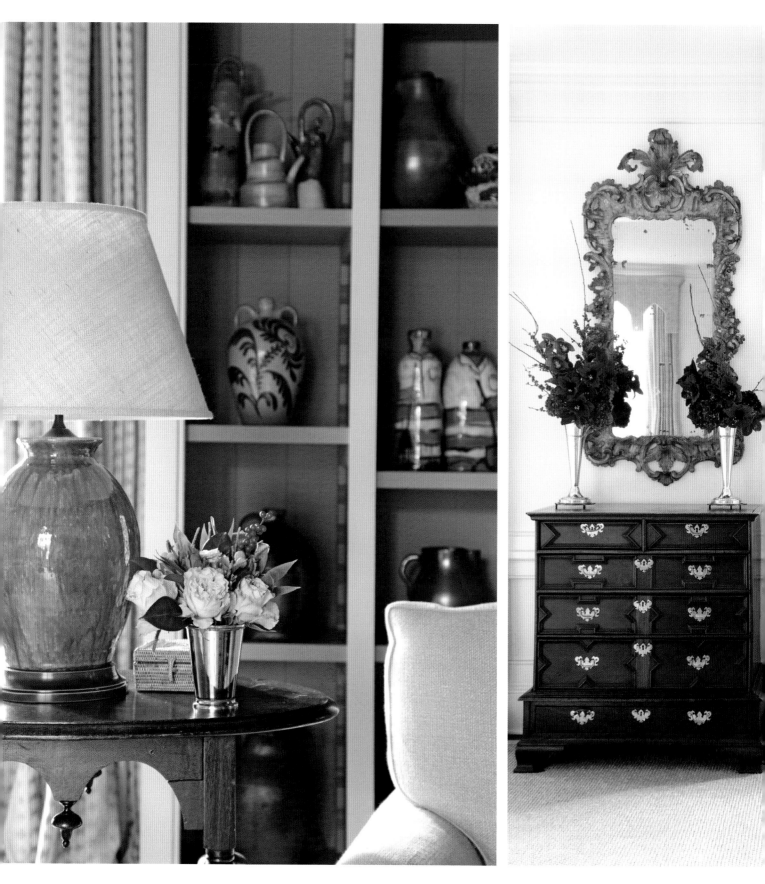

I love how the lime green roses and camellia work together with Agarista and magnolia greens to create a seasonal theme of holiday colors throughout the house.

Crimson, burgundy, true red, raspberry and scarlet meld with jade, lime, forest, pine and silvery greens—all set off by brown back magnolia leaves, blue and white pieces, and polished silver julep cups and trophies. The night was festive and fabulous!

I love to use citrus at the holidays—especially for Christmas décor—and blending oranges and grapefruits with bright green apples in gorgeous pottery bowls that are works of art themselves is an added layer of lushness. Flowers and greenery were literally the backdrop for the much-loved bride and groom and their families. When a home is well designed, flowers simply accentuate the décor and serve as enhancements like no other. Times to celebrate with "party clients" like this family are memorable and heartwarming—and, yes, a lot of work. But the work is a joy when honoring a beloved couple in Southern style.

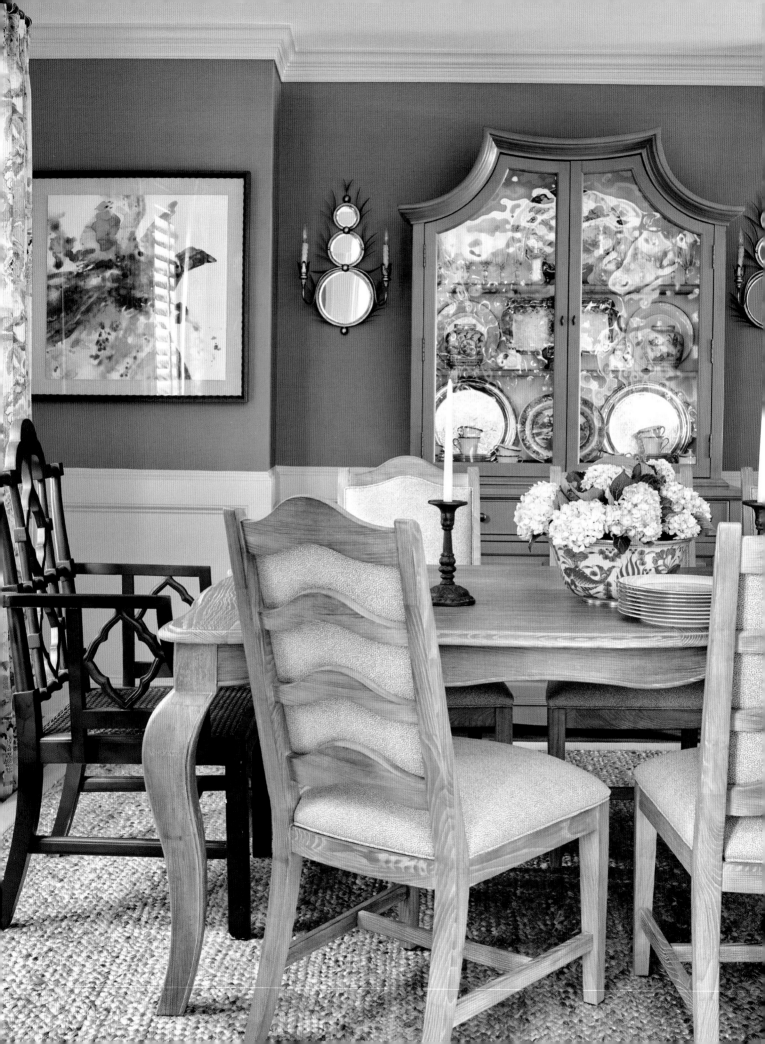

Tradition with a Twist

In the suburban sprawl of Atlanta, neighborhoods and communities have made small towns like Marietta and Alpharetta into large towns brimming with great stores, shopping, schools and restaurants. These incredible developments are hardly fathomable to a kid from a small town like Perry—let alone for a couple from Perry who find themselves moving to one of these lovely neighborhoods in a bustling community. The couple, who have been friends for years and their extended family clients of mine too, experienced a story not unique to many Georgians: the husband's work and amazing career opportunity led them to Atlanta and a new, large home completely different from their house in Perry.

The wife called me to help with window treatments in the living room—which led to a complete redecoration of the room, a terrace-level renovation, further furnishing of the first floor and reimagining an outdoor space that makes their home a resort they never have to leave. The husband always tells me, "This is the last project," and then we move on to something else in the home, because the wife's reply is, "You moved me to Atlanta, so I'm just trying to make it feel like home." Ha!

Wedding china, silver and blue and white jars, plates and platters fill the china cabinet, which is flanked with antiqued mirrored sconces—continuing the singsong of silvers and golds that look so sharp with the melon-hued walls.

The living room is what I call the "hip bone" because it reminds me of the old song "The hip bone's connected to the leg bone . . ." for this is the room that started the redo of the whole house. Watery blue Schumacher linen soars two stories upwards on the tall windows. Herringbone tweed in neutral threads upholsters two sofas, with contemporary tailoring and nailheads for a fresh approach on a classic style. English oak pub tables, celadon jars turned into lamps, touches of silver and crystal and, of course, fresh flowers add touches of Southern style and warmth in the room.

Downstairs, the terrace level became the "stay at home resort" for these clients. Creating a full kitchen in one of the spaces, a dining area, a living area and a room for additional lounging and a pool table practically made this terrace level into a complete other home—only steps away rather than a drive or flight. To unify the spaces, we chose Benjamin Moore "Palladian Blue" for the walls and painted the doors Benjamin Moore "Wrought Iron" for contrast. Taking inspiration from the blue, a nearly all-blue-and-white scheme developed for the main living area. Incredible folding metal and glass doors open back onto themselves, and the entire kitchen, living room and pool room can be open to the pool terrace and outdoor fireplace. For entertaining, this is superb! Friends and family can lounge by the pool, fireplace or on the bedswing only steps away from the indoors.

Each time I visit this house, I love that my team and I have made a couple of folks feel so very "at home," even removed from their hometown. Here their hearts are happy and their souls content. The joy and delight my job brings to people when they see the finished project revealed is unparalleled by just about any other reaction. For these clients, creating a destination for relaxation, entertaining and family time within their home was so special.

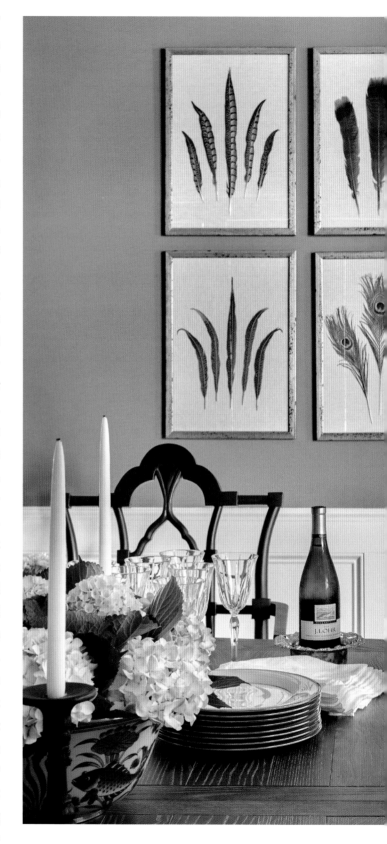

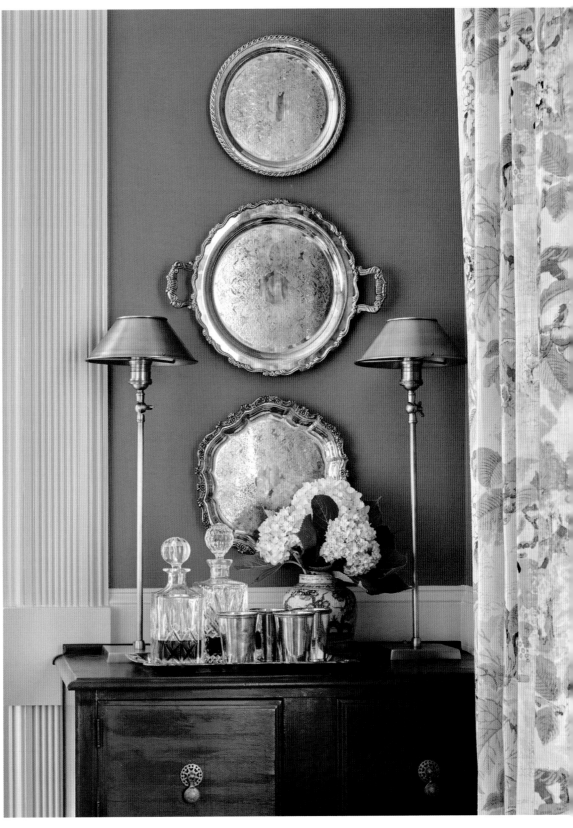

In the dining room, we pulled the sherbet orange from the Lee Jofa linen on the windows, which gives the room a fresh glow and sets off artwork and pressed feathers. I love to mix the old with the new, along with mixed metals too, so family silver pieces over a family server complement brass buffet lamps to create a perfect little bar.

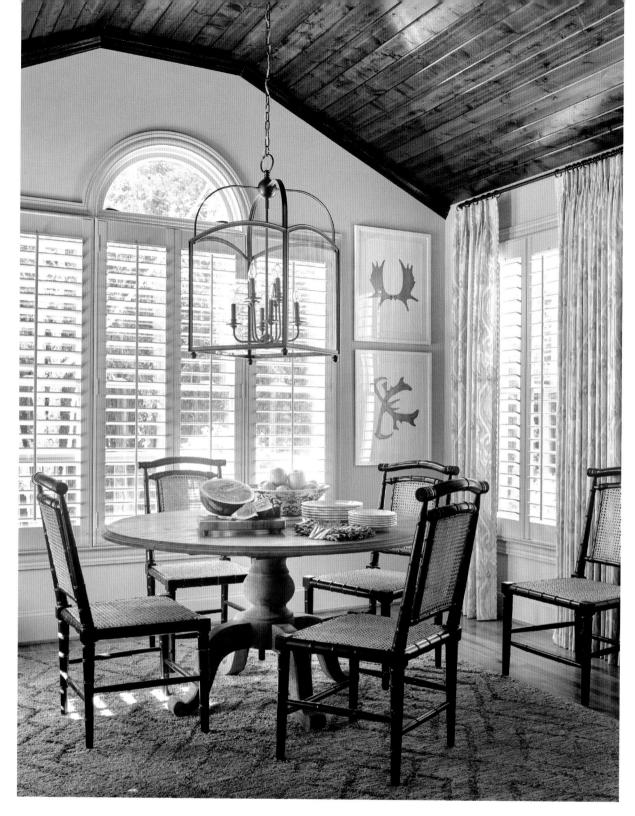

The breakfast room opens onto the kitchen and is the hub of the house. Round and oval tables are my favorites, and this square space hosts a round table beautifully, in a nod to geometry and balance. An ikat pattern with faux bois details by Cowtan and Tout dresses the windows in tone-on-tone shades of camel and cream, sparring nicely with the grayish green walls. The stained wood ceiling adds a hearty, handsome element.

I love to mix accents of black with shades of camel or caramel and rushed or caned seating. Here, a contemporary take on black bamboo chairs adds a bit of elegance to a casual space. Gold leaf antlers in white lacquered frames are current versions of ever-fashionable studies in taxidermy, flora and fauna. A jute rug with accents of green in its trellis pattern grounds the space.

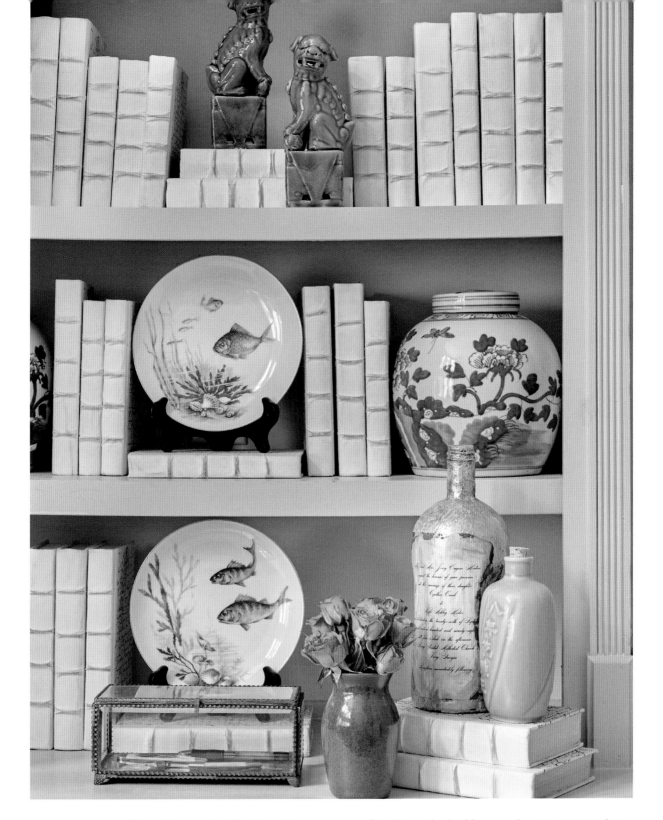

ABOVE AND OVERLEAF: Deep tobacco-hued leather chairs ensure comfortable seating in this room. An ottoman sporting an oversized Cowtan and Tout plaid is the perfect perch to prop one's feet up and relax. Placing the television over the mantel allowed us to formulate the furniture in a two-sofa, four-chair layout, which is so congenial for conversation and watching TV too. Shelves flanking the fireplace and mantel are filled with white leather-bound books, antique German fish plates, blue and white melon jars and family photographs. I often like to paint the backs of shelves a contrasting or complementary shade to offset the collections arranged there. Here "Ice Cap" by Benjamin Moore is a soothing tone for chic, classically proportioned shelves. Spreading across the width of the room is a soft jute rug layered with a gorgeous Oushak.

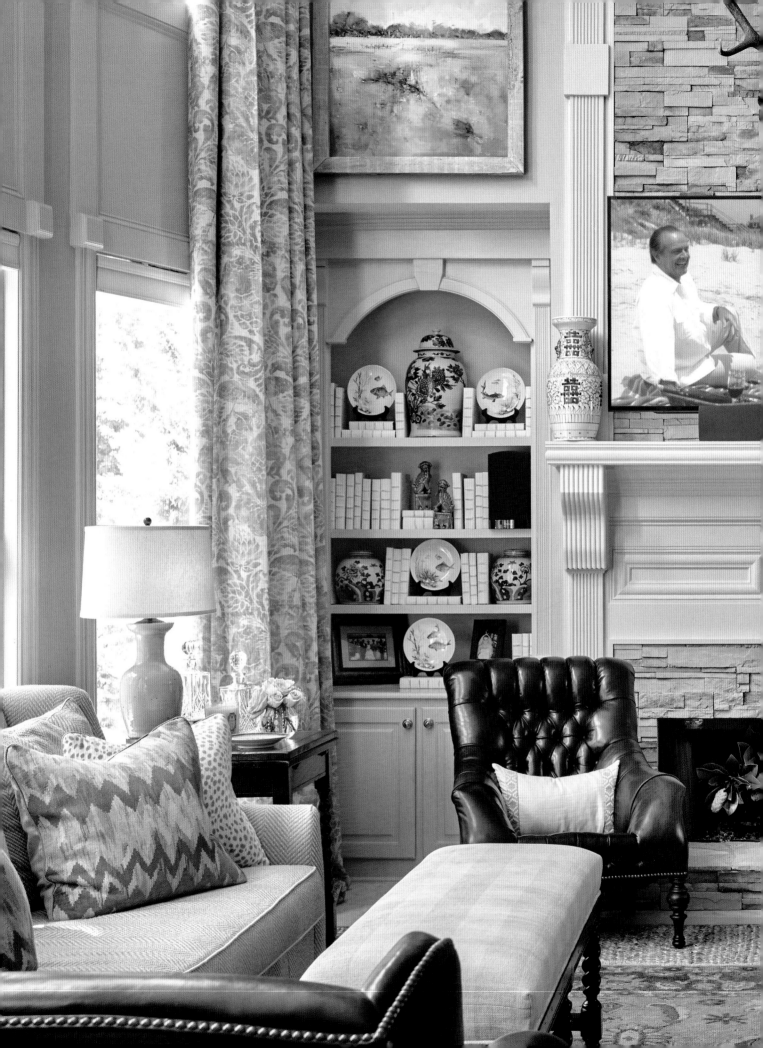

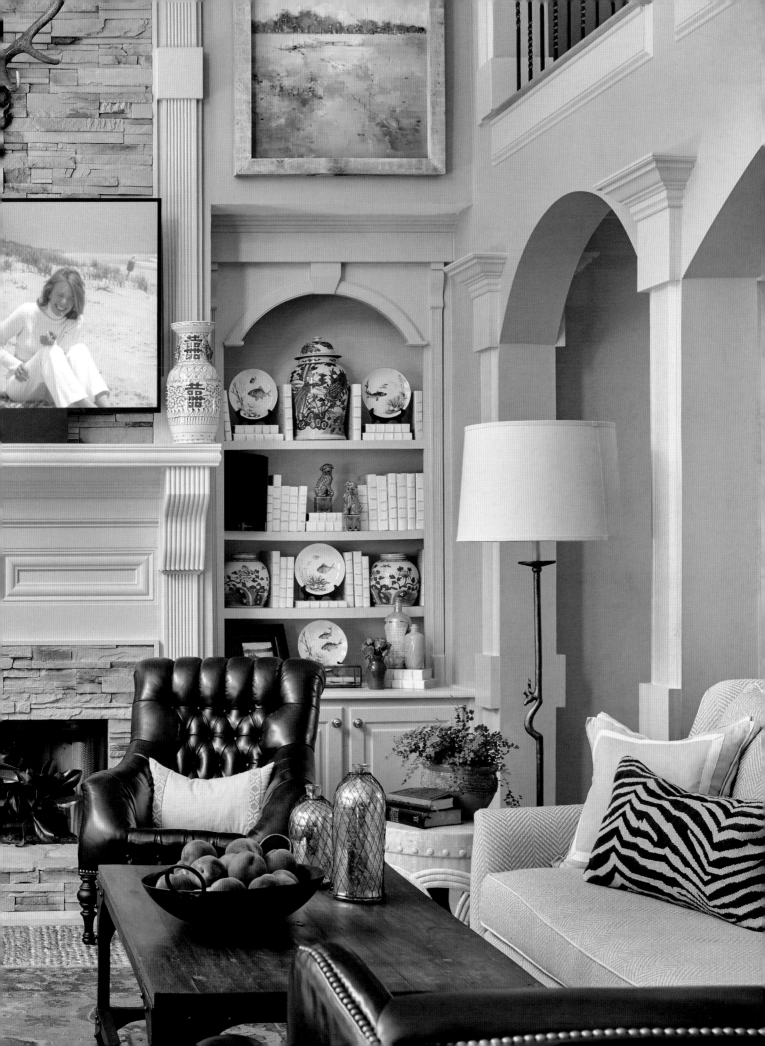

For the new kitchen in this terrace level, woven chairs, wooden countertops, and a weathered wood island add warm softness and contrast to the tile and stainless appliances. Simple Shaker-style cabinet doors pair well with many styles and décor elements. Garden greenery, pops of lemony yellow and fresh foliage all bring the outdoors indoors.

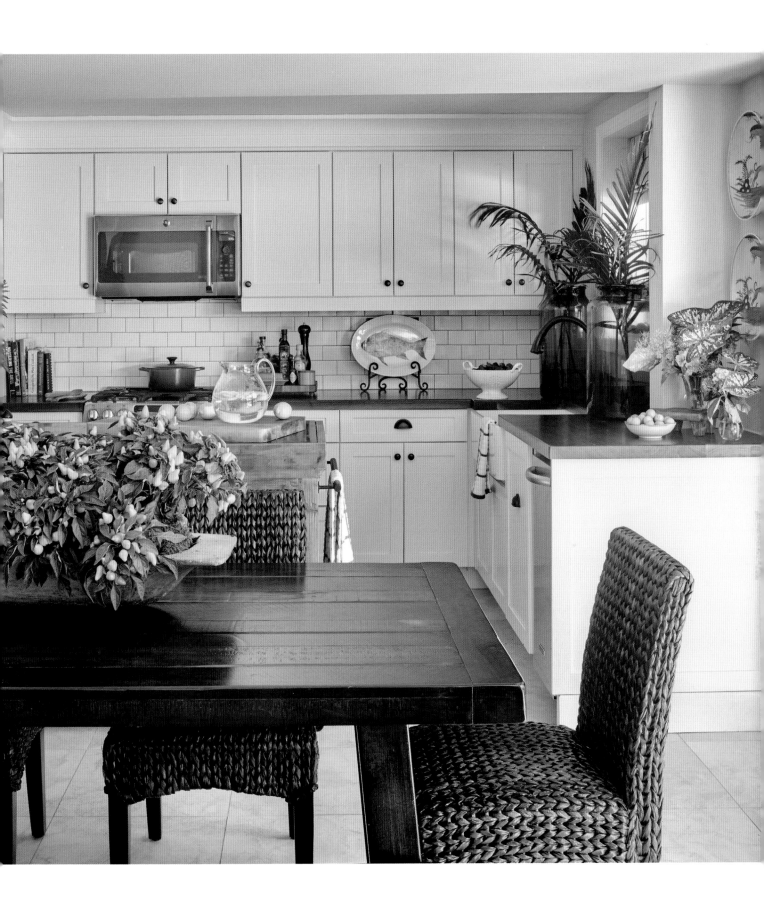

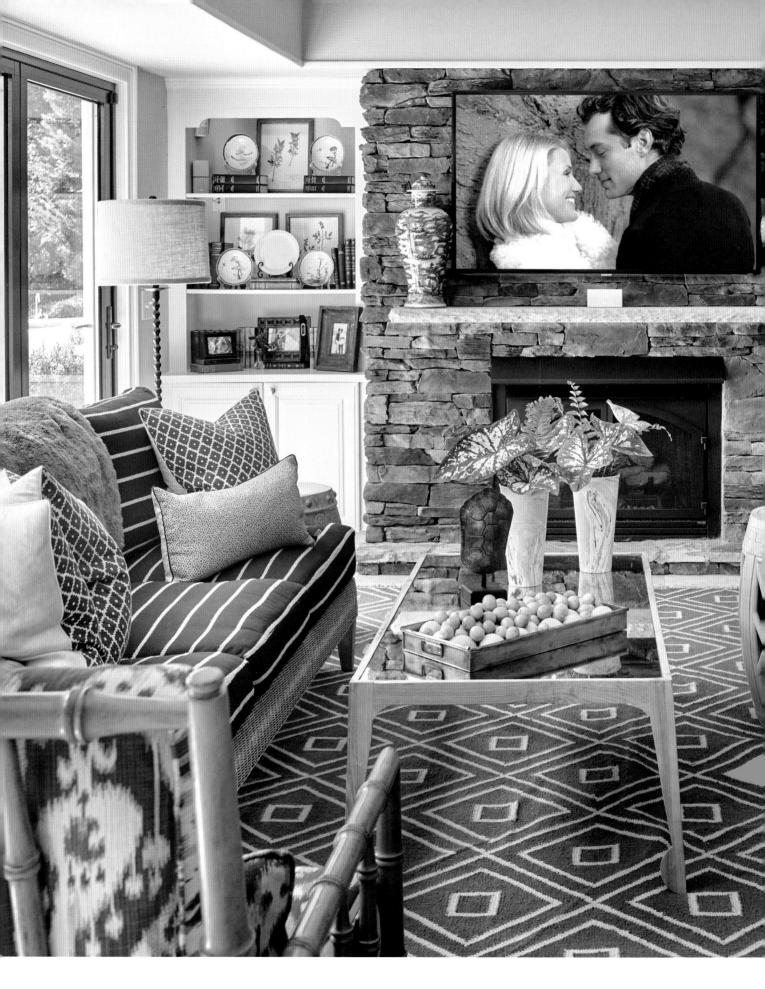

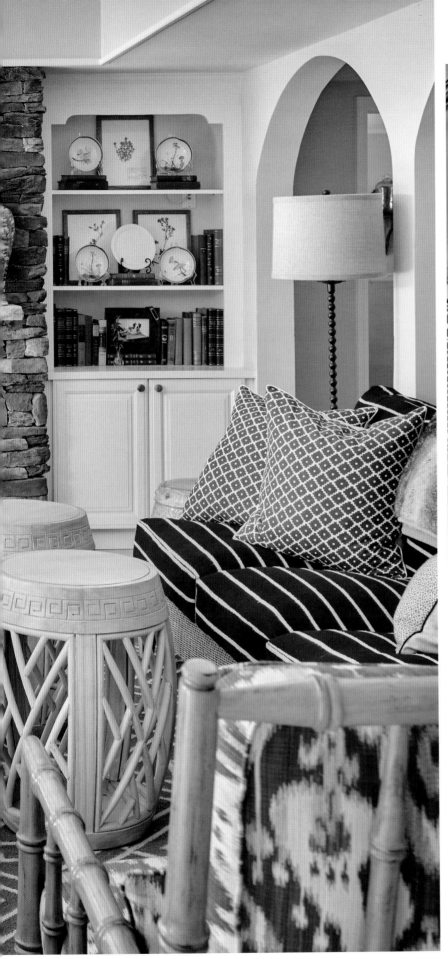

Deep indigo-and-white-striped upholstered wicker sofas create the central seating area. Bamboo armchairs wearing a blue and white pattern keep the blue, indigo, black and navy theme in check. Four metal bobbin floor lamps and four faint celadon garden stools serve as lighting and perches for drinks. I love how shades of blue in varying depths layer and contrast with one another. A whitewashed wood-and-mercury-glass-top coffee table adds a dose of glam to the room atop the Dash and Albert diamond-patterned rug. Shelves flanking the fireplace are filled with finds such as pressed botanicals, blue and white pottery, collections of childhood and other books. All the fabrics are outdoor material, so there is nothing to stop folks with wet bathing suits from enjoying the room.

In the game room, one end is grounded with a classic pool table and brass billiards light. Weathered baskets, brackets and mercury glass bottles adorn the walls. Bamboo armchairs provide extra seating while waiting one's turn at the table.

The other end of the room is comfortably appointed with a sofa and chairs for lounging and watching television. The sofa makes into a bed for overflow company. Prints of shorebirds and brown brushstroke lamps add sepia and earthy accents to the room's blues and grays. Plaid and tiger patterns in accent pillows add texture.

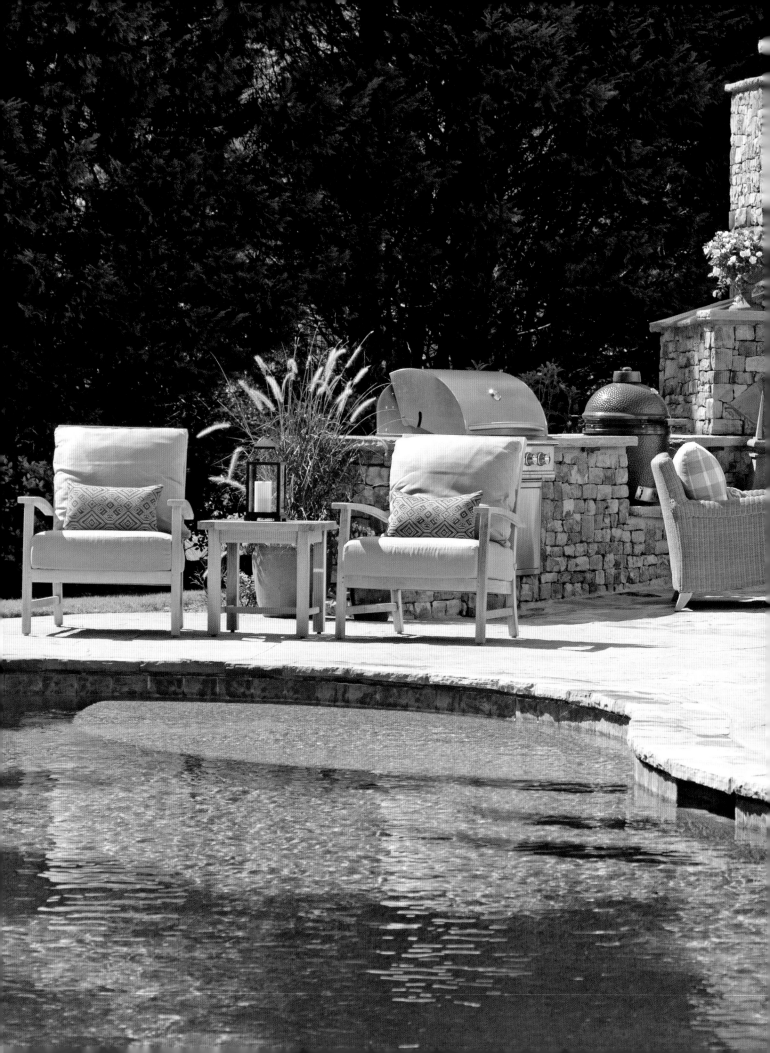

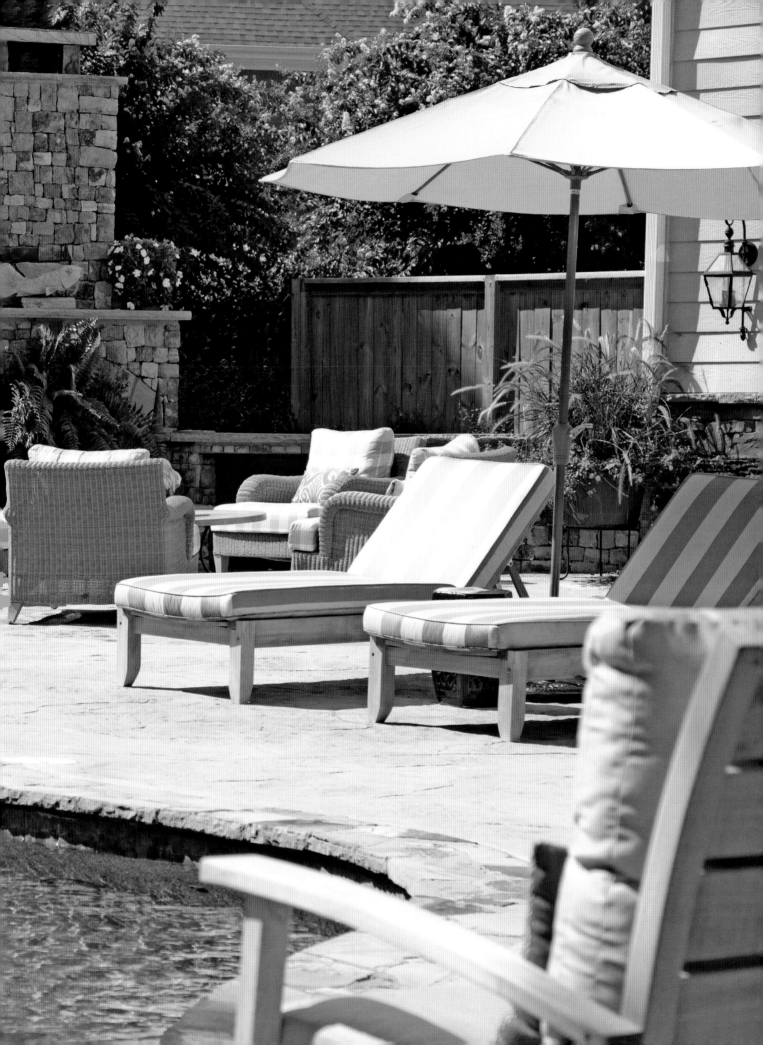

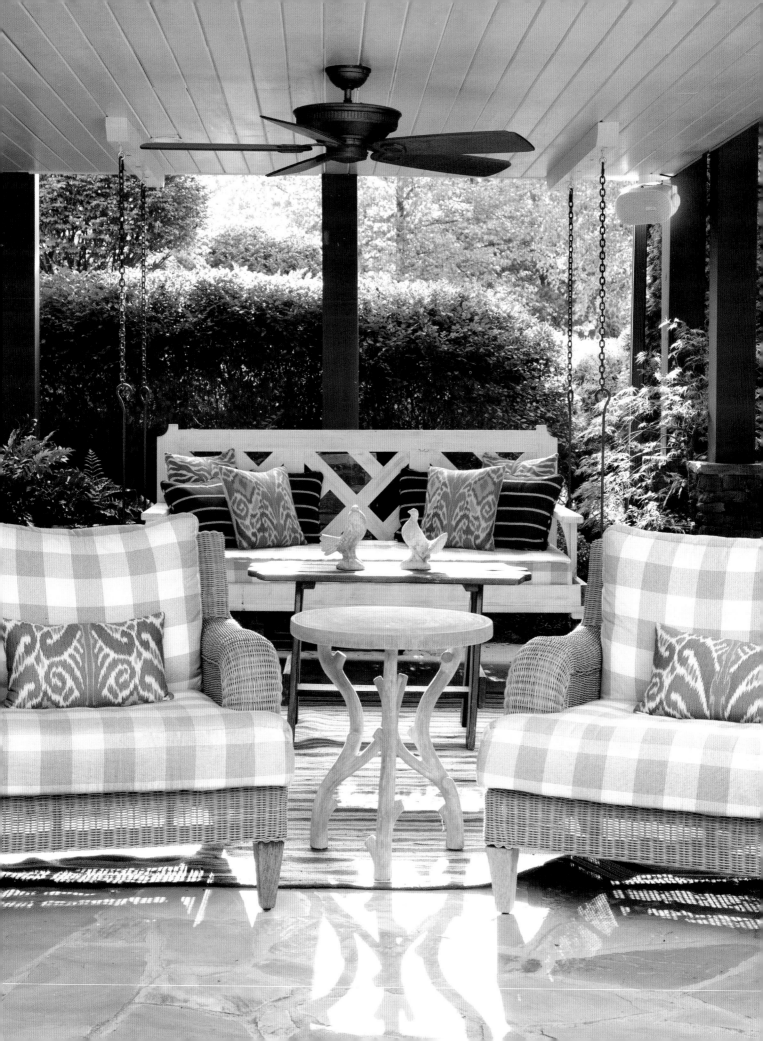

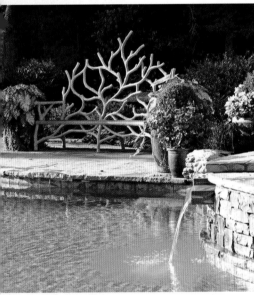

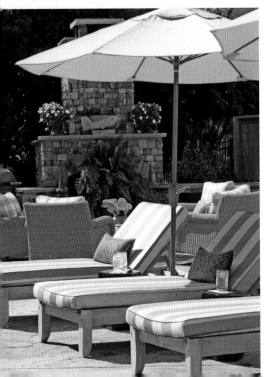

SOUTHERN OUTDOOR LIVING

Outside these interior spaces are outdoor spaces just as well appointed and comfortable. The bedswing is a sought-after spot, while rows of chaise lounges, deep armchairs and teak club chairs ensure that sunbathing and relaxation are top priorities. The outdoor fireplace is a go-to destination for s'mores and chilly weather fires.

A faux bois bench is a dramatic touch in the pool landscape. A outdoor fireplace, deep seating and gracious plantings make the pool a destination. Lush plantings of ferns, caladiums, lantana and begonias keep the garden in bloom for the long, warm outdoor season in the South.

Resources

ANTIQUE SHOPS

Antiques and Beyond
Atlanta, GA
@antiquesbeyond
www.antiquesandbeyond.com

Boxwoods
Atlanta, GA
@boxwoodsatlanta
boxwoodsonline.com

Crown and Colony
Fairhope, AL
@crownandcolonyantiques
www.crownandcolony.com

Dovetail Antiques
Cashiers, NC
@dovetail_antiques
www.dovetail-antiques.com

Foxglove Antiques
Atlanta, GA
@foxgloveantiques
foxgloveantiques.com

Jules L Pass Antiques
St Louis, MO
314.991.1522

Low Country Walk Antiques
St Simons Island, GA
912.638.1216

Madison Markets—Antiques and Interiors
Madison, GA
madisonmarkets.com

Peachtree Battle Antiques
Atlanta, GA
@peachtreebattleantiques
www.peachtreebattleantiques.com

The Plantation Shop
Amelia Island, FL
@theplantationshop
www.theplantationshop.com

Rusticks
Cashiers, NC
www.rusticks.com

Scott Antique Markets
Atlanta, GA
@scotts_market
www.scottantiquemarket.com

Vivianne Metzger Antiques
Vicki Miller Pottery
Cashiers, NC
vmantiques.com

GIFT AND TABLETOP SHOPS

Appointments at Five
Athens, GA
@apptsat5
www.appointmentsatfive.com

Beverly Bremer Silver Shop
Atlanta, GA
@beverlybremer_silvershop
www.beverlybremer.com

Erika Reade Ltd
Atlanta, GA
@erikareadeltd
www.erikareade.com

Francie Hargrove
Cashiers, NC
@franciehargrovedesign
franciehargrove.com

The Front Porch of Vinings
Atlanta, GA
@thefrontporchofvinings
thefrontporchofvinings.com

Greenhouse Mercantile
Newnan, GA
@greenhousemercantile
mkt.com/greenhouse

James Farmer Inc
Perry, GA
@jamesfarmerinc
www.jamesfarmer.com

Onward Reserve
Atlanta, GA
@onwardreserve
onwardreserve.com

Perfect Settings
Valdosta, GA
@perfect_settings
perfectsettingsga.com

Place on the Pointe
Albany, GA
@placeonthepointe

Provision
Oxford, MS
@provisionoxford
www.provisionoxford.com

Provvista Designs
Perry, GA
@provvistadesigns
provvistadesigns.com

Smith's Jewelers
Dublin, GA
@smithsofdublin

Table Matters
Mountain Brook, AL
@tablematters
www.table-matters.com

Two Friends
Perry, GA
@twofriendsperry

FABRIC HOUSES, FURNITURE LINES AND SHOWROOMS (TO THE TRADE)

Ainsworth-Noah
@ainsworthnoah
www.ainsworth-noah.com

Brunschwig & Fils
@brunschwigfils
www.brunschwig.com

China Seas
quadrillefabrics.com/chinaseas.html

Cowtan & Tout
@cowtanandtout
cowtan.com

Kravet
@kravetinc
www.kravet.com/products/furniture

Lee Industries
@leeindustries
www.leeindustries.com

Lee Jofa
@leejofa
www.leejofa.com

Lewis & Wood
@lewisandwood
www.lewisandwood.co.uk

Logan Gardens
@logangardens
www.logangardens.com

Patterson, Flynn and Martin
@pattersonflynnmartin
pattersonflynnmartin.com

Quadrille
@quadrillefabrics
quadrillefabrics.com

Schumacher and Co.
@schumacher1889
www.fschumacher.com

Thibaut
@thibaut_1886
www.thibautdesign.com

ARTISTS AND GALLERIES

Sally King Benedict
@sallykingbenedict
www.sallybenedict.com

Caroline Boykin
@carolineboykin_
www.caroline-boykin.com

Renee Buchon
@reneebuchon
reneebuchon.com

Elaine Burge
@elaineoyeburge
www.elaineburge.com

Lauren Dunn
@laurendunnartist
www.laurendunn.co

EMYO
@emyoartwork
www.emyoart.com

Gregg Irby Gallery
@greggirbygallery
greggirbygallery.com

Andrew Lee
@andrewleedesign
andrewleedesigns.com

Anne Neilson Fine Art
@anneneilsonfineart
anneneilsonfineart.com

Derek Taylor
@derektaylorstudio

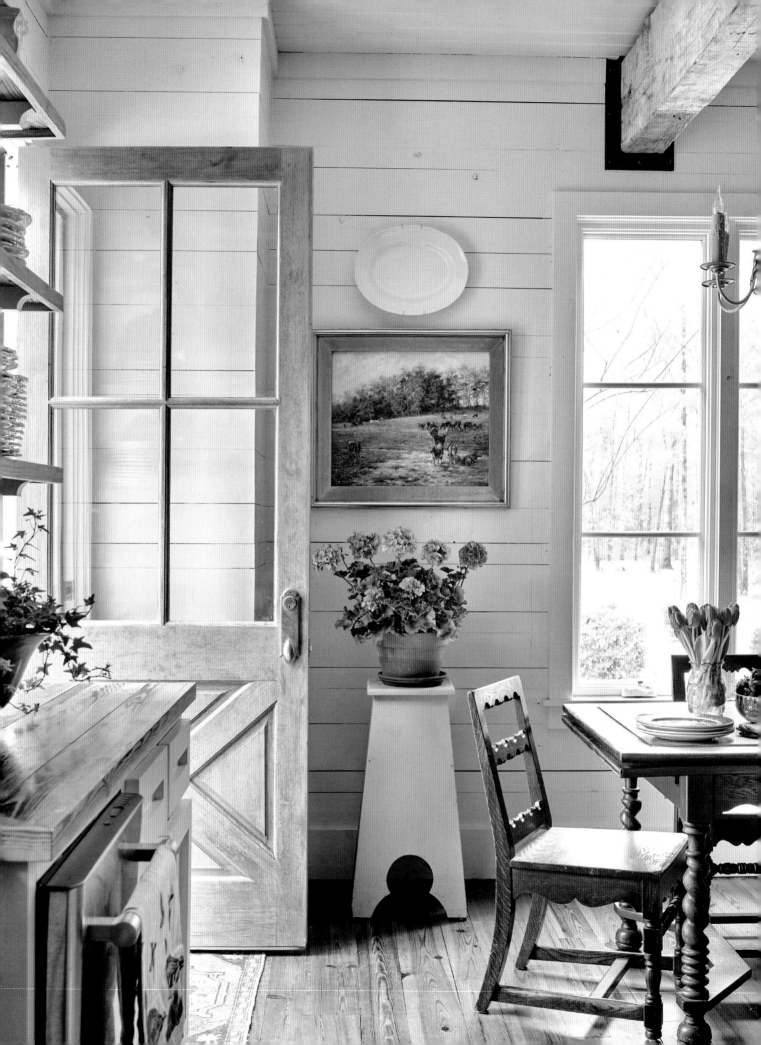

Acknowledgments

There are so many folks that helped make this book possible. My design team and our trusting clients are why this book is even a reality. I want to personally thank Carol McNeal, Pat and Mike Strain, Melissa and David Bowen, Meredith and Jim Holbrook, Brenda and Chop Evans, Caitlin and Charlie Evans, Regina and Steve Hennessy, Paula and Mark Hennessy, and Cindy and Kyle Hester. Y'all have opened your lives and homes to me and my team, and I am ever grateful to be a part of your homes' stories. Thank you!

Emily Followill, your talent and eye for detail are evident in the gorgeous images seen throughout the book. I truly love working with you and consider it all joy to be your friend! Thank you for all you do for me. Love you!

I must thank my dear friends Sally and Ross Singletary for letting me use their Cashiers home as my "place to call home" to write this book. Y'all are solid gold friends!

Matt and Jess Margeson's skill and friendship helped make the Christmas party possible. Thank you, friends!

Mrs. Linda Johnson, our wonderful seamstress, you are like a mama to us all. You keep us in stitches—literally!

My family—y'all put me up and put up with me! Love you all and thank you for all your support. Aunt Kathy and Uncle Gerry, aka "Bee and Papa," Meredith and Keaton, Maggie, Zach and Baby Napp, Daddy and Julie, Aunt Sally and Big Napp and Natalie—I love and appreciate y'all so much! Thank you for continuing to love and support me as Mama and Mimi did.

My work family—Sarah Grace, Jesse, Nancy, Robin and Madeline—thank you! Two little words to cover the big tasks, projects and undertakings y'all handle for me. It's truly an honor to have y'all as my "pride."

Madge Baird, my editor, once again provided unfailing guidance and support on this project. I always say you're my "North Star"; thank you for being so!

From our reps at fabric houses to our awesome installers, artists, upholsterers and craftsmen—you make the design dreams become realities. Thank you all!

First Edition
21 20 19 18 17 5 4 3 2

Text copyright © 2017 by James T. Farmer III
Photographs © 2017 by Emily Followill

Published by
Gibbs Smith
P.O. Box 667
Layton, Utah 84041

1.800.835.4993 orders
www.gibbs-smith.com

Designed by Sheryl Dickert
Printed and bound in Hong Kong

End sheets: "Sika" by Lewis and Wood

Gibbs Smith books are printed on either recycled, 100% post-consumer waste,
FSC-certified papers or on paper produced from sustainable PEFC-certified forest/
controlled wood source. Learn more at www.pefc.org.

Library of Congress Cataloging-in-Publication Data

Names: Farmer, James T., III, author.
Title: A place to call home : timeless Southern charm / James T. Farmer III ;
photographs by Emily J. Followill.
Description: First edition. | Layton, Utah : Gibbs Smith, 2017.
Identifiers: LCCN 2016059084 | ISBN 9781423645436 (hardcover)
Subjects: LCSH: Farmer, James T., III—Themes, motives. | Interior decoration—
Southern States.
Classification: LCC NK2004.3.F37 A4 2017 | DDC 747.0975—dc23
LC record available at https://lccn.loc.gov/2016059084

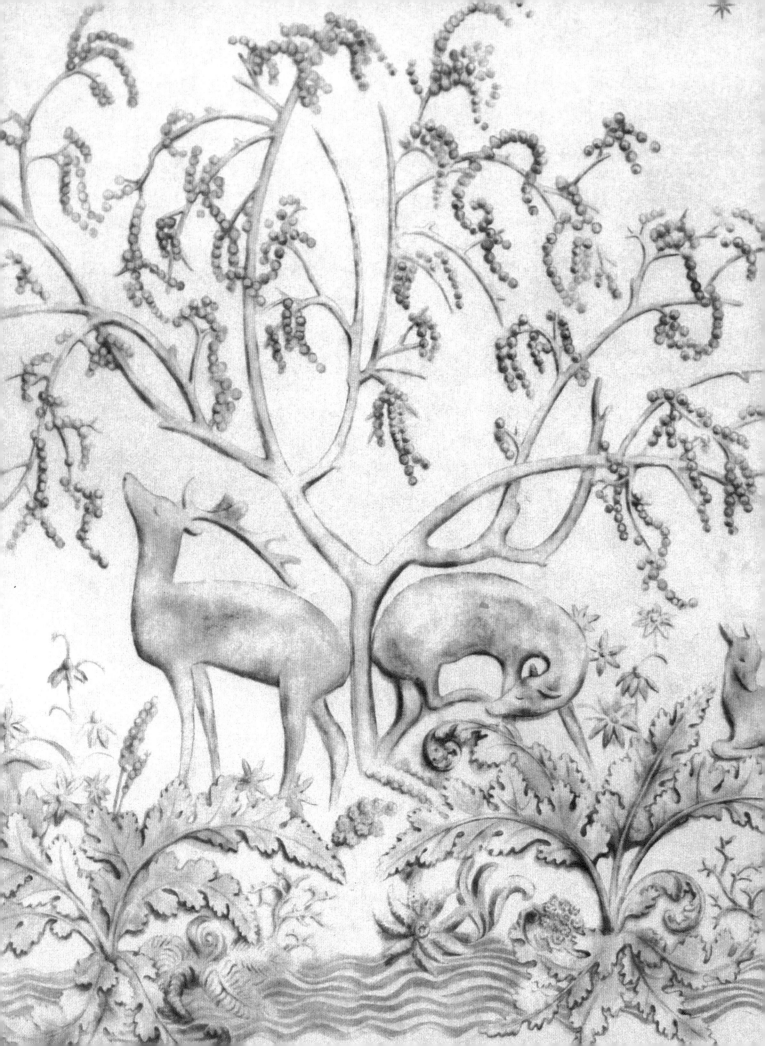